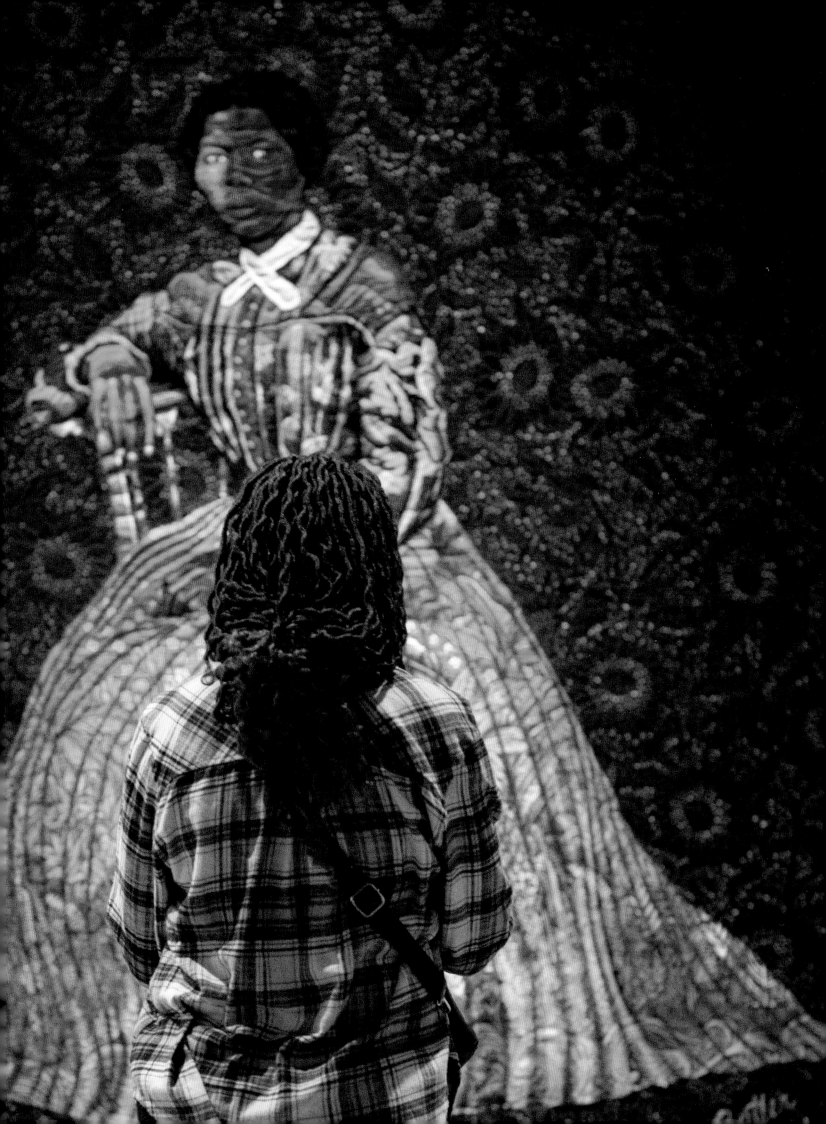

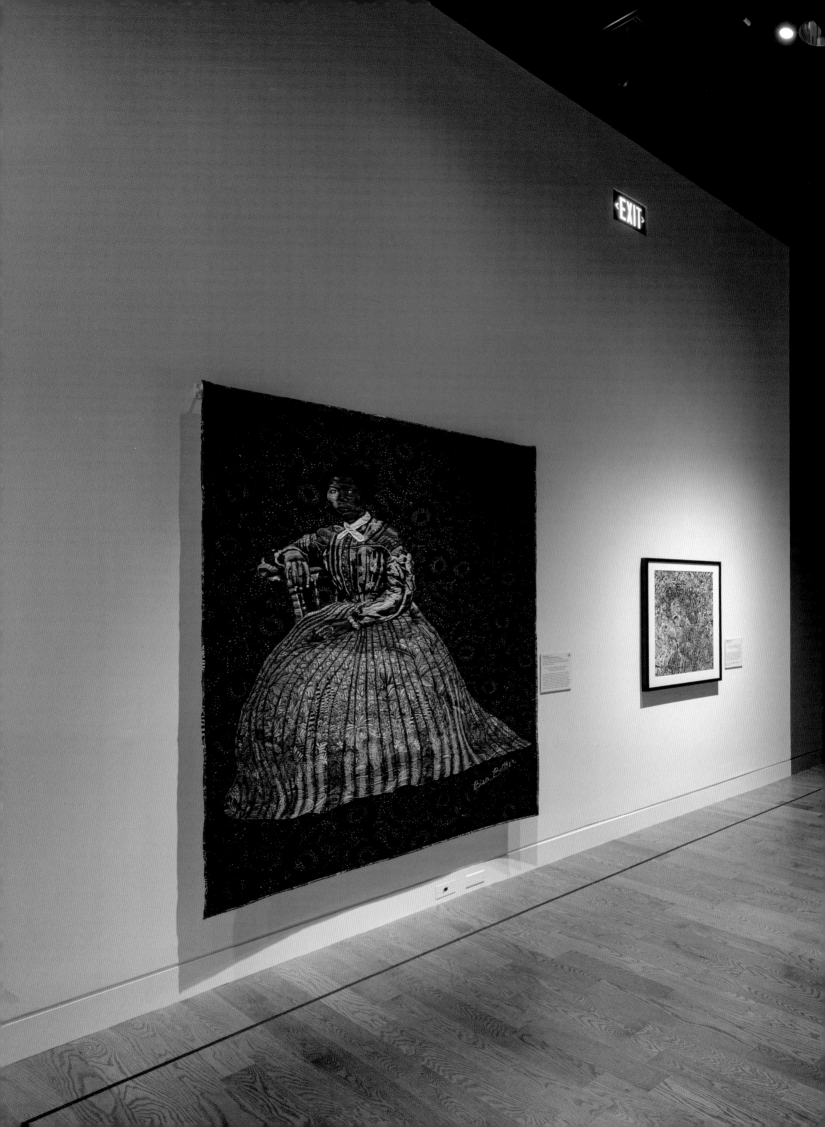

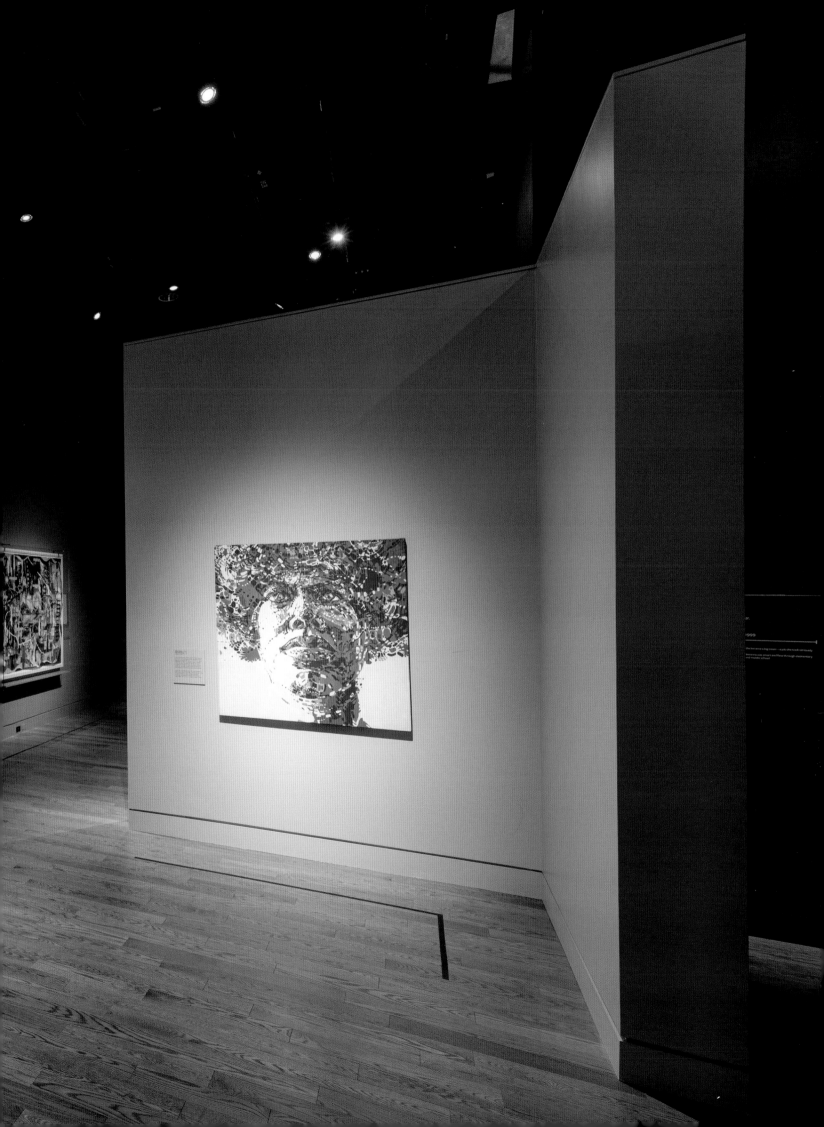

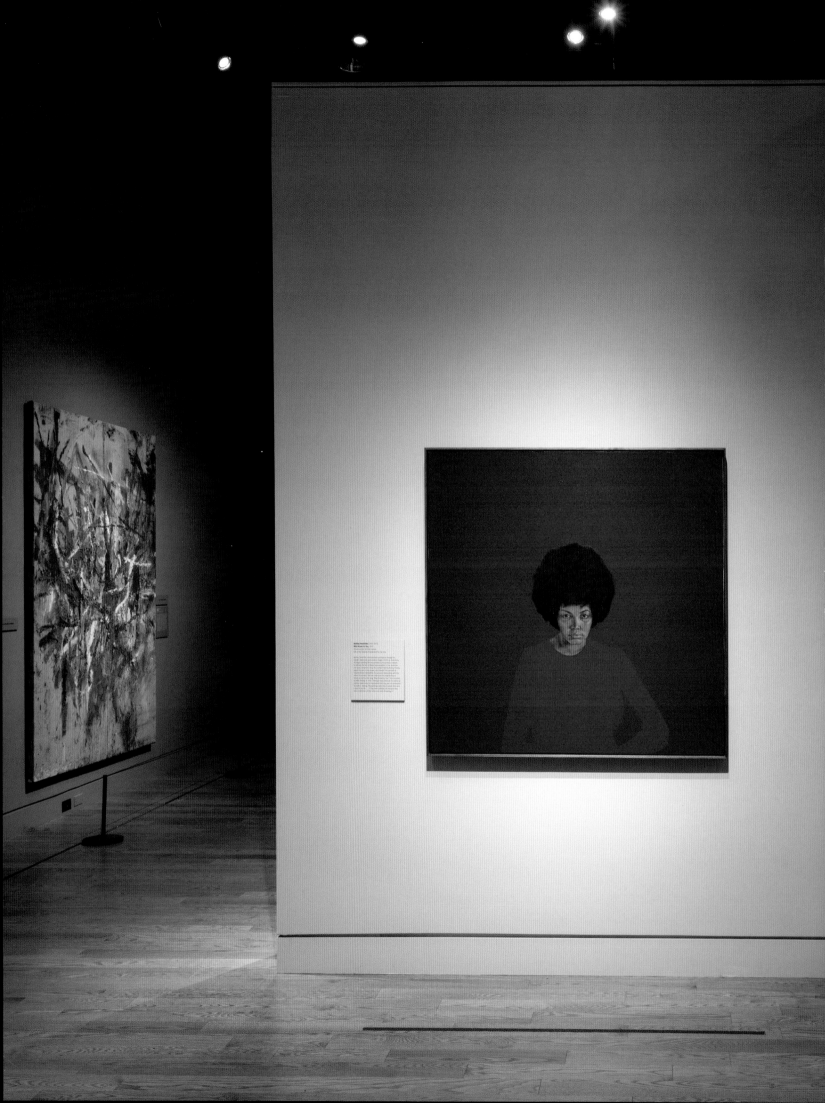

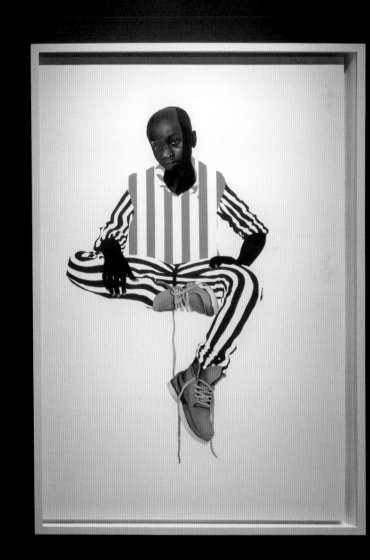

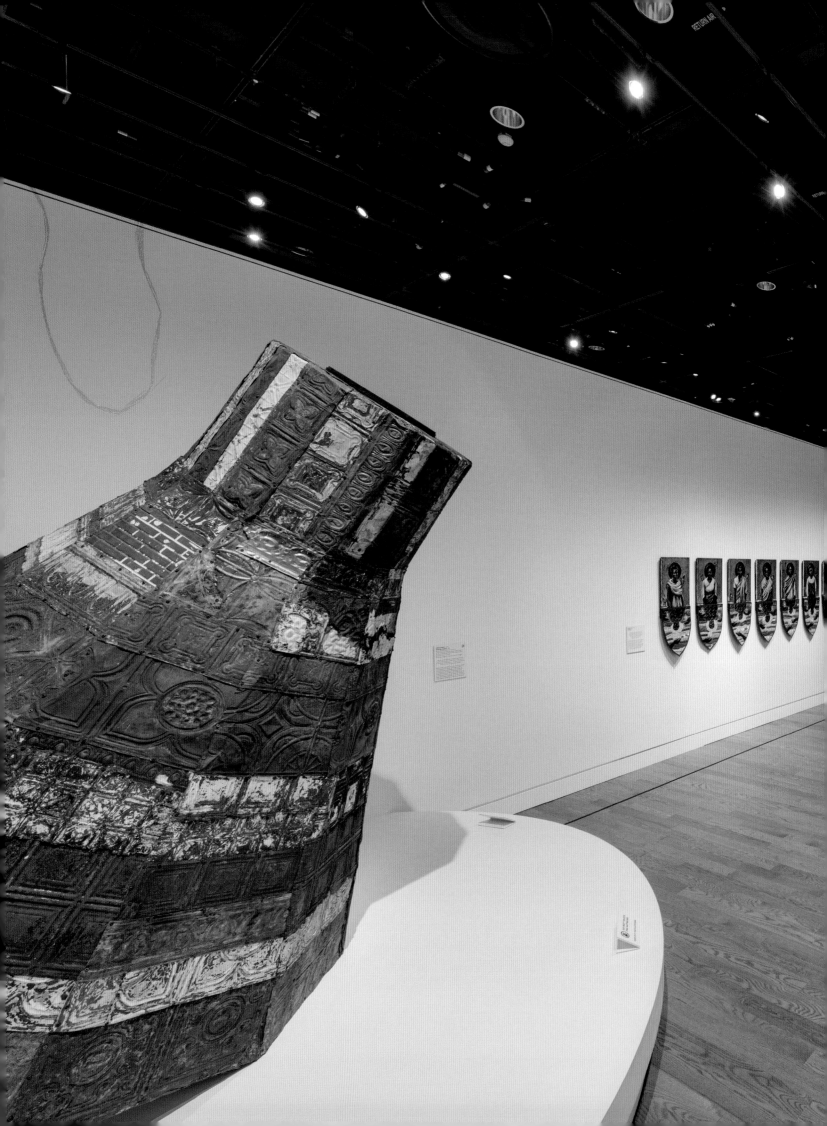

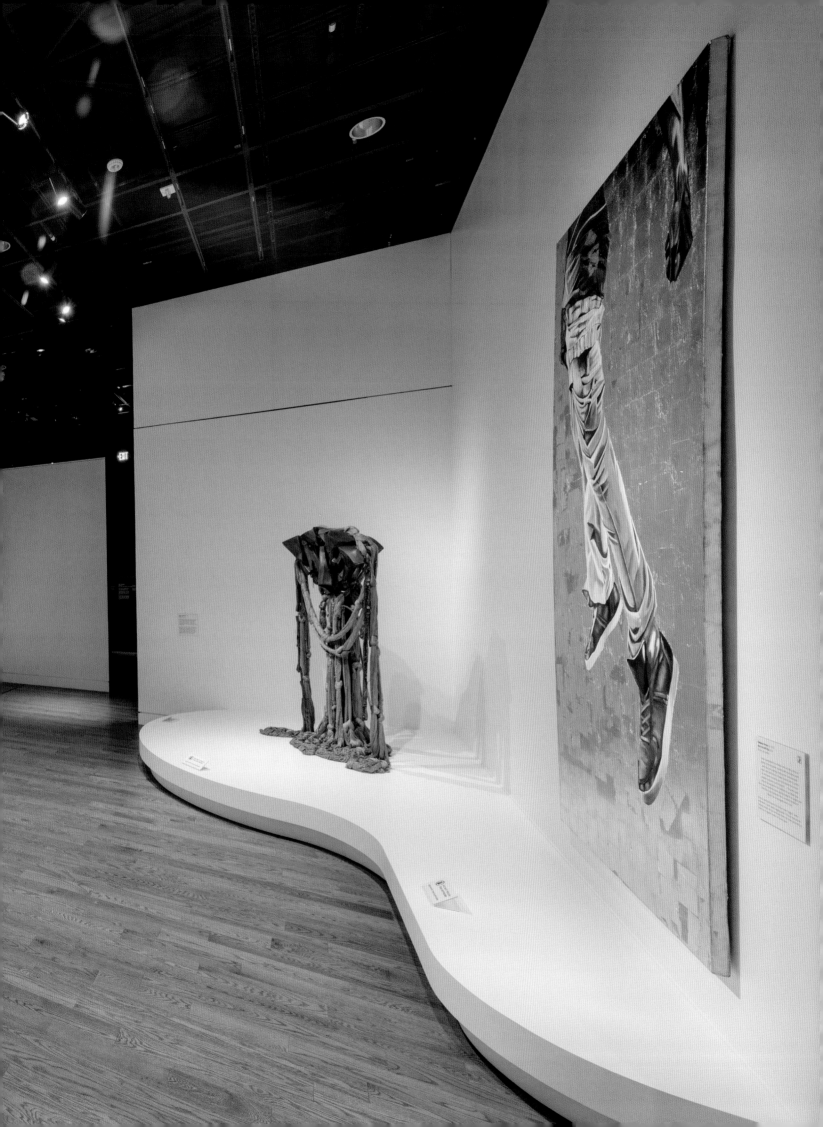

RECKO

ONING

RECKONING
PROTEST. DEFIANCE. RESILIENCE.

AARON BRYANT

BISA BUTLER

MICHELLE D. COMMANDER

TULIZA FLEMING

AMY SHERALD

DEBORAH WILLIS

KEVIN YOUNG

NATIONAL MUSEUM
of AFRICAN AMERICAN
HISTORY & CULTURE

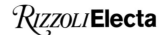
Rizzoli Electa

TABLE OF CONTENTS

Director's Foreword 16
KEVIN YOUNG

***De Oppresso Liber*:**
Benny Andrews and the
Trope of the Kneeling Black Man 20
AARON BRYANT

PLATES **30**

Black Women Artists
on the Vanguard of Social Justice 58
TULIZA FLEMING

PLATES **68**

Portraiture at the
Intersection of Art and History 100
A CONVERSATION WITH DEBORAH WILLIS,
AMY SHERALD, AND BISA BUTLER

PLATES **108**

On Reverence and Spiritual Reckonings 136
MICHELLE D. COMMANDER

PLATES **142**

Installation Views 168

Illustrated Index 196

Contributor Bios 236

Acknowledgments 238

Photo Credits 240

FOREWORD

First conceived, developed, installed, and opened in 2021, the exhibition *Reckoning* contends with American history and art history, exploring the ways that visual art has long provided its own protest, commentary, escape, and perspective for African Americans. The show arose out of the twin pandemics of COVID-19 and systemic racism, whose impact on daily life for all Americans became undeniable throughout 2020. As the world witnessed the killing of George Floyd and other African Americans at the hands of police, leading to some of the largest protests in U.S. history, the time was often called one of reckoning. The subsequent show and now catalog *Reckoning: Protest. Defiance. Resilience.* highlights the ways that the painters, sculptors, photographers, and textile artists featured here exemplify the tradition of exhibiting resilience in times of conflict, the ritual of creation, and the defiant pleasure of healing.

Reckoning provides a testament to how artists have used their work to pay tribute to those we have lost, lifting up names such as Eric Garner, George Floyd, and Breonna Taylor at demonstrations and in communities online, as well as in their work. The show journeys from defiance to acceptance, from racial violence and cultural resilience to grief and mourning, hope and change.

Reckoning also highlights the range and robustness of more than a century of artists in the permanent collection of the Smithsonian's National Museum of African American History and Culture. Over the course of its three-year run, the exhibition has featured over one hundred artworks from the collection, by artists including Jean-Michel Basquiat, Sheila Pree Bright, Elizabeth Catlett, Barbara Chase-Riboud, Torkwase Dyson, Barkley L. Hendricks, Jacob Lawrence, Deana Lawson, Spencer Lewis, Roberto Lugo, Mavis Pusey, Deborah Roberts, Alison Saar, Lorna Simpson, Lava Thomas, Mildred Thompson, Kara Walker, Charles White, and Kehinde Wiley, to name just a few. The oldest of the works in the show is *Ethiopia* (1921; p. 121), by Harlem Renaissance artist Meta Vaux Warrick Fuller; among the most recent are Amy Sherald's now-iconic portrait of Breonna Taylor, who has become a symbol of ongoing injustice and female power (2020; pp. 69–71). Sherald's other work in the show, *Grand Dame Queenie* (2012; p. 161), one of the first by the artist in any museum collection, appears alongside the first-ever artwork added to our collection, Charles Alston's *Walking* (1958; p. 131)—as well as important recent acquisitions such as David Hammons's influential *African-American Flag* from 1990 (p. 165) and Bisa Butler's now-classic portrait of Harriet Tubman, *I Go To Prepare A Place For You*, commissioned by the Museum in 2021 (cover and pp. 109–11).

Reckoning literally reoriented our Rhimes Family Foundation Visual Art Gallery. This reorientation was both practical and symbolic: visitors to the show, currently numbering a million as of this writing, now enter right off the escalator, connecting the sanctuary of the space to the rich history and culture found throughout the Museum. Combining art history and the broader history featured across the Museum's eight floors of exhibitions, *Reckoning* reaffirms the ways in which African American history is American history. Visitors emerge finding it a transformed and transformative space.

16

The show's bold context and continuity have allowed several key rotations, with the *African-American Flag* taking *Breonna Taylor*'s place of honor in a room rebuilt for these important works. Hammons's flag currently appears beside *80 days* (2018; p. 143), a powerful work by Deborah Roberts about George Stinney Jr., the youngest person ever executed in the United States, at only fourteen years old. His conviction has since been vacated.

I am always struck by the ways that visitors who rise up through the building, itself an artwork, draw immediate parallels: between Emmett Till's casket, restored and preserved in one of the Museum's most sacred spaces, and Sherald's startling portrait of Taylor or Roberts's of Stinney; or between the Emily Howland Photograph Album with the earliest known portrait of Tubman, which the Smithsonian shares with the Library of Congress, and Butler's stunning quilt based on the image of the Great Liberator. I might have expected the impact that seeing Sherald's moving posthumous portrait—which we are honored to share with the Speed Art Museum in Louisville, Kentucky, Taylor's hometown—would have on visitors, but I don't think I could have anticipated the emotional journey the entire show provides.

I ended up calling it the *force field:* that space in the galleries between Tubman and Taylor, regarding each other across space and time, as rendered by two essential artists. In the midst of that region of influence and likeness, between Tubman and Taylor—or now, the *African-American Flag*—one toggles between protest, defiance, resilience, and the artistry of centuries of Black experience. The American flag is indeed an important motif in the show, from Basquiat's small, typewritten one to David Hammons's epic statement to Patrick Campbell's *New Age of Slavery* (2014; p. 87), which went viral online and appears on the gallery walls on a T-shirt of a protester (p. 86). Distilled in oil and textiles, brush and thread, gold leaf and burlap, cast bronze and plaster made to look like bronze, these artworks—embedded by the artists with meaning—speak to the generations.

As its title suggests, *Reckoning* is about looking, or, better yet, witnessing—and to be a witness is to see but also to say. *Reckoning* also invokes the folk meaning of "to reckon," meaning both wrestling with history and thinking aloud about it. "I reckon" is both a supposing and summing up, an assumption and an assertion. Whether found in Hendricks or Butler, Sherald or Alston, Lava Thomas's portraits of Montgomery Bus Boycotters after their arrests or Lorna Simpson's crossed arms, many of the artworks here bear that look Black folks know well: of Black women looking at and looking through the nonsense, regarding you with their knowing disregard. That's *Miss Brown to You*.

Ultimately, the story that *Reckoning* tells is of tragedy and triumph, precision and perseverance, seeing and being seen—of looking back, looking through, and looking ahead to a future we all must bring into being.

Kevin Young
Andrew W. Mellon Director, National Museum of African American History and Culture

17

RECKO

Bailey, Basquiat, Dyso
Hollingsworth, Lugo, M
Simpson, Thomas, Wa

ONING.

Hammons,
rtinez, Pindell, Rucker,
er, & White.

DE OPPRESSO LIBER:
BENNY ANDREWS AND THE TROPE OF THE KNEELING BLACK MAN

Aaron Bryant

He stood kneeling. As a symbol of peace and resistance, he kneeled to take a stand. Who knew that such a simple gesture or act of acknowledgment could ignite shards of emotion and controversy? From the fields and streets across our nation to debates from Congress to the Oval Office, taking a knee often communicated more powerfully than standing and watching in apathy or sitting in silence along the sidelines. So he stood and kneeled to suppress indifference with a soundless symbol of resilience and recognition. Motionless, with a still mouth and stare, a speechless figure spoke in an appeal to promised democracies through silent cries against injustice. Rosa Parks sat. In Greensboro and India, they sat. In this portrait, however, he kneels to stand and demand his dreams of America.

In September 2021, the National Museum of African American History and Culture installed a new exhibition, *Reckoning: Protest. Defiance. Resilience.* A response to the Black Lives Matter demonstrations of 2020, the show features works that span one hundred years of art as a discursive medium for resilience and protest, including *Militant*, a mixed-media collage by Benny Andrews that measures approximately thirty inches high and twenty-two and a half inches wide (fig. 1). Both figurative and minimalist in its execution, the work captures the silhouette of a kneeling figure that is marbled by gradations of blacks and grays. The subject's groin and torso, along with a single arm and leg, are bound by the United States flag, and although the subject bends, he does not bow. He wrestles the nation's flag from a kneeling position, while entangled by its paradox of "liberty and justice for all." This essay places the collage within a historical context of other works in which the iconography of a kneeling Black figure has been used in the visual arts, decorative arts, and photography across four centuries. It also considers *Militant* within the context of Andrews's life history.

Throughout our nation's history, a kneeling Black man has been a recurring symbol used to evoke emotions in shifting debates on race, patriotism, and social progress. The iconography for the antislavery medallion "Am I Not a Man and a Brother?," for example, was created in the late eighteenth century as part of abolitionist movements in Europe. In both Europe and America, opponents of slavery wore the image engraved or embossed on small porcelain and ceramic jewelry produced by artisans such as the British potter Josiah Wedgwood. In time, the symbol appeared on objects ranging from cameos and coins

"Do not underestimate the power of a people who can put together the powers of ownership with the determination to have their voices and images firmly implanted in the fields of the culture they have cultivated."[1]

Benny Andrews, journal entry, January 29, 2003

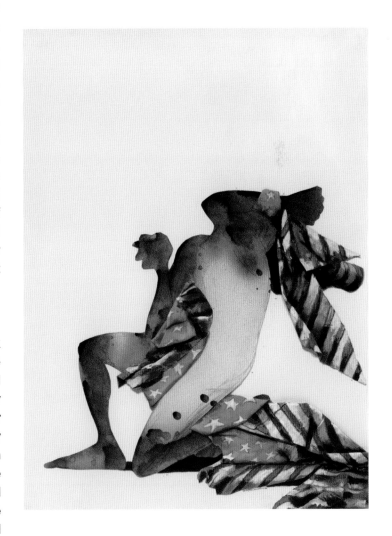

1 Benny Andrews, *Militant*, 1996.

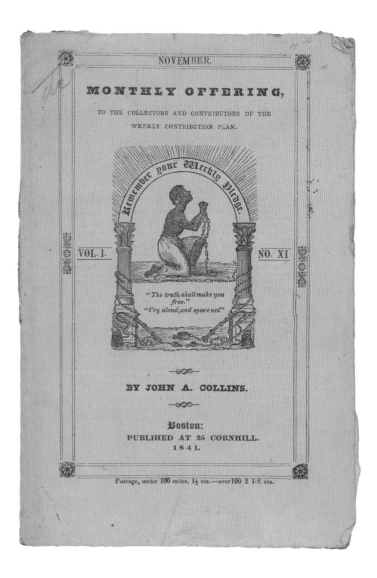

to cuff links and pamphlets (fig. 2). The seal originally was designed for the Society for the Abolition of the Slave Trade, a religious organization founded in 1787. While its presentation was deceptively simple, the image was complex with racial, religious, and political meaning.

Designed in neoclassical form with its aesthetic references to early Western civilization and its visual narratives of morality, the image portrays a kneeling enslaved Black man shackled with chains. While he is on a bended knee with his hands positioned in supplication, his posture communicates prayers and pleas for deliverance and salvation. This connotes Christianity and the Christian principles of faith and righteousness, as Jesus kneeled to pray in the Garden of Gethsemane.[2] The subject's near nakedness suggests virtue and the vulnerability of his humanity, while communicating a social position and relationship to God. By 1788, Wedgwood shipped cameos with the image to Benjamin Franklin in Philadelphia, where it became popular iconography that adorned antislavery pamphlets and jewelry. While most abolitionists hoped to abolish the transatlantic slave trade, they did not all agree on abolishing ongoing domestic slavery. Nor did they all agree on abolishing the established cultural assumptions of white supremacy and Black inferiority, which the image also implies through the subject's hands and gestures of supplication.

Nearly a century later, African Americans working on their own behalf to commemorate both the recent end of slavery and the assassination of Abraham Lincoln raised $20,000 to create and erect the Emancipation Statue in Washington, DC's Lincoln Park in 1876. Still standing today, the monument, which is also referred to as the Freedman's Memorial, was designed and sculpted by Thomas Ball and funded by African Americans who were formerly enslaved. The monument portrays Abraham Lincoln holding a copy of the Emancipation Proclamation in his right hand while his left hand gestures above a formerly enslaved subject (fig. 3). The newly emancipated figure is believed to be Archer Alexander, who was the subject of the 1885 biography *The Story of Archer Alexander, from Slavery to Freedom, March 30, 1863*. While Lincoln gestures with his left hand above the kneeling figure, the subject is on one knee as if he might rise to stand. The newly freed man looks forward and clenches his right fist as his chains fall at Lincoln's feet.

Created more than a century afterward, Andrews's *Militant* offers commentary on the complex historical relationships African Americans had with the myths and symbols of democracy at a time when questions surrounding Black liberation and the limits of abolition

2 Image of a kneeling enslaved person printed on the cover of a periodical, the *Monthly Offering* vol. 1, no. 11.

were at the forefront. On the one hand, the portrait's featureless subject represents African Americans who, since this nation's founding, have wrestled with the meaning of Americanism and myths of liberty and freedom. At the same time, however, the collage is a self-portrait and a personal reflection of the artist's early years in the South and his evolution as an artist and activist in New York during the 1960s and 1970s.

Benny Andrews was born in November 1930 in Plainview, Georgia, a small farming town southeast of Atlanta, where his parents, George and Viola, were sharecroppers. One of ten children, Andrews inherited his father's gifts and curiosities as an artist early in life. Although he often sketched to capture the dreams in his imagination, the young artist, as a child of farmers during the Depression era, still was required to work in the fields while attending school whenever possible. "No words can adequately articulate the sharecropper's reality," Andrews wrote in his journal. "It is too demeaning, demoralizing and dehumanizing to get into a verbal language."[3] As an artist, however, Benny Andrews developed a visual language to communicate social insights on his life and cultural experiences as an artist and African American.

He finished high school in 1948 and, with a scholarship from the 4-H Club, enrolled at Fort Valley State, a historically Black college in Fort Valley, Georgia. After a year of struggling through courses, however, he left Fort Valley in 1950 and enlisted in the U.S. Air Force. Andrews served during the Korean War in Alaska and the Far East, and by the war's end in 1953, he achieved the rank of staff sergeant and was honorably discharged from military service in 1954. With benefits through the GI Bill, the artist enrolled at the School of the Art Institute of Chicago, where he visited an art museum for the first time. As Andrews recalled, "I got to Chicago about a week before it was time to go to school and I used to walk down Michigan Avenue to the Art Institute and just look. It was like the answer to my dreams to see this big place, this prestige place I was going to."[4]

Andrews graduated from the Art Institute school in 1958 and left Chicago to pursue a career in New York (fig. 4). Within two years of arriving in Manhattan, his first solo exhibition opened, followed by his second in 1962. In New York, the artist began defining his technique, voice, and style of communicating his artistic and personal ideas. While scholars might categorize his work as figurative expressionism, Andrews operated in diverse genres, ranging from an expressionist mannerism that is as illustrative as

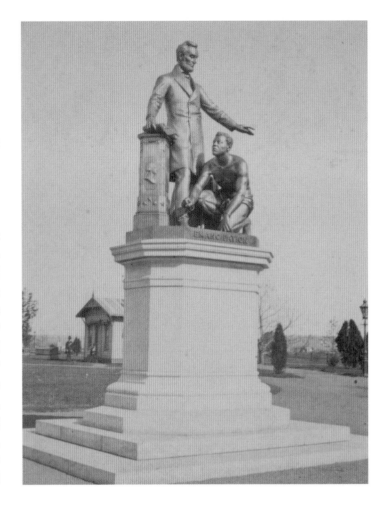

3 J. F. Jarvis (publisher), *Emancipation Monument, Lincoln Park, Washington, D.C.—Thomas Ball, Sculptor*, between 1876 and 1910.

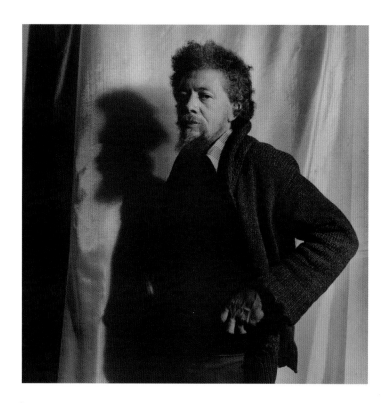

4 Anthony Barboza, *Benny Andrews – Artist*, 1975.

the sixteenth-century Mannerism of Italian religious paintings to Surrealist works and expressionist collages that are more subtle in communicating a broad range of emotions and narrative ideas.

By the late 1960s, Benny Andrews evolved to become more politically active in his personal and professional work. While denouncing restrictive categorizations as an artist, including the perceived encumbrances of racial categories, artistic media, and aesthetics, Andrews grew increasingly conscious of the sociopolitical realities he confronted, particularly following Dr. Martin Luther King Jr.'s assassination in April 1968. On June 4, 1968, for example, the artist attended an event hosted by New York City's Metropolitan Museum of Art at which the museum announced its exhibition *Harlem on My Mind: Cultural Capital of Black America, 1900–1968*. Black artists and activists alike were present, including H. Rap Brown, who is known primarily for his work and associations with the Student Nonviolent Coordinating Committee (SNCC) and the Black Panther Party. In an essay for *Arts Magazine*, Andrews recalled what he felt while attending the preview. He wrote, "I was struck by the ignorance of the Museum's advisors when, on arriving at the opening preview, I found that many of the best known black artists, who had lived in Harlem for years—Norman Lewis, for example—were not invited; the precious and chic advisors who had scurried about never heard of them. On the other hand," he continued, "artists like myself, whose names had recently appeared in the *New York Times* regarding an exhibition of black artists . . . were invited."[5]

In response, Benny Andrews, along with painter Clifford Joseph and others, cofounded the Black Emergency Cultural Coalition (BECC) in January 1969. The group mobilized artists, critics, and writers, such as Henri Ghent, Faith Ringgold, Romare Bearden, and Norman Lewis, to protest the lack of African American representation and participation in organizing the exhibition. This included the Met's exclusion of Black artists, curators, and scholars. As Andrews recalled:

> I thought about that strange event called the "Preview Reception for the Harlem on my Mind Exhibition," and what really stuck in my throat was the flippant and superficial attitude of the people I'd met there who were connected with the show. I remember how helpless I felt as an artist and as an individual. That episode was to enable me to sustain a sense of indignation that will be with me as long as I live.[6]

24

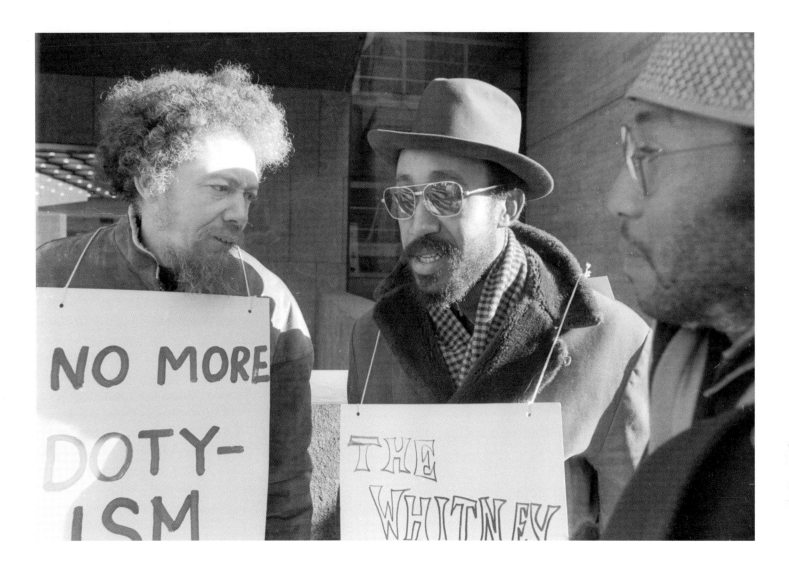

The BECC launched its first public protest of the Met exhibition at the museum's front entrance on January 12, 1969. They formed a picket line and marched with protest signs while distributing leaflets to pedestrians and museum guests. As Andrews noted, "At 1:00 p.m. we started our demonstration at the Metropolitan against the 'Harlem on My Mind' show. The police were waiting for us with barricades and very stern looks. A line of the Museum's staff," he continued, "were right inside the Museum with their noses pressed against the glass doors peering out at us. We formed a long oval line and started to walk slowly around and around the police barricades with our placards denouncing the exhibition."[7] A second demonstration followed on January 14, and by the night of the exhibition's opening reception on January 16, others joined the protest, among them Richard Mayhew, Barbara Carter, Roy DeCarava, and Vivian Browne.

Months later, following its success in mobilizing protests at the Metropolitan Museum of Art, the BECC followed with negotiations at the Whitney Museum of American Art to protest the planned exhibition *Contemporary Black Artists in America*. Andrews and Ghent met with the Whitney's director, John

5 Jan Van Raay (photographer), Benny Andrews (left) and Art Coppedge (center) during the Black Emergency Cultural Coalition protest at the Whitney Museum of American Art, New York, January 31, 1971.

25

6 Benny Andrews, *Flag Day*, 1966.

Baur, on April 24 to discuss the museum's policies and its exclusion of African Americans in shaping the museum's curatorial direction and discourse on American art. The group later presented a list of demands to advocate for an African American guest curator for the contemporary Black artists exhibition; the inclusion of more Black artists in the Whitney Annual exhibit; a permanent staff of African American curators; and a series of solo exhibitions for African Americans. After two years of negotiating, the BECC and the Whitney were unable to reach a compromise, so the group of artists and activists launched protests at the Whitney in 1971 (fig. 5). It was during this period, between the late 1960s and early 1970s, that Benny Andrews cultivated his reputation as a leader among artists and activists in New York's Black arts community. As J. Richard Gruber observed:

> Because of his activities in academic and art world events during the late 1960s, and because of his accessibility to the media, Benny Andrews became an increasingly influential leader and spokesman for diverse social and artistic causes. And, because he was increasingly labeled as a "militant," many collectors and curators began to avoid the art he created, in essence forming a new prejudice that he would continue to face well into the next decade. He continued to pursue the goals articulated by the BECC and other groups, despite the labels applied to him and the negative impact this had on his reputation.[8]

Benny Andrews jeopardized his reputation and career in taking a stand against injustice, and beginning in the mid-1960s, as the Civil Rights Movement matured, the artist created work that more overtly interrogated inequality. He challenged publics to question myths and symbols of democracy and face the realities of Americanism. Challenging himself throughout his career, Andrews deployed the flag as a recurring motif primed for interrogation (fig. 6). The flag appears in *Flag Day* (1966), *Did the Bear Sit Under a Tree?* (1969), *No More Games* (1970), *Liberty #6* (1971), and *Demagogue* (1990), among other works. The American flag and other symbols of patriotism, including the national anthem, became primary sites for artists to signify on myths of equal justice, while history proved there was liberty and justice for some but not all. Erasures and reinterpretations of history provided myths with false analogies to normalize their existence, while myths transformed misconceptions of history into sociopolitical tribalism and ideologies that presented themselves as patriotism. In *Militant*,

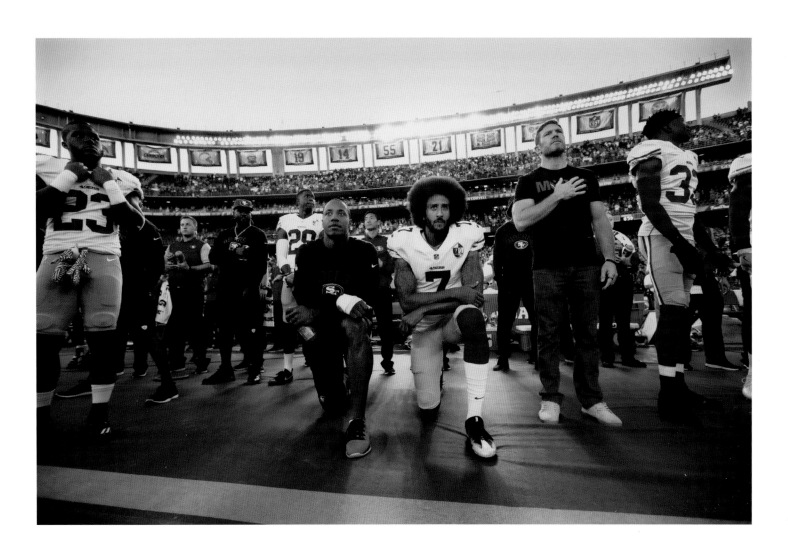

Andrews meticulously portrays the flag and presents a featureless figure as a shadow or silhouette that wrestles with the ideals of nationalism and citizenship.

In August 2016, for example, Colin Kaepernick, the starting quarterback for the San Francisco 49ers, began his protests against the shootings of unarmed African Americans across the country. At first, the athlete sat during the national anthem, but on September 1, to start his final exhibition game of the season, Kaepernick kneeled alongside teammate Eric Reid, after conversations with Nate Boyer, a former Green Beret (U.S. Army Special Forces). Boyer had a brief stint with the Seattle Seahawks as a free agent in 2015 (fig. 7). As Boyer recalled, "Soldiers take a knee in front of a fallen brother's grave . . . to show respect,"[9] and Kaepernick likewise kneeled to recognize the lives of the unarmed African Americans who mattered but fell as victims of police shootings earlier that summer. The simple gesture would jeopardize Kaepernick's career. "If they take football away, my endorsements from me," Kaepernick said, "I know that I stood up for what is right."[10]

In a country in which our greatest strength, and challenge, is a vast diversity of perspectives and experiences, Kaepernick was both celebrated

7 Michael Zagaris (photographer), Eric Reid (left) and Colin Kaepernick (center) kneeling next to Nate Boyer (standing, right) during the National Anthem at Qualcomm Stadium, San Diego, September 1, 2016.

and maligned for what he saw as a call for justice and peace. While Kaepernick's activism ignited a discourse on defining justice and democracy in the United States, debates between tribes and ideologies eventually ended Kaepernick's future in the National Football League. "I'm not anti-American," he said. "I love America. I love people. That's why I'm doing this. I want to help make America better."[11]

Throughout U.S. history, the iconography of kneeling Black men has been used to challenge our national myths and assumptions about race and democracy. Each example should lead viewers to question the motivation behind the creation of these myths, to which each trope responds. In reading Benny Andrews's *Militant*, for example, one might signify on Roland Barthes's thesis regarding the underlying meanings encoded into images, artifacts, symbols, and practices to ask: What are the conscious or subconscious human impulses or needs that underlie the creation of the myths that Andrews confronts? How do particular interests, including economic, religious, and political interests, contribute to the process of creating these myths? Whose interests are served by these myths and whose are not? Who is allowed to call themselves American and claim the rights of citizenship? These are the questions that Andrews presents to his viewers through his work and the kinds of challenges the museum presents in its *Reckoning* exhibition.

In a September 2018 Sports section of the *Los Angeles Times*, writer Sam Farmer wrote a feature on Nate Boyer, "the ex-Green Beret who inspired Colin Kaepernick to kneel instead of sit" during the national anthem. In the article, Farmer reports that Boyer, in his initial open letter to Kaepernick, wrote, "I look forward to the day you're once again inspired to stand during our national anthem. I'll be standing right there next to you. Keep on trying. . . . De Oppresso Liber."[12] Boyer ended the letter with a Latin phrase that is the motto for the Army Special Forces. The phrase means "to free the oppressed." As *Militant* by Benny Andrews suggests, however, sometimes we are oppressed by our symbols of patriotism and the myths we carry to define who and what we consider American. While *Militant* is a self-portrait of an artist whose life and work challenges us to reckon with our nation's history of injustice, it is also a portrait for every American who sat, stood, marched, and kneeled *de oppresso liber*.

Endnotes

1 Quoted in *Benny Andrews: There Must Be a Heaven* (New York: Michael Rosenfeld Gallery, 2013), 4.
2 Matthew 26:36–56.
3 Lowery Stokes Sims, "Benny Andrews: From Earth to Heaven and Back," in *Benny Andrews*, 11.
4 Benny Andrews, interview by Henri Ghent, June 20, 1968, Oral History, Smithsonian Archives of American Art, transcript, 9.
5 Mark Godfrey and Zoé Whitley, eds., *Soul of a Nation: Art in the Age of Black Power* (London: Tate Publishing, 2017), 222.
6 Godfrey and Whitley, *Soul of a Nation*, 223.
7 J. Richard Gruber, *American Icons: From Madison to Manhattan, the Art of Benny Andrews, 1948–1997* (Jackson: University Press of Mississippi, 2005), 141.
8 Gruber, *American Icons*, 144.
9 Cindy Boren, "A Timeline of Colin Kaepernick's Protests against Police Brutality, Four Years after They Began," *Washington Post*, August 26, 2020, https://www.washingtonpost.com/sports/2020/06/01/colin-kaepernick-kneeling-history/.
10 Boren, "Timeline of Colin Kaepernick's Protests."
11 Boren, "Timeline of Colin Kaepernick's Protests."
12 Sam Farmer, "Must Reads: The Ex-Green Beret Who Inspired Colin Kaepernick to Kneel Instead of Sit during the Anthem Would Like to Clear a Few Things Up," *Los Angeles Times*, September 17, 2018, https://www.latimes.com/sports/nfl/la-sp-kaepernick-kneel-boyer-20180916-story.html.

Jean-Michel Basquiat, *Untitled (Flag)*, ca. 1979–80

Rashaun Rucker, *Psychological Redlining*, 2020

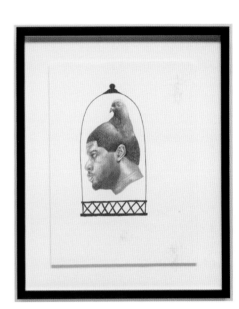
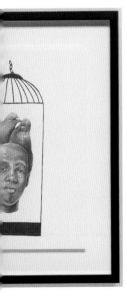
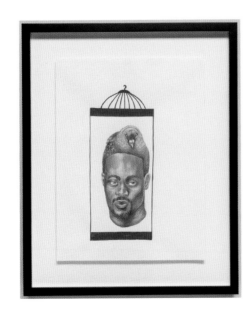
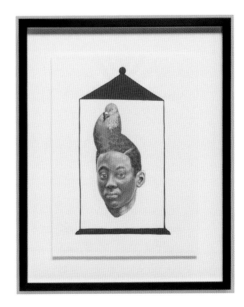

Rashaun Rucker, *Psychological Redlining* **(details), 2020**

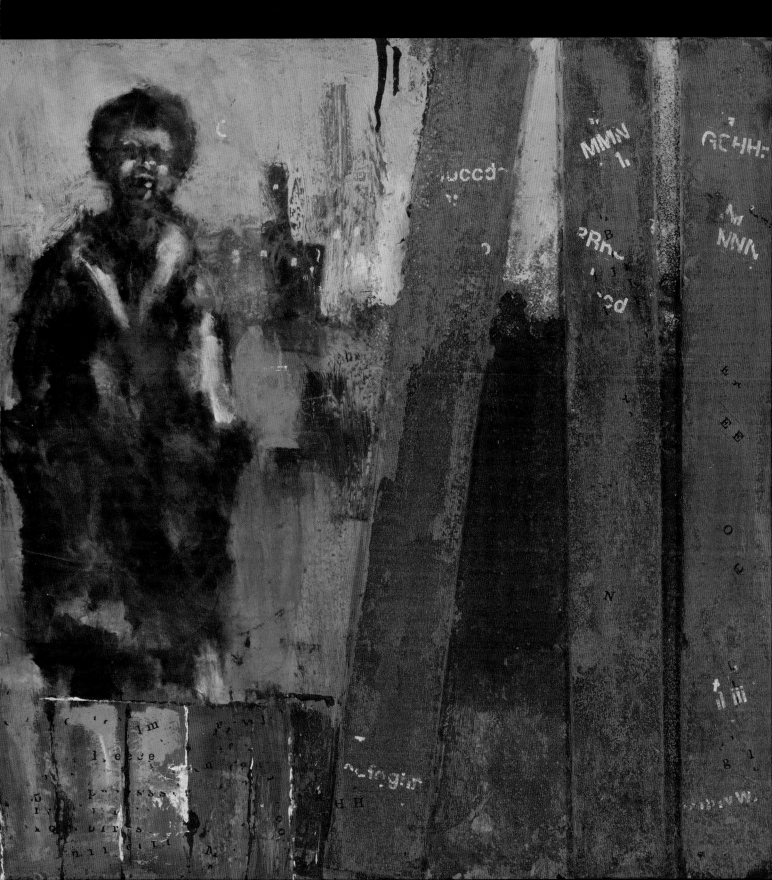

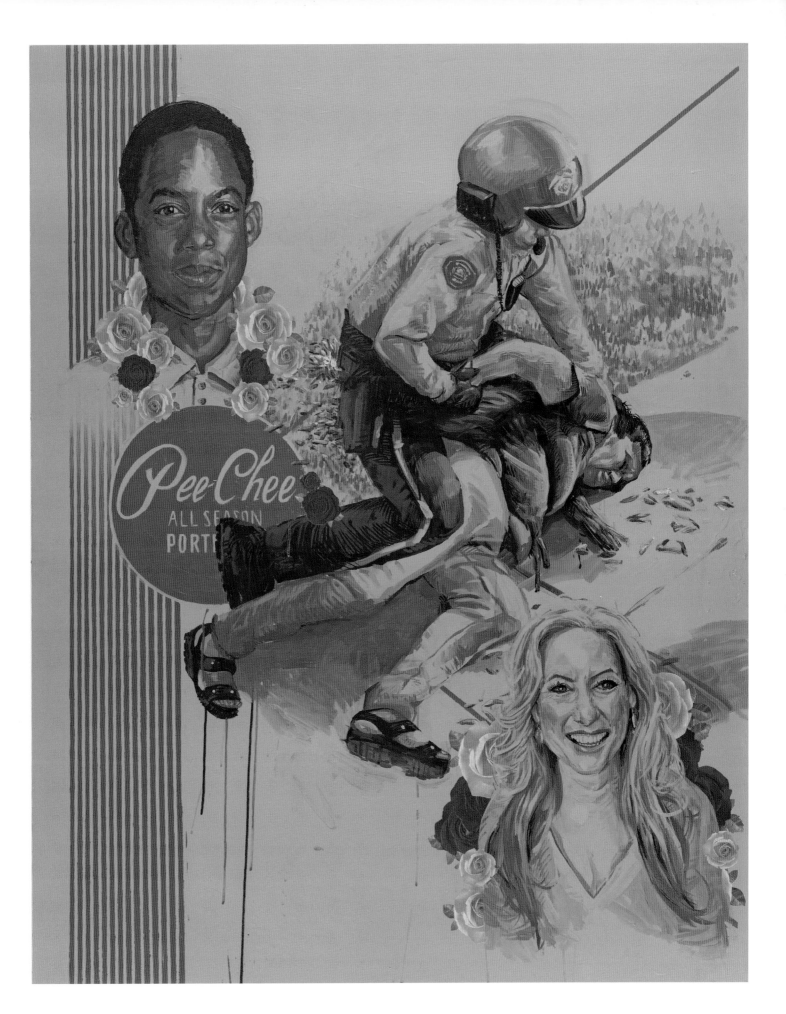

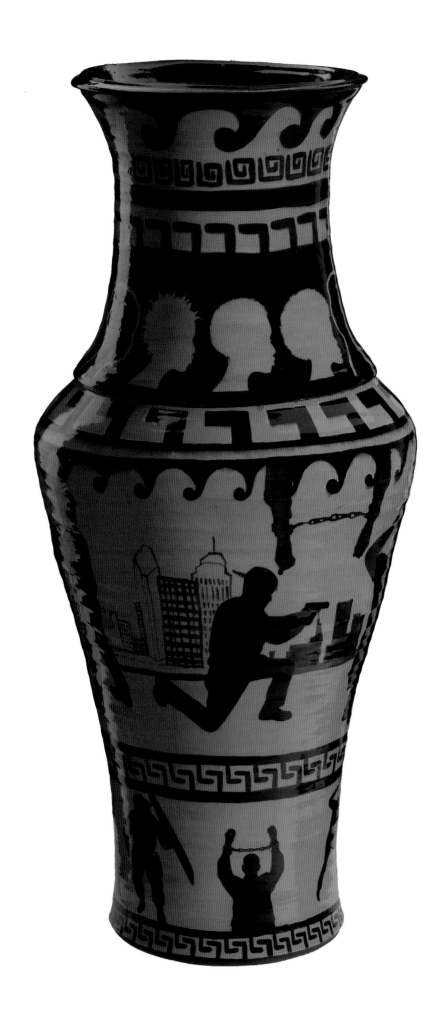

Roberto Lugo, *Ghetto Krater*, 2018

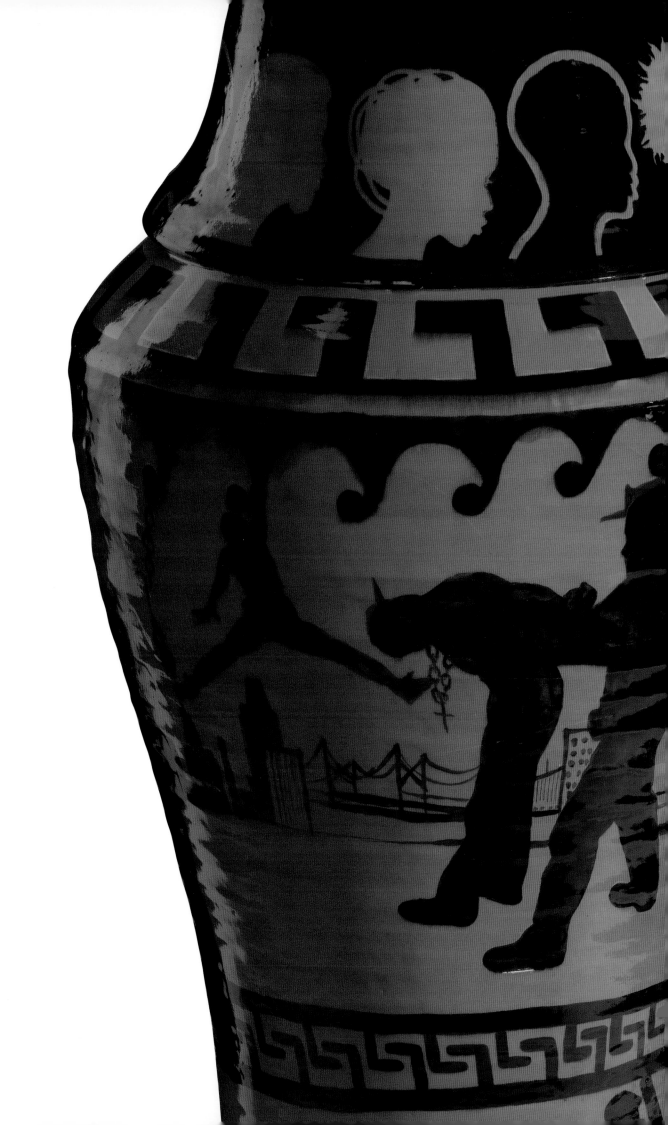

Merton Simpson, *Confrontation 28A* **and** *Confrontation 28AA*, 1966

42

Lava Thomas, *Euretta F. Adair*, 2018

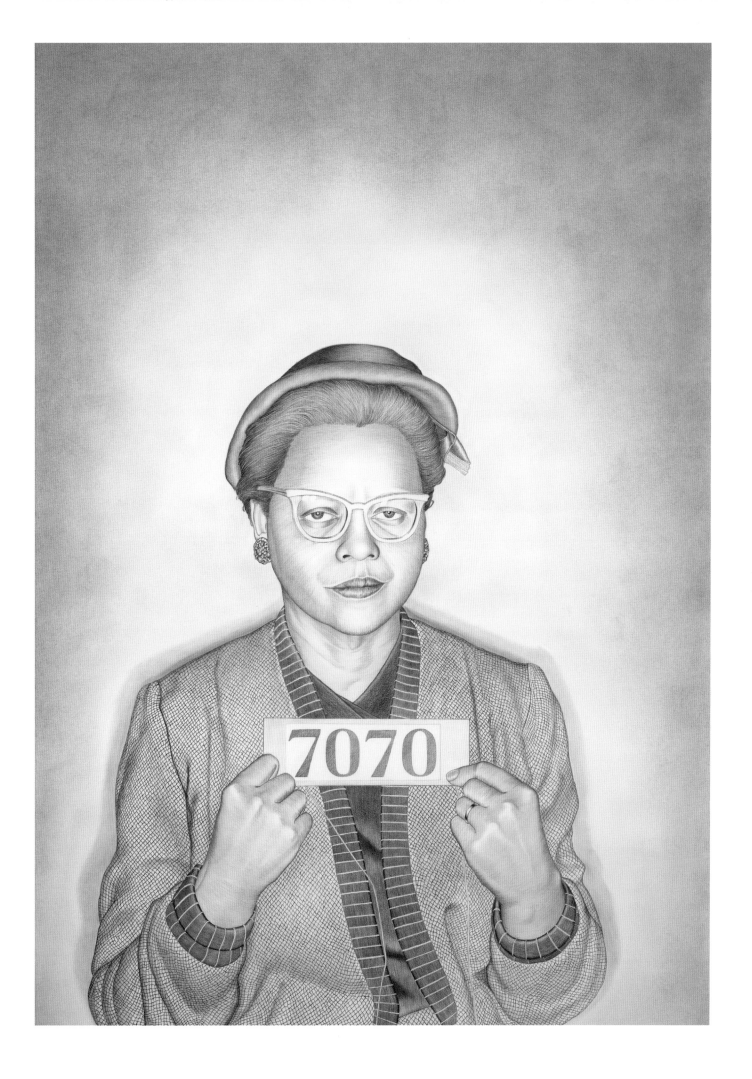

47

Howardena Pindell, *Separate But Equal: Apartheid*, 1987

Kara Walker, *no world*, 2010

49　　Torkwase Dyson, *I Can't Breathe (Water Table)*, 2018

Radcliffe Bailey, *Enroute*, 2000

David Hammons, *The Man Nobody Killed*, 1986

THE MAN NOBODY KILLED

NAPA VALLEY 1981
PINOT NOIR

GROWN, PRODUCED & BOTTLED BY
TREFETHEN VINEYARDS
NAPA, CALIFORNIA, U.S.A.

ALCOHOL 13.2% BY VOLUME

MICHAEL
STEWART
1958–
1984

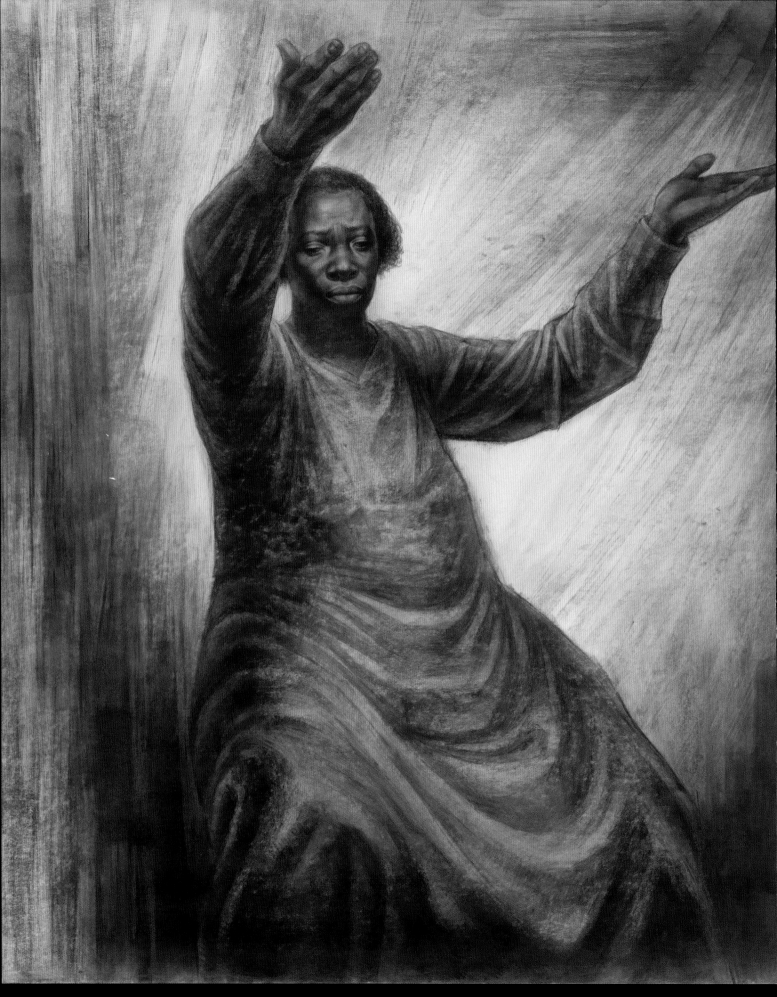

Charles White, *Move On Up a Little Higher*, 1961

PROT

Allen, Billops, Bright, C
Hendricks, Jones-Hog
Lee, Oliver, Pusey, Ro

:ST.

:mpbell, Ekpuk, Gibbs,

, Lawrence, Lawson,

ison, & Sherald.

BLACK WOMEN ARTISTS ON THE VANGUARD OF SOCIAL JUSTICE

Tuliza Fleming

Reckoning: Protest. Defiance. Resilience. situates African American women activists and artists as central figures in the long duration of Black freedom movements in the United States. Black women have and continue to occupy a space where they are on the vanguard of civil rights protests and movements. As revolutionaries, foot soldiers, activists, truth tellers, and often unrecognized leaders, African American women artists have long challenged social and political injustice in their lives and through their artworks. Across the twentieth and twenty-first centuries, however, far too many of these women have been relegated to the sidelines of historical records, contemporary scholarship, and popular dialogue. This exhibition celebrates the images and stories that women artists have created that underscore their belief in the possibility of the full liberation of people of African descent in the United States, as well as their insistence on representing the true contours of Black humanity, history, and culture. *Reckoning* also brings attention to the struggle for equality and social justice that Black women face within the African American community itself.

African American women artists have participated in the struggle for equality in this country since at least the turn of the nineteenth century. Often activists themselves, these artists infused their work with symbols of dignity, strength, resistance, protest, and resilience. The earliest example in the exhibition of this practice is Meta Vaux Warrick Fuller's (1877–1968) *Ethiopia* (1921; p. 121), which represents the cultural agency that Black women possessed in the struggle against racial injustice at home and abroad. Widely considered one of the first Pan-African artworks created in the United States, *Ethiopia* represents a visual embodiment of the Pan-African movement— a transnational effort and advocacy group based, in part, on recognizing and promoting a common goal of unity between continent-based Africans and those in the African diaspora, with the purpose of eliminating colonialism and white supremacy.

The scholar, historian, and socialist W. E. B. Du Bois was among the original participants of the Pan-African Congress (founded in 1897), and later became one of the leading advocates of the Pan-African movement. In 1919, Du Bois, along with the writer and civil rights activist James Weldon Johnson, was invited to participate in the America's Making Exposition, which opened in New York City in 1921. The exposition was conceived as a tribute to the aggregate contributions of immigrants to the history and culture of the United States. Although the vast majority of African Americans did not enter the country as immigrants, Du Bois and Johnson accepted the offer to organize and curate the "Americans of Negro Lineage" section for the exposition. As part of this exhibition, Du Bois and Johnson commissioned Fuller to sculpt an allegorical figure of Ethiopia to represent racial pride, African American origin, and the overall contributions of Black culture and history to the United States.

Fuller created *Ethiopia*, a twelve-inch plaster figure of a semi-mummified Black woman in full Egyptian headdress (or *Nemes*) looking languidly over her shoulder. The name of the sculpture, paired with the accoutrements worn by Egyptian pharaohs, links the historical achievements of ancient Egypt with Ethiopian resistance to colonial rule. Her visual conflation of symbols of Egyptian royalty with her title, *Ethiopia*, was firmly ensconced in the Black imagination and literature of the time. This popular perception of Egypt and Ethiopia as symbolic representations of a bright and storied past, and a foundation for future possibilities, was underscored by the "Americans of Negro Lineage" entry in the exposition's book. The entry featured an image of the sculpture, describing it as "A Symbolic Statue of the EMANCIPATION of the NEGRO RACE" (fig. 1).

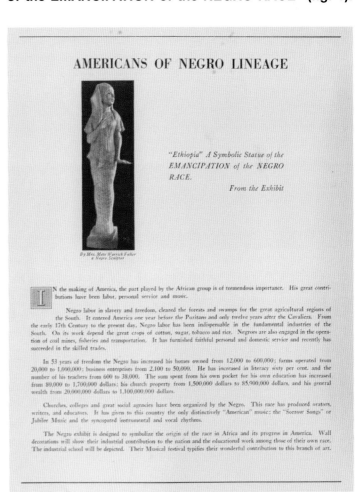

1 "Americans of Negro Lineage" entry in the *Book of the America's Making Exposition*, 1921. Published by the City and State Departments of Education, New York.

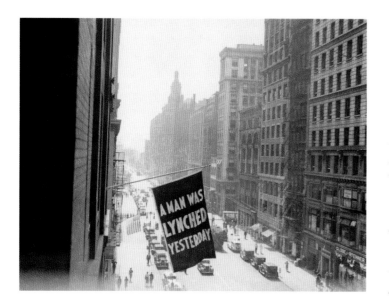

2 NAACP, *A Man Was Lynched Yesterday*, 1936.

The elegant, unbent posture of *Ethiopia* became even more of a representation of the ways that African Americans would aim to negotiate the ever-evolving and violent reactions to their attempts at full citizenship.

One of the most practiced methods of preventing African Americans from fully exercising their rights as American citizens was the implementation of terroristic tactics, mob violence, and lynching. Mildred Thompson's (1936–2003) *Untitled (Lynching of a Woman)* (1963; pp. 126–27), documents the pure horror of lynching in the United States that saw its rise as a brutal American pastime starting in the Reconstruction era. A system of deadly racial violence designed to keep African Americans in their "place," lynching was used as an extralegal means to control Black people primarily in the South as well as Black Northerners who ventured to the South and violated social racial etiquette. Some of the most common reasons African Americans were lynched were for allegedly raping a white woman; not showing enough deference to white people; attempting to leave the hard labor jobs and sharecropping in the South for more profitable industrial positions in the North; and simply for advocating for equal rights and the voting franchise for African Americans.

According to National Association for the Advancement of Colored People (NAACP) records, between 1882 and 1968, some 4,743 people were lynched, 3,446 of whom were African American.[1] In the early twentieth century, the NAACP raised awareness relating to the number of lynchings that occurred in the United States by erecting flags outside their New York headquarters to indicate that another African American had been lynched the previous day (fig. 2). Taken on their own, these murders were vicious, macabre acts of violence. However, for many white people in the South, lynching was a form of entertainment. On many occasions, white people would bring their families (even young children) to a lynching, sometimes picnicking on the lawn while watching the spectacle of one or more African Americans being hanged.

Between 1890 and 1930, anti-lynching organizations were founded across the country to put an end to the practice of mob violence. Women were extremely active in the anti-lynching movement, in part because the lynching of Black men had a serious impact on the well-being of the Black family. The social justice activist Ida B. Wells was particularly involved in the anti-lynching campaign after three of her friends were murdered. In her 1892 publication *Southern Horrors: Lynch Law in All Its Phases*, Wells described the insidious nature of sexual and mob violence perpetrated against Black women throughout the South.

She recounted in disturbing detail the horrific instances in which Black women were stripped naked, raped by one or multiple white men, hanged, and mutilated. Wells's organization and many other African American women and women's groups fought to obtain justice for these victims, as the number of Black women who were abused and murdered through mob violence was too often overlooked.

Thompson's pen-and-ink line drawing depicts a group of white men celebrating the lynching of a nude Black woman. The drawing recalls the 1918 case of Mary Turner, who at the time was eight months pregnant. Turner was mutilated and hanged by a white mob for speaking out regarding the lynching of her husband the previous day. In retaliation for her speaking out, a violent mob took Turner, bound her feet, hanged her upside down, threw gasoline on her body and lit her on fire, cut the fetus from her abdomen, and stomped it into the ground. Turner was still alive at this gruesome point, leading the bloodthirsty mob to continue the horror—they riddled her body with hundreds of gunshots. In Thompson's rendering, the mob is hooded—though not so much to render them anonymous as to highlight the absurdity of their being.[2]

Despite the dangers presented by white domestic terrorists, Black women continued to rally against the omnipresent power structure that sought to limit Black mobility through racial violence and intimidation. Instead, Black women continued to risk their lives in the fight against vigilante "justice" and legal segregation—individually and as a collective. *Untitled (Lynching of a Woman)* is particularly poignant as it was drawn from the point of view of the artist—a Black southern female artist who, at the time of its creation, was herself struggling with the negative impact of sexism and racism on her life and career.

Another act of violence perpetrated against Black women was the often unjust incarceration and execution of Black men in the prison system. These acts engendered adverse psychological, familial, and financial damage when women's sons, husbands, brothers, and friends were forcibly removed from Black households. Deborah Roberts (b. 1962) is renowned for her incorporation of multiple layers and meanings in her artwork to create a more expansive understanding of the Black cultural experience. In *80 days* (2018; fig. 3 and p. 143), from the *Nessun Dorma* (None Shall Sleep) series, Roberts challenges the criminal lens through which society frequently views young Black boys, whose futures are often detrimentally and unjustly impacted by disproportionate police violence and incarceration. Roberts's work also confronts mainstream perceptions of young Black boys

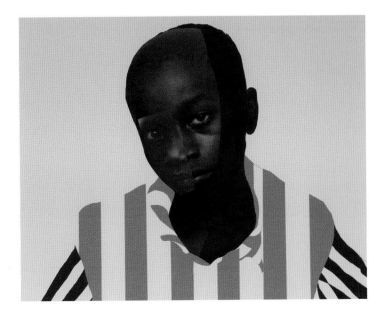

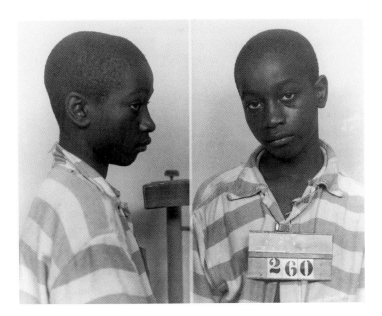

3 Deborah Roberts, *80 days* (detail), 2018.
4 George Stinney Jr.'s South Carolina Department of Corrections identification photo, 1944.

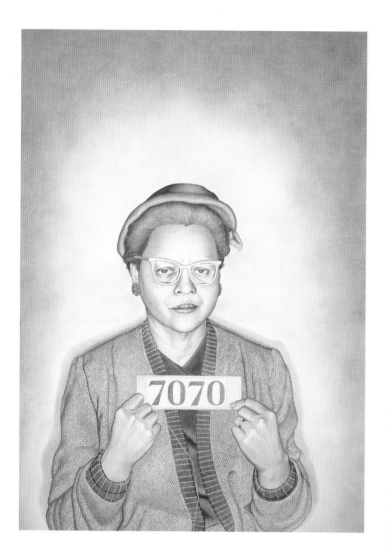

as unintelligent criminals whose lives are disposable. Roberts created *80 days* in honor George Stinney Jr., a fourteen-year-old boy who became the youngest person executed in a U.S. prison during the twentieth and twenty-first centuries (fig. 4).

In March 1944, two white girls (Betty June Binnicker, age eleven, and Mary Emma Thames, age seven) were found murdered. They had been beaten with a blunt instrument and dumped in a ditch. Police claimed, without eyewitness testimony or other significant evidence, that George Stinney and his sister were the last people to see the girls alive. Law enforcement officers identified Stinney as the culprit and moved to arrest him for the murder, later questioning him without legal counsel or a parent present. The officers claimed that he confessed to the murders because he wanted to have sex with the elder girl. No physical records of this purported confession exist. Though police had charged Stinney without corroborating evidence, a two-hour trial and ten-minute jury deliberation was enough for the jurors to find Stinney guilty. He was electrocuted on June 16, 1944. In only about eighty short days, Stinney was arrested, charged, convicted, sentenced to die, and executed, all without proper representation or any appeals filed on his behalf. Seventy years following his death, a judge vacated his conviction, ruling that Stinney had not received a fair trial, because he was not effectively defended and his Sixth Amendment rights had been violated.

Roberts's *80 days* sheds light on one of the darkest chapters in the history of the American penal system. Unfortunately, these types of actions are still being practiced. According to the Southern Poverty Law Center, in Florida during 2020–21, for example, Black children constituted 61 percent of the juveniles arrested statewide who were transferred to adult courts.[3] Roberts's work encapsulates the cruelty of sentencing young Black boys to languish or worse in adult prisons instead of in juvenile detention centers. Her portrait of Stinney captures the innocence of a young child steeped in the sadness of his circumstance. The stripes of his prison uniform metaphorically reflect both his status as an inmate and the bars in his cell that prevent his escape. As the series title of this portrait, *Nessun Dorma* or "None Shall Sleep," suggests, we should not rest until the practice of perceiving and punishing Black boys as grown men ceases to occur.

Lava Thomas's (b. 1958) drawing *Euretta F. Adair* (2018; fig. 5) exemplifies the continued legacy of Black female agency in the face of violence and persecution. It was created as a part of a series of drawings titled *Mugshot Portraits: Women of the Montgomery Bus*

5 Lava Thomas, *Euretta F. Adair*, 2018.

Boycott. Drawn from actual mug shots taken of women activists, where Stinney's mug shot merely reveals his youth, Thomas's portraits celebrate the dignity, commitment, and bravery of women who have been historically overlooked as significant civil rights leaders due to their gender. A longtime civil rights activist in Montgomery, Alabama, Adair was a member of the Women's Political Council (WPC), an organization founded in 1946 and composed of professional and middle-class women in the city. The council sought to improve the conditions of African Americans by calling for desegregation, encouraging voter registration, and addressing racial disparities.

The WPC was one of the first organizations to establish a plan for a boycott of the Montgomery bus system. In 1954 and 1955, prior to Rosa Parks's arrest, the council and other African American leaders met several times with city officials to present their complaints regarding the racist treatment of Black bus riders in the city. During the meeting, the WPC outlined three main complaints: African Americans had to stand in the bus when there were empty seats in the white section; they were forced to pay in the front of the bus, then get off and reenter in the rear; and there were fewer stops in Black neighborhoods than in white areas. Although the WPC's pleas for policy changes in public transportation were initially ignored, the city relented on one point and agreed in March 1954 to increase the number of stops in Black neighborhoods.

On the same day that Rosa Parks refused to vacate her seat to a white passenger on a Montgomery city bus in an act of studied civil disobedience, the WPC decided to initiate its plans for boycotting the city's transportation center, announcing a strike to occur just four days later. That afternoon, religious leaders met and organized the Montgomery Improvement Association (MIA), electing Dr. Martin Luther King Jr. as their leader. The organization's mission was to oversee the boycott, improve race relations, and uplift the general tenor of the community. Adair served on the executive board of the MIA. She was one of more than eighty political activists who were arrested in Montgomery for protesting.

As Adair's story demonstrates, women were and continue to be the driving force behind the long Civil Rights Movement. *Mugshot Portraits: Women of the Montgomery Bus Boycott* sheds a much-needed spotlight on the leadership roles that women like Adair and her compatriots played in the creation and success of the bus boycott. Regrettably, the important contributions of women such as Adair have been sidelined due to pervasive gender inequality during the Civil Rights Movement and throughout its historical legacy. The inclusion of Thomas's portrait in the *Reckoning* exhibition seeks to rectify the pervasive erasure of Black women activists in recorded history and in the popular imagination, going beyond the singular contributions of activists like Parks.

During the late 1960s and early 1970s, a new era of self-awareness and style of political activism began to manifest among many African Americans, leading to the emergence of the movement for Black Power. Within the United States, a younger generation of artists was galvanized to take part in the struggle against injustice because of incidents such as the brutal attacks on civil rights demonstrators in Birmingham, Alabama (1963); the assassination of Medgar Evers (1963); the March on Washington for Jobs and Freedom (1963); the Sixteenth Street Baptist Church bombing that killed four little girls (1963); Malcolm X's historic speech "The Ballot or the Bullet" (1964) and his assassination (1965); the Watts rebellion (1965); the founding of the Black Panther Party (1966); and the adoption of the "Black Power" concept by the Congress of Racial Equality and Student Nonviolent Coordinating Committee (1966). As a result, this generation began to question the traditional methods of the Civil Rights Movement and its goal of racial integration.

Black women were influential leaders in this new vanguard. For example, Shirley Chisholm became the first African American woman member of Congress (1968); Angela Davis served as a leading voice in both the Communist Party and the Black Panther Party; Kathleen Cleaver became the first female member of the Black Panther Party's Central Committee; and the Third World Women's Alliance was formed, in part, to address the intersection of race, gender, and male chauvinism within Black nationalist organizations. This growing awareness of and participation in the movement by younger generations of women revived the concept and desire to create a separate Black Arts movement, independent from the predominantly white heterosexual male art world.

Barbara Jones-Hogu (1938–2017), for instance, was a founding member of the African Commune of Bad Relevant Artists (AfriCOBRA), which remains one of the longest extant artist collectives in the United States. Established in 1968 by Jeff Donaldson, Wadsworth Jarrell, Jae Jarrell, Gerald Williams, and Jones-Hogu, the group was formed for the purpose of creating a new art aesthetic that would appeal to the visual sensibilities of African American communities and the particular social and political situation of their lives. The members of AfriCOBRA were among this younger generation of arts activists who sought alternative strategies for creating and promoting their

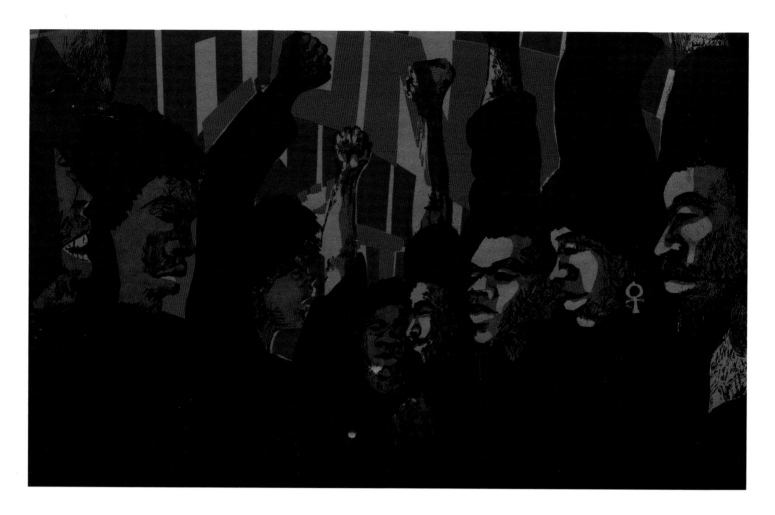

work. When the group first coalesced, the members crafted a manifesto to define who they were and how their art functioned aesthetically. Philosophically, they were inspired by the African American experience and committed to the struggle for liberation. Additionally, they developed a new aesthetic that emphasized syncopated rhythmic repetition, mimesis at midpoint, clarity of form and line, bright colors, and words and symbols to supplement the image and message.

Jones-Hogu's use of lettering in print designs, illustrated by her dynamic repetition of the word "unite," was an important component of this early visual aesthetic (fig. 6). Her image of young African American male and female protesters—dressed in black, standing in solidarity with raised fists, and united against the dominant power structures—is emblematic of Black radical strength and the AfriCOBRA ideal. One of the most significant outcomes of these power structures is the systematic subjugation of Black boys and men through police violence. The history of the modern-day police force is deeply intertwined with the history of policing and controlling Black bodies, particularly through excessive force. The origins of the police force in Southern states dates to the 1700s with the advent of slave patrols. These patrols were both deputized groups and vigilante mobs who were granted the power to suppress slave rebellions and

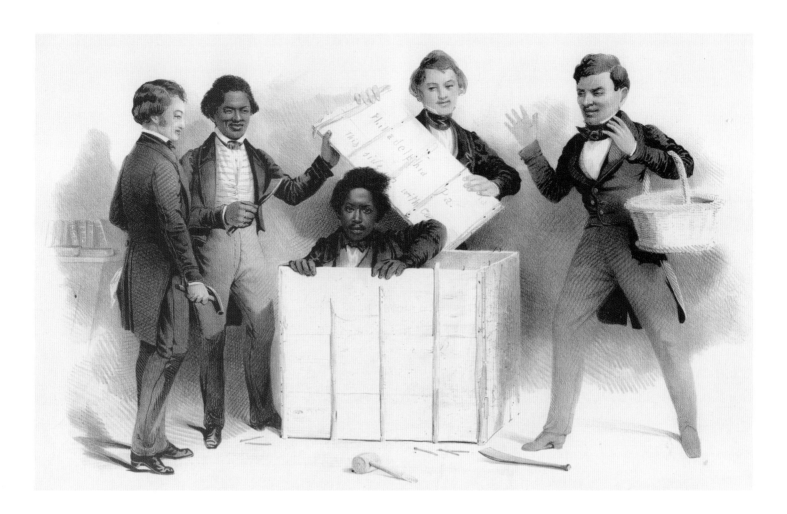

to pursue enslaved Black people through violent and terroristic means. After the Civil War, slave patrols were replaced by militia-like groups whose purpose was to prevent formerly enslaved people from accessing their rights as citizens of the United States. By the turn of the twentieth century, the South began to professionalize police departments, in part to enforce local laws including severe Jim Crow restrictions—a practice that continued into the 1960s.[4] At its worst, modern-day policing continues to employ systemic abuse, harassment, violence, and the slaying of African Americans without recourse.

In 2013, in response to the murder of Trayvon Martin and the acquittal of his killer, George Zimmerman, activists Alicia Garza, Patrisse Cullors, and Opal Tometi founded the grassroots organization Black Lives Matter. In July 2014, police detained a forty-three-year-old man named Eric Garner for allegedly selling illegal loose cigarettes. Garner was held in a prohibited chokehold by police officer Daniel Pantaleo while he pleaded with the officer, stating, "I can't breathe" eleven times before losing consciousness and dying. Even though the incident was captured on video and officially deemed a homicide, Pantaleo was not indicted. Following his death, Garner's final words became a rallying cry for the Black Lives Matter movement.

7 *The Resurrection of Henry Box Brown at Philadelphia*, ca. 1850.

In a similar fashion to the work of the Black Lives Matter movement, the title of Torkwase Dyson's (b. 1973) painting *I Can't Breathe* (*Water Table*) (2018; p. 49) amplifies the voice and humanity of Eric Garner. Through her implementation of special geometry, architecture, and abstraction, Dyson symbolically explores the spatial order that Garner once inhabited and the absence that his death left behind.

A part of Dyson's *Water Table* series, *I Can't Breathe* was exhibited in her 2018 solo exhibition, *Dear Henry*. The exhibition was created as a visually symbolic letter/homage to Henry "Box" Brown, an enslaved African American who escaped to freedom by shipping himself to Philadelphia in 1849. Brown's journey by railroad, ferry, and wagon in a cramped 3 × 2.67 × 2 ft. wooden crate, which was routinely jostled and at times turned upside down, lasted twenty-seven hours (fig. 7). Although finally free, Brown's sense of liberty was severely impacted by the passing of the Fugitive Slave Act in 1850, which required law enforcement even in free states to help capture all self-liberated persons and return them to their enslavers. In response to the act, Brown left the United States to live in England. Dyson's tribute to Brown's courage and heroism is a nod to the ingenuity of Black people and the Black community's ability to adapt whatever means and resources surrounding them to achieve freedom of the body as well as of the mind.

The women artists featured in *Reckoning: Protest. Defiance. Resilience.* have created work that challenges, engages, and directly confronts our history of racial violence and our continuing fight against social and political injustice. They have elevated the role of Black women activists from the periphery to the center of our shared history. Although each artwork is visually unique, all of them share an underlying foundation—the impulse to call out, represent, and bear witness to the ongoing legacy of racial injustice in America and emphasize African Americans' enduring determination to live.

Endnotes

1 "History of Lynching in America." NAACP, February 11, 2022. https://naacp.org/find-resources/history-explained/history-lynching-america.

2 Thompson's work brings to mind and certainly expands on the powerful satirical and grotesquerie work of George Grosz and Philip Guston, both of whom took up the subject matter in the 1930s and 1960s, respectively, via their renderings of the Ku Klux Klan and Nazi Party's political and vigilante violence. See https://www.moma.org/collection/works/79541 and https://time.com/5672506/hitler-art-activism/.

3 Dwayne Fatherree, "Criminal Injustice: States Unfairly Prosecute Children as Adults," Southern Poverty Law Center, January 21, 2022, https://www.splcenter.org/news/2022/01/21/criminal-injustice-states-unfairly-prosecute-children-adults.

4 Elizabeth Hinton and DeAnza Cook, "The Mass Criminalization of Black Americans: A Historical Overview," *Annual Review of Criminology* 4, no. 1 (January 2021), https://www.annualreviews.org/doi/10.1146/annurev-criminol-060520-033306.

Amy Sherald, *Breonna Taylor*, 2020

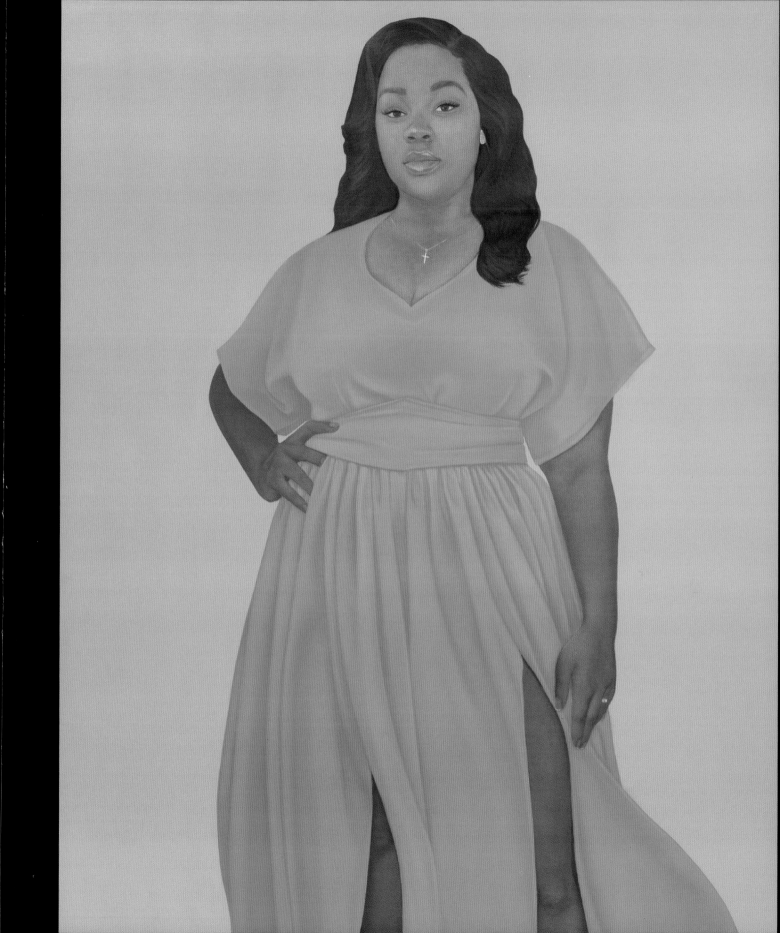

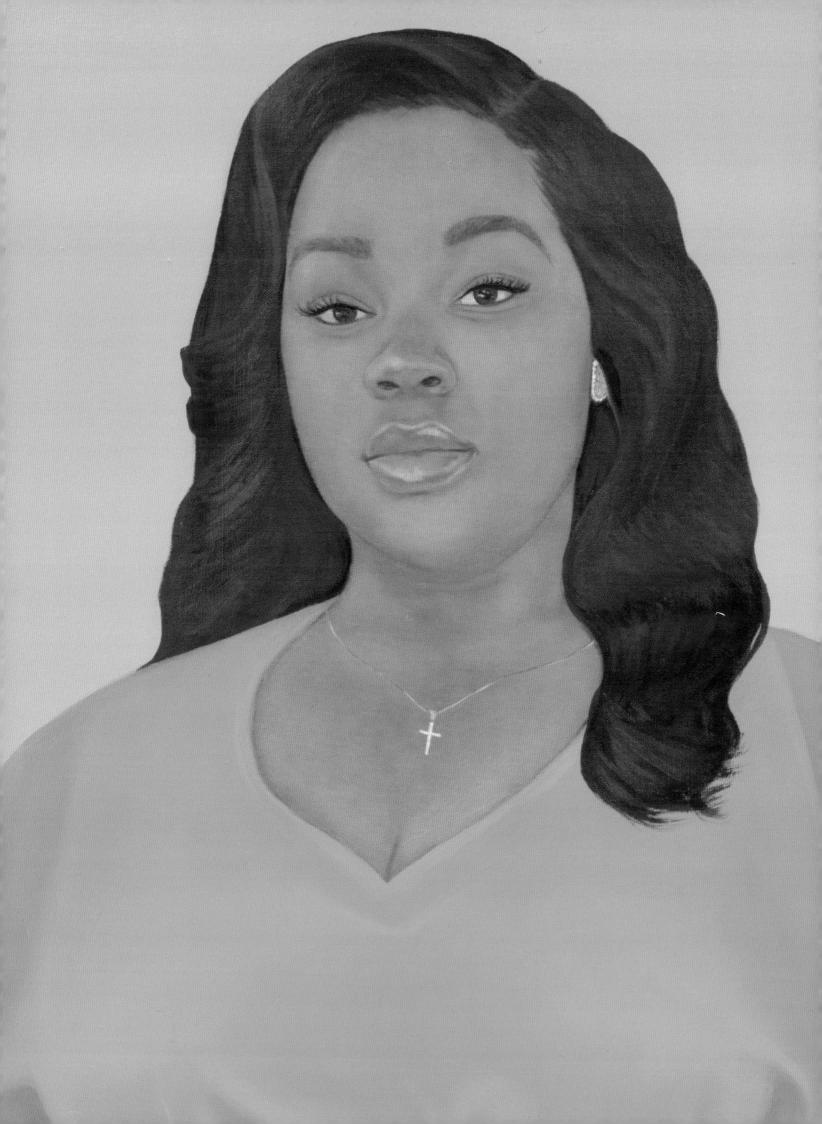

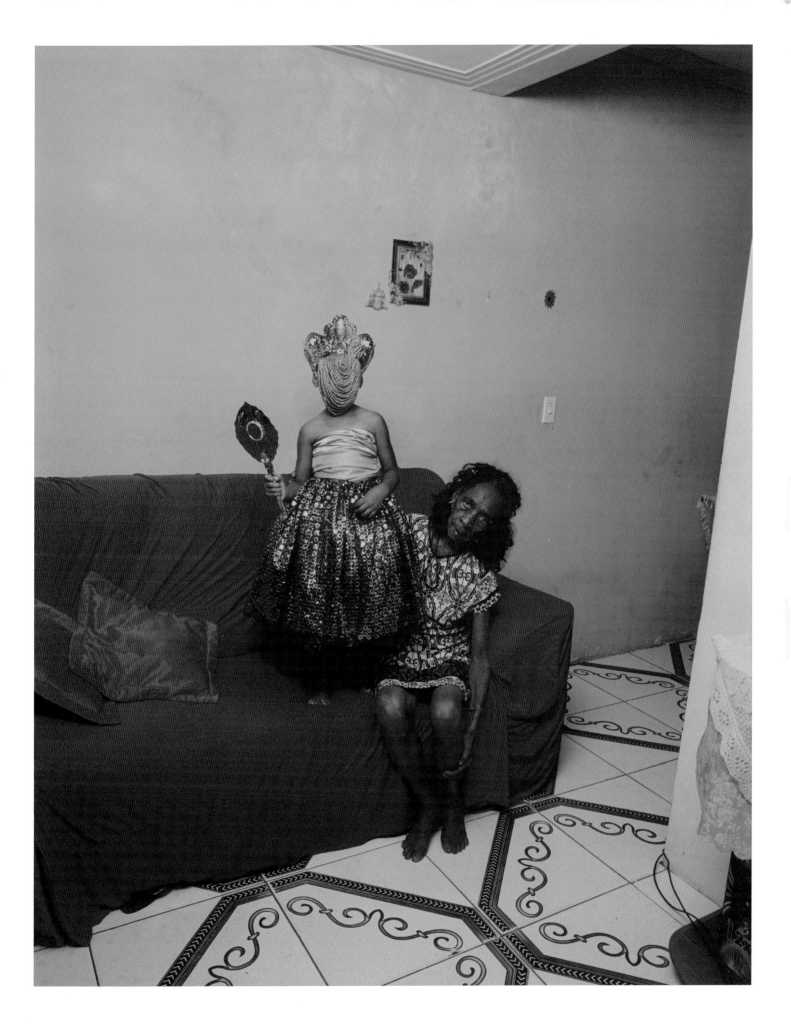

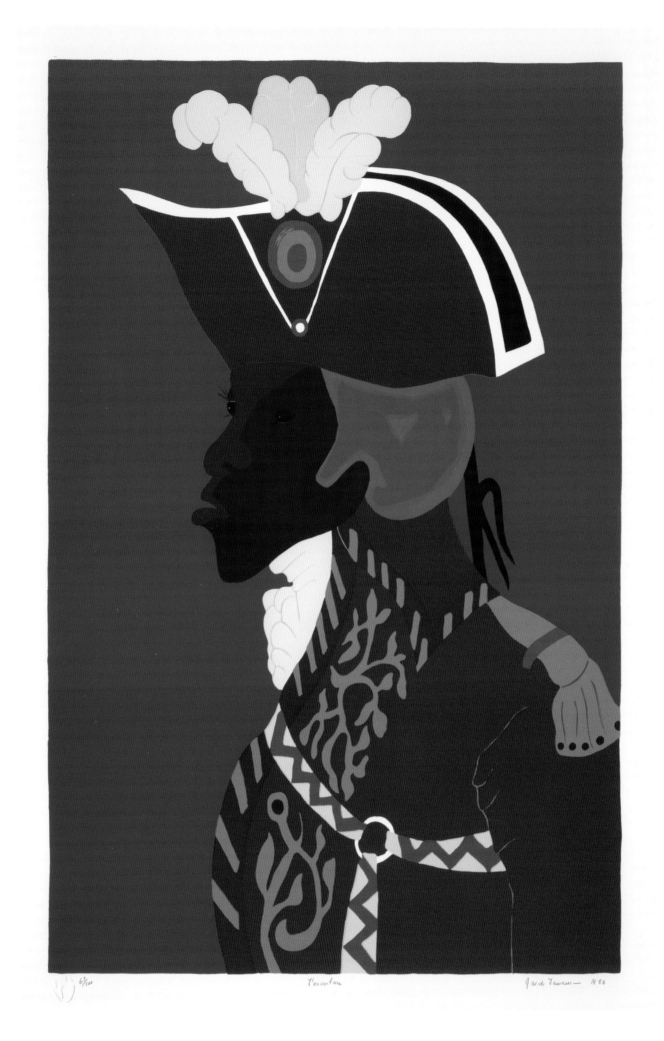

Jacob Lawrence, _The Life of Toussaint L'Ouverture_, 1986–97

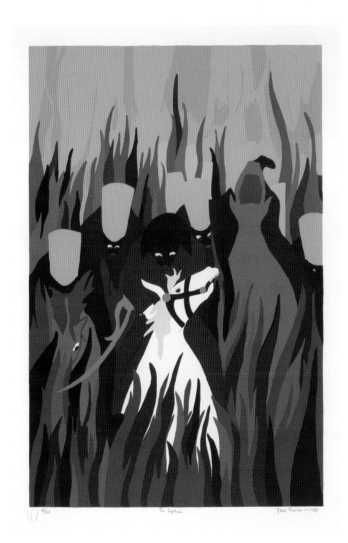

75

Jacob Lawrence, *The Life of Toussaint L'Ouverture*, 1986–97

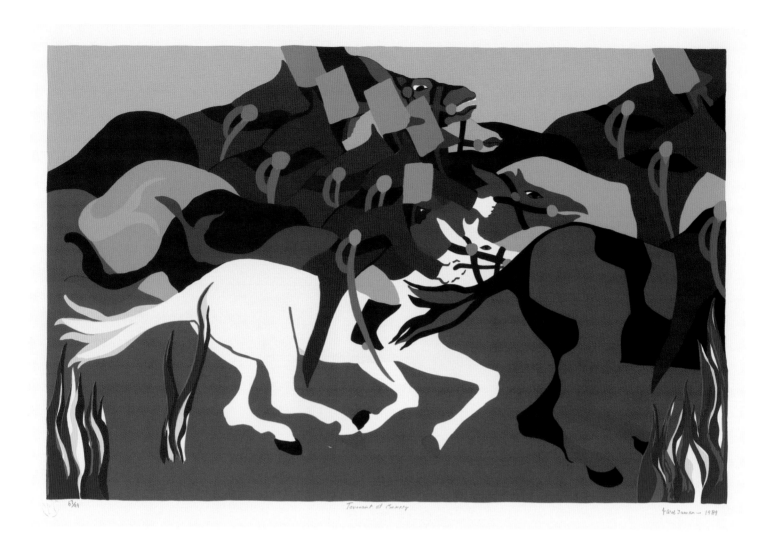

Jacob Lawrence, *The Life of Toussaint L'Ouverture*, 1986–97

76

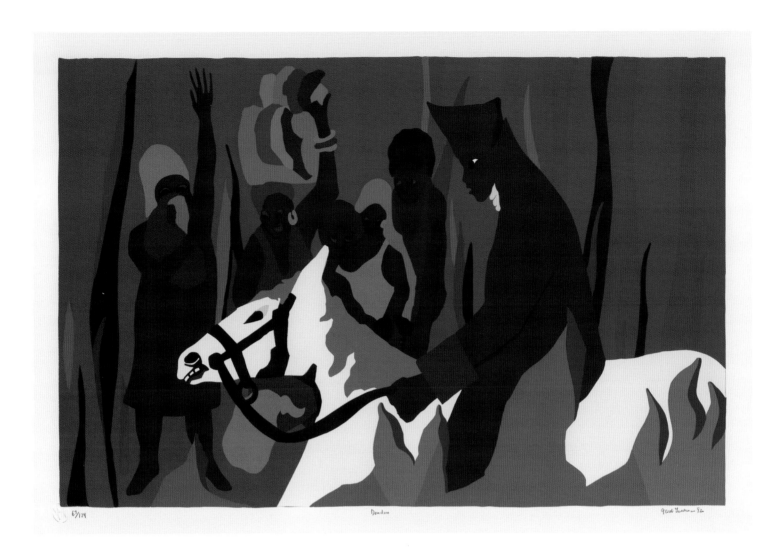

Jacob Lawrence, *The Life of Toussaint L'Ouverture*, 1986–97

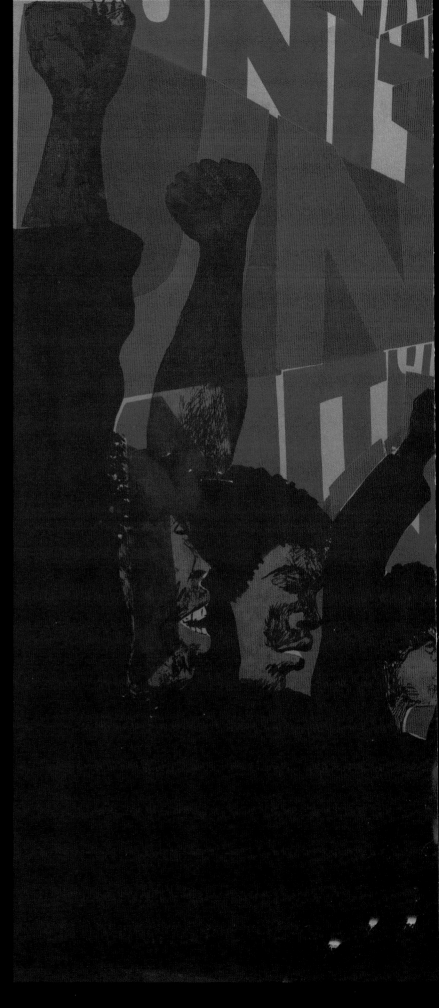

Barbara Jones-Hogu, *Unite,* **1971**

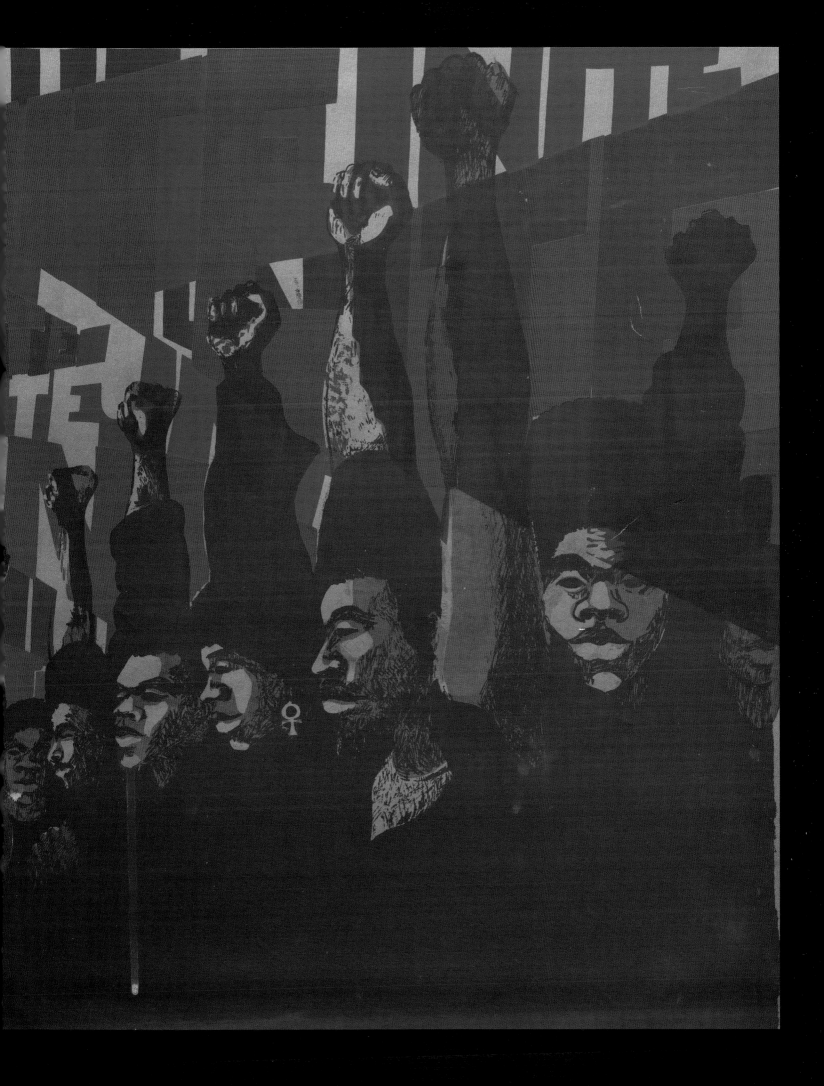

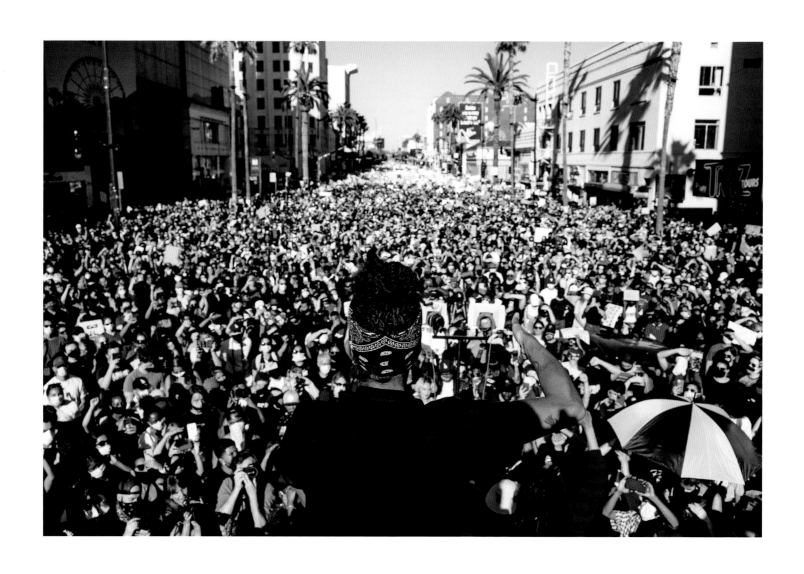

Tommy Oliver, *Untitled,* **Janaya Khan, LA protests,**
Hollywood Boulevard, Los Angeles, June 7, 2020

80

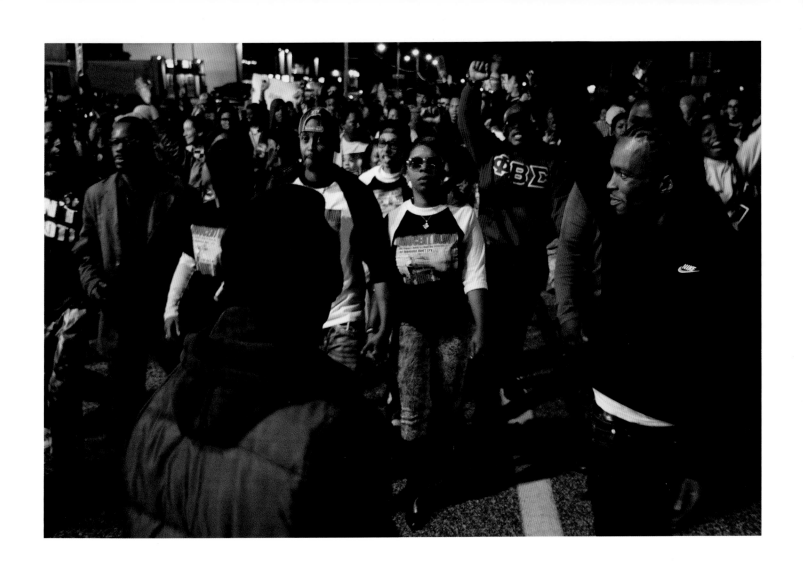

Zun Lee, *Untitled*, a nightly demonstration led by the Brown family winds its way down Ferguson Avenue, Ferguson, Missouri, October 11, 2014; from the series *Black Love Matters*

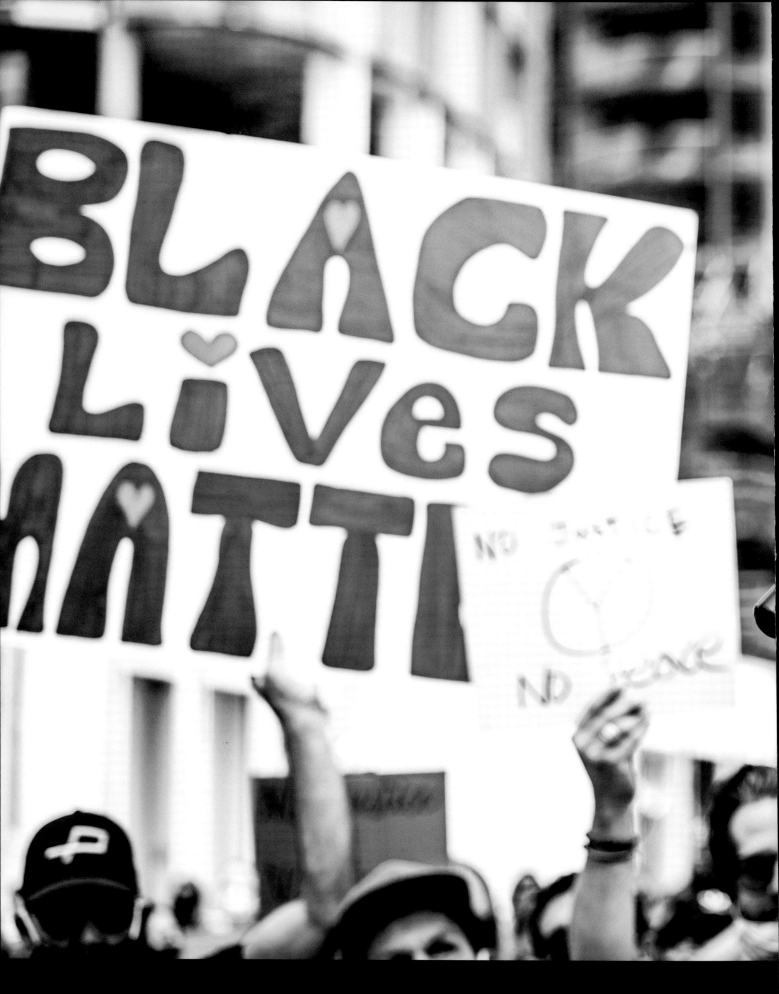

Tommy Oliver, *Untitled*, Michael B. Jordan, LA protests,
Hollywood Boulevard, Los Angeles, June 6, 2020

82

Tommy Oliver, *Untitled*, Cedric the Entertainer, LA protests,
Hollywood Boulevard, Los Angeles, June 3, 2020

84

Jermaine Gibbs, *Untitled*, protesters linking arms,
Baltimore, April 25, 2015

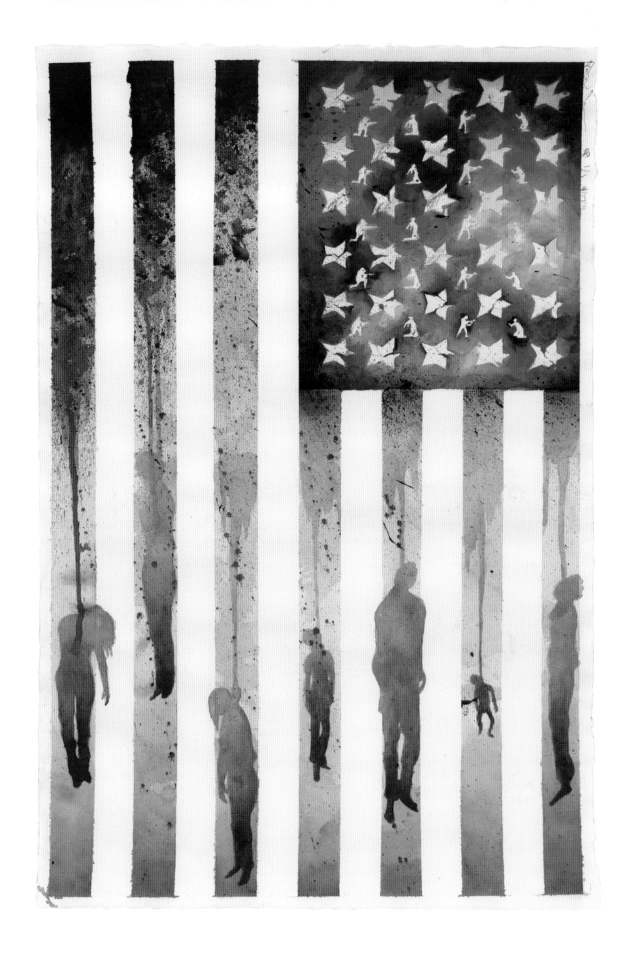

Patrick Campbell, *New Age of Slavery*, 2014

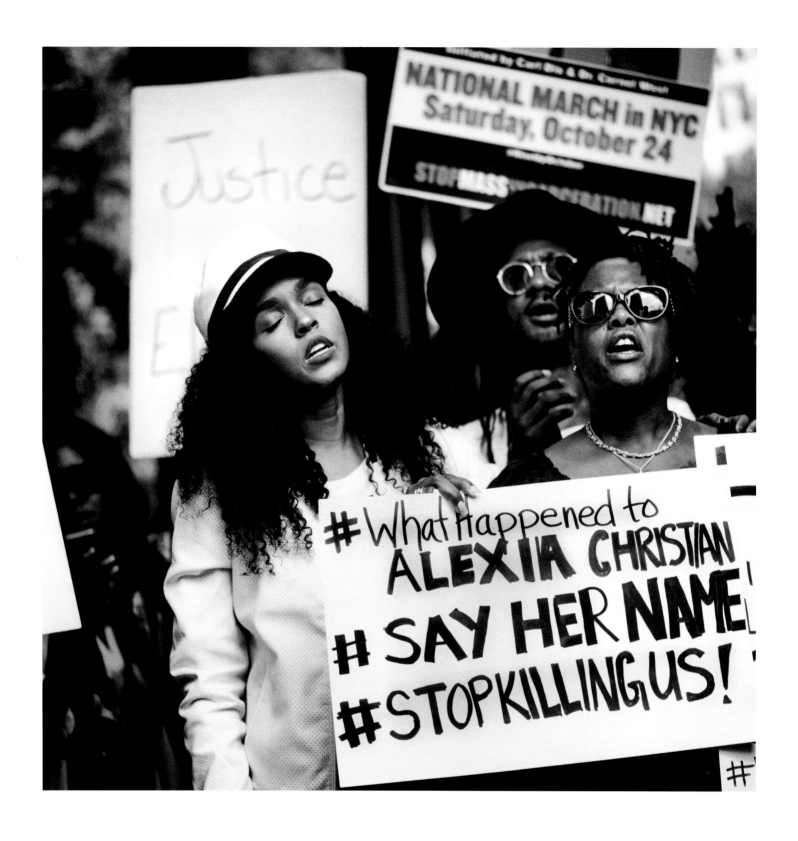

Sheila Pree Bright, *Untitled, Hell You Talmbout / Janelle Monáe,*
Atlanta, 2015; from the series #1960Now

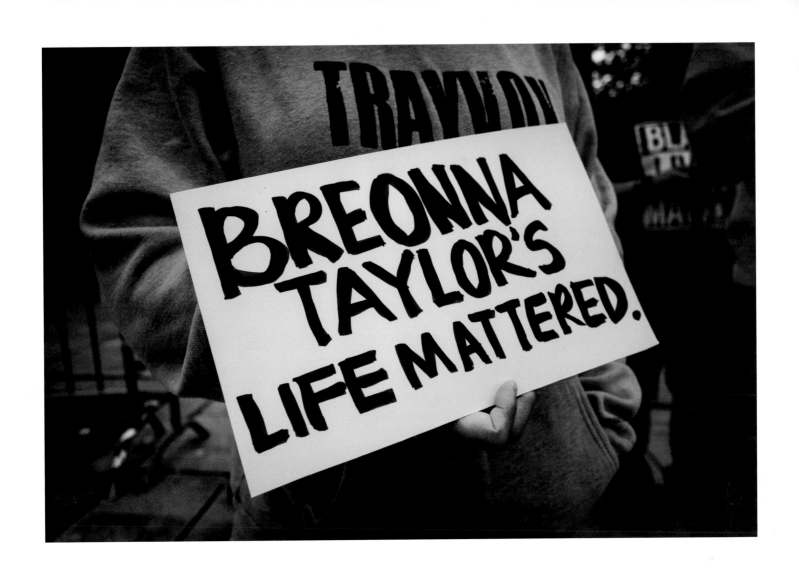

Sheila Pree Bright, *The People's Uprising, Justice for Breonna Taylor,*
Atlanta, 2020; from the series *#1960Now*

Devin Allen, *Untitled*, 2015

90

Camille Billops, *The KKK Boutique*, 1994

Victor Ekpuk, *Union of Saint and Venus*, 2012

Mavis Pusey, *Recarte,* **ca. 1968**

Avis Collins Robinson, Mensie Lee Pettway, and Andrea Pettway Williams,
Sharecropper's Masterpiece, 2008

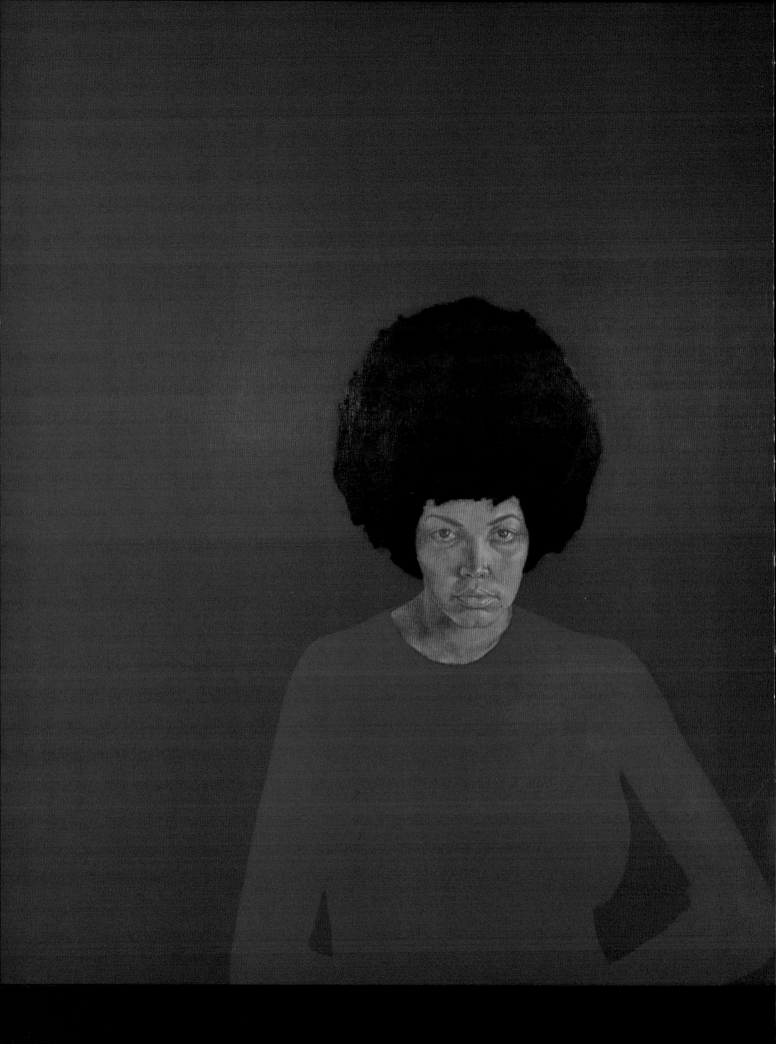

DEFIA

Alston, Andrews, Beal,

Fuller, Jarrell Sr., Lawre

Simpson, Stevens, Tho

NCE.

tler, Catlett, Donaldson,
ce, Lewis, McCoy, Saar,
pson, & Veasey-Cullors.

PORTRAITURE AT THE INTERSECTION OF ART AND HISTORY

A Conversation with Deborah Willis, Amy Sherald, and Bisa Butler

DEBORAH WILLIS: I'd like to start off with questions and explore some moments of beauty, moments of reflection, moments of reference and representation, and ask questions about what it means to create a portrait.

I'd like to start off with this image here in 2017 (fig. 1).

Amy, with this camera—what made you consider what a portrait meant in this sense of the mechanical aspect of creating a portrait through your paintings?

AMY SHERALD: I think I was beginning to understand the impact of what my portraiture was. And at that time, I was also reading your [Willis's] work and understanding the meaning of the camera, and the fact that if it wasn't for the camera, we wouldn't have been able to become authors of our own narrative in a way that we did. That impacted me—learning about Frederick Douglass being the most photographed man, and how profound that was—so I was really working through what photography meant to me.

Growing up, it was my connection to my past. It wasn't like I could look at a painting. My family didn't have painted portraits of ourselves hanging around the house. It was a book of family photographs that I had that really impacted me, and growing up with that gave me a deep sense of self, of dignity, and of how to be, how to become.

I think I was working through those ideas and understandings of what photography meant for my work, and also what it meant for a greater collective of people [regarding] our history.

DW: It is really important to think about what it is about Alice in this image. But then to follow up three years later to make this portrait from a photograph—can you talk about this image in terms of Breonna Taylor and what it meant for you to respond to the protest voices during this time period?

AS: I feel very lucky to have had this opportunity. I, like you, was sitting at home not able to go out in the streets. I'm immunosuppressed—it was COVID, and you know a lot of us are still just walking around afraid of everything and everybody. I'm sure you were getting phone calls and people were becoming activated, some for all of the right reasons and some for all of the wrong reasons. I got a phone call from Ta-Nehisi Coates, and he told me that they're putting together something, and we talked about the cover of *Vanity Fair*. I had never painted anybody that I wasn't able to photograph, so I was a little bit intimidated by the idea of that, and was [wondering whether] I was going to be able to capture her through all of the other images that were floating around?

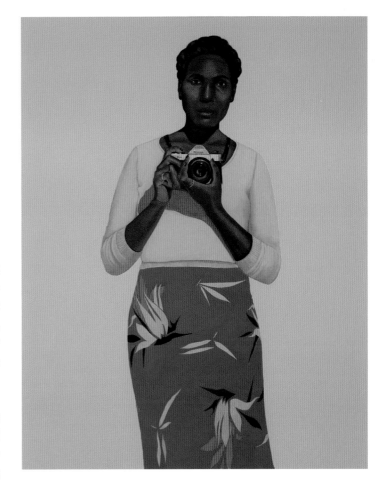

1 Amy Sherald, *What's different about Alice is that she has the most incisive way of telling the truth*, 2017.

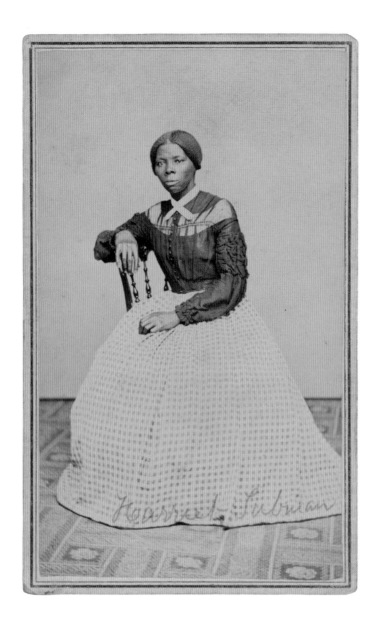

2 Benjamin F. Powelson, Carte-de-visite portrait of Harriet Tubman, 1868–69.

I knew I had to do it. I knew it was a way to focus not on her death, but to focus on her aliveness and what her life meant—not only to us, but also to her family, of course. I started with just trying to find an image that had not been floating around social media, but I ended up using the one that most of you have probably seen—a selfie in her car. Then I was able to pose the model and then photograph the model to kind of fit that head tilt, to bring it all together. I really wanted this moment to embody freedom and power. I wanted to leave her family with that memory. Not that it can erase the tragedy that happened, but to offer them some kind of solace in the way that she's represented in the world now. In our collective consciousness this would serve to remind us of her aliveness.

DW: And you were able to do that in terms of sharing [this sentiment widely]. The fact that it is at the Speed [Art Museum] and here at the Smithsonian—that exchange was really important for all of us to have the opportunity. Thank you.

AS: Thank you.

DW: Bisa Butler, I want you to think about when you turn pages in the archives. When you look through photographs to find ways to tell stories, how do portraits such as the portrait here guide you in creating this piece?

Bisa Butler: Portraits have always inspired me, and your books have inspired me from the very beginning.

AS: You have a fan club up here!

DW: We didn't plan this.

[LAUGHTER]

BB: I mean, and that's no exaggeration, how many tabs I have stuck in a book because you expose and bring us images that we would never see if you didn't think that they were important. There's this whole thing about who gets their photos taken, and then who gets to save that photo. And then our family photos, a lot of times, the subject or the person is written about on the back. Or the old photos sometimes had the date, but without that, after you pass a few generations, that information is lost.

This photo—the original—was a carte-de-visite. Was it 2018 that it came to light? I found it—no, I didn't just find it (fig. 2). The National Museum of African American History and Culture shared it with me, and then I was able to create a quilt based off of that

photo—and thank God for whoever saved that photo. Yes, Harriet was about forty-four or so, fortyish, and we had never seen her young before. At the time when I was creating this quilt, I was the same age, and we were in the middle of the pandemic, like Amy said. I was thinking, what would she think of me at this point? It made me really have to do better, because it was like she's like this quilt—if you haven't had a chance to see it, it's upstairs, and she's life-size, a little bit larger than life—so Harriet is sitting across from me, and that's a whole 'nother level of judgment on my life.

DW: But it's really important to think about both of you in terms of gesture—the arm, the hands on the hip—with the previous image. How did you select the colors? We see flowers, we see the floral, we see all of these experiences that we imagine her making a journey.

BB: Exactly. If you look at her skirt—that particular fabric was designed by women in the Congo, and they are living in a refuge called the City of Joy. These women are victims of war crimes—war sexual assaults—they have children, and they can't necessarily go home with the children of the soldiers or the guerrilla warfare. They're children of that crisis, and these women were given an opportunity to have a fashion show. This company came through, an African fabric company, and they did the fashion show. At the end, they asked the women, "Is there anything more we can do for you?" And [the women] said, "We want to design fabric like you. We want to be like you. [We] don't want just a fashion show. [We] need a vocation and also a way to express [ourselves]." That fabric at the bottom, those waves at the bottom of her skirt, represents the turbulence that they went through, and then as you move up, you'll see, like, the jungle and the thicket. I hid a little lion in there. The lion is like the spirit of Harriet. And then as you move up, you see more sky, more flowers, clouds, and at the very top, you'll see birds and a heart. So that fabric was made by these women who suffered now, and their experience was like a mirror in a way—Black women and their trials from Harriet's time till now—and I felt like it would be a perfect fit (fig. 4).

The background is sunflowers, but it's dark—there's sunflowers at night—and I thought about a couple of things. First of all, her traveling at night. And has anybody ever been in a tropical place where there's no diffuse light? How dark it is sometimes. I'll think about that—I don't even want to get out of the car. But imagine having to go back and forth [to usher runaways to freedom] or just not having to choose to go back and forth. Sunflower enthusiasts refer to it as a devotional flower, because as the sun moves across the sky, [the

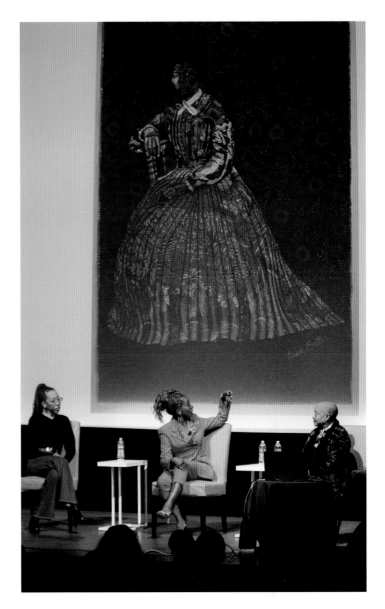

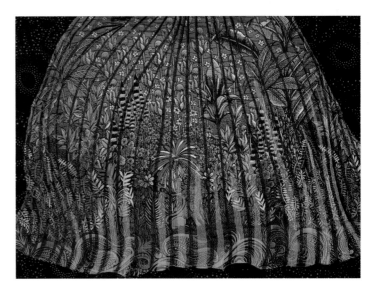

3 Bisa Butler (center) gesturing toward an image of *I Go To Prepare A Place For You* during a conversation with Amy Sherald (left) and Deborah Willis (right), March 16, 2023.
4 Detail of the fabric used by Bisa Butler for Harriet Tubman's skirt in *I Go To Prepare A Place For You*, 2021.

103

flower moves to follow it] and appears to praise the sun. I read that Harriet was a very deeply Christian and deeply God-fearing woman—that she felt that she got messages from God, that she heard God's voice.

DW: You said something, just in terms of changing the language: you said she chose. How did your experiences and art departments at the HBCUs you chose to attend prepare you for your careers?

AS: Oh, how didn't it? I mean, it was life-changing for me. From kindergarten to twelfth grade, I was in Catholic school, so I felt like I needed to go to an HBCU. So that I could really ground myself and not be "Black Amy" but just to have the freedom to be Amy.

I met Arturo Lindsay, who was the painting instructor [at Spelman College], and—it sounds crazy—but he was the first living artist that I met who was showing at the time. I went to his show at Nexus Contemporary, which was an art gallery space there. Because of [Arturo], who started the Spelman College art colony in Portobelo, Panama, I got to travel to Panama for the first time, and that was my introduction to the African diaspora: through the people from the Congo, the maroons [who] were brave enough to run into the jungle away from these Spaniards, and the Spaniards didn't want to follow them. And then I was in this magical village next to the ocean and learning about who I am in the world, in a sense, and I remember noting the difference between my American Blackness and the Black Panamanians . . . It opened my eyes up to so much and really grounded me in who I am.

That experience fortified me enough to go out into the world and be emboldened and speak out. And somehow I found my voice, and I am making the work that I make now. It's in my DNA, my palette—all of those things came from spending time in Panama. Being there with my colleagues, Calida Garcia-Rawls and all the other art students that were there, and painting together, having these important conversations—we were just in and of ourselves, becoming, and it was important for me to have that experience.

BB: I can definitely second that, being able to have professors who look like you, and who are actually exhibiting actively.

AS: And understood what you were trying to make.

BB: They understand you; they care about you.

AS: [They] could have a conversation with you about [your work].

BB: You don't have to explain to them your background.

AS: Right.

BB: This is where it comes from, but we're not all the same. My father is from Ghana, and my mother is from New Orleans, Louisiana. My professors, like you, traveled throughout Africa. It wasn't like they never asked me questions that might be really insulting. . . . When you're the only Black one in the room, you [can be seen as having all the answers] to Black culture. Our professors were some of the most powerful and strong artists in the art world. Well, I would say the "world" to us was the HBCU world, so that was the world: Elizabeth Catlett, John Biggers, Jeff Donaldson, Frank Smith, and Al Smith. Our professors were the best, and they still are. If you can imagine a primarily white institution—imagine if Picasso was teaching there and Kandinsky . . . Monet, and Manet. The expectations for us were high—they were a little tough at times, because their professors came out of the Harlem Renaissance. If you're a professor and your poetry professor was Countee Cullen or something, you're not going to accept the excuse, "I had a late night and I just wasn't ready"—no.

DW: Magazines and popular culture: your images are found in popular culture such as this one, and then here you are on *Vanity Fair*'s cover (fig. 5). How did you select the color for this?

AS: It was tough, to be honest. I literally talked to [Breonna]. I was like, "What color do you want this dress? I need you to tell me." I really wanted her, in the spirit world, to be happy with what this portrait represented. When I spoke to her mom, I didn't want her mom to feel like she had homework, so I [began] texting with her. I really wanted more than what I asked for, but I [asked her to] send me some images of Breonna when she thought that she was looking cute. Her mom was like, "You know she's a little diva—she loves getting dressed up" (in the best sense of the word). She sent me a couple of pictures, but it wasn't what I needed—I couldn't exactly use those as references, so I [opened] Adobe Photoshop and just [tried] one iteration after another—yellow and red or orange and purple. I asked, "Breonna, what color do you want this dress?" I hit two buttons and it ended on this blue monotone background, and I thought that was interesting because I've never done that before. Should I do that? Because I'm a Virgo, I give myself rules that don't exist [for everyone else]. There's something about blue that's very powerful, that's very spiritual, that's very otherworldly, but yet of the earth. It's infinite in its capacity

to hold energy, so I think that's what drew me to that. It didn't confine her. If the dress was red, she would have been confined by that specific color choice and the narrative that is assigned to that color, but it's too big to name essentially.

I wanted people to feel that she was floating inside of a space that you could be in as well as stand outside of, and just have your moment of solace. When I thought about the work going to the Speed, I was thinking this could be a balm in Gilead. People are hurting now, and they need somewhere to go, to think. Maybe this color is soothing in that way to all. It's peaceful and calming.

DW: I felt that, even on the cover of *Vanity Fair* with that backdrop. Bisa, your 369th [Infantry Regiment], the [Harlem] Hellfighters. Again, color—can you talk about the importance of this image and also where it's located?

BB: Sure, but one quick thing. One time, I asked my grandmother Violet what color is love, and she said blue because it was infinite.

AS: It *is* infinite.

BB: You've got that exactly spot-on. I call this piece *Don't Tread on Me, God Damn, Let's Go!* (fig. 6). That is a powerful statement, but that was their slogan. I just took that right off of Wikipedia, so if that doesn't say at all about what these guys were like . . . It is currently hanging at the Smithsonian American Art Museum in the Renwick Gallery, right next to the White House.

The Harlem Hellfighters . . . were World War I soldiers—an all-Black and Puerto Rican unit out of Philly, Harlem, New York, and New Jersey. They fought in a segregated unit in the United States government. I don't think they desegregated until . . . 1948.

I chose the colors around the 369th because they fought with the French. The American soldiers, at the time—the whole country was hoodwinked. [Most] believed that Black people didn't have the intellectual capacity to fight next to white men, because Black men weren't [viewed as real] men, but the French, who were white men, were like, "Yes, we need boots on the ground, and we need soldiers in the front who will be sacrificed."

The United States Army loaned out the Hellfighters. They were the 369th at the time. The Germans called them the "Hollenkampfer" because they were so fierce and they had been waiting to fight. You're twenty-one, you're nineteen—you went there to fight and you're [only] digging ditches, and you finally got guns.

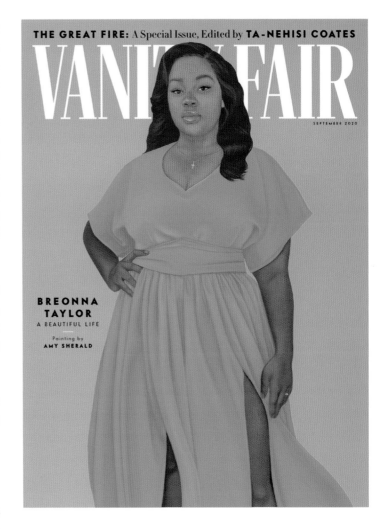

5 Cover of *Vanity Fair* featuring Amy Sherald's portrait of Breonna Taylor, September 2020.

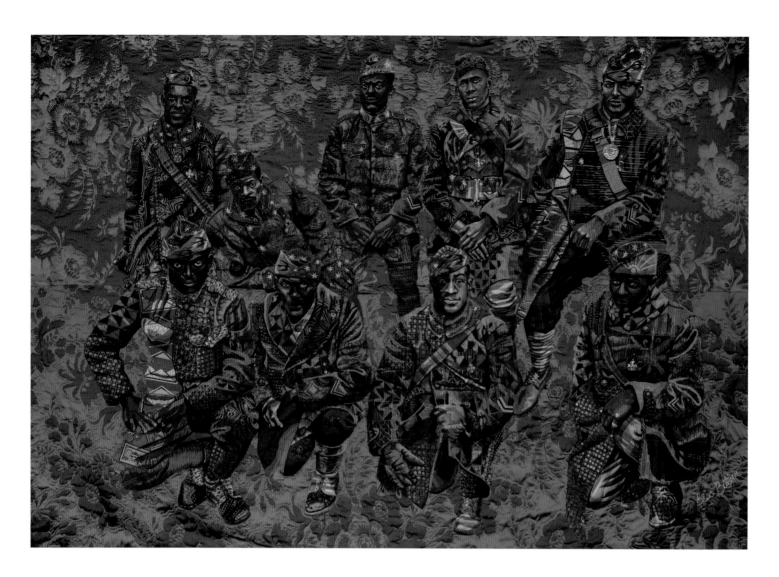

They fought like there was no tomorrow. None of them were taken as prisoners of war because the United States was not going to negotiate [for a Black person], so they fought to either win or die, and they fought like hell. They became known as the Hellfighters.

DW: It is important to think about [fifty] years after Emancipation—to think about the notion of the Civil War—and these are descendants of that conflict who are fighting.

BB: Exactly.

DW: Amy, how do you put the light in your subjects' eyes?

AS: Literally with a mixture of an off-white. There's the white dot, and then there's the light inside of the eye. It's just about figuring out where your light source is coming from and then hitting it as it would bounce across the eyeball, if you will. I really think the two dots that I use are more on the generic side—it's just about the placement, and once you paint the eyes, the soul in the painting is alive.

6 Bisa Butler, *Don't Tread on Me, God Damn, Let's Go!—The Harlem Hellfighters*, 2021.

106

DW: That sense of reflection—and we see in a lot of your pieces, in your paintings, such as what it means in *A Midsummer Afternoon Dream*, a sense of dreaming. When we see these moments, clearly unspoken—and then this recent work again, *Deliverance*. What about the sense of light and joy in this painting?

AS: I'm chasing happiness. My work represents where I am in my life. I started making this work when I was living with heart failure, so I think for me it was really important to get down to the nitty-gritty of what my existence meant and who I was outside of all the constructs. I really want to portray that in the work to offer a resting place for reflection, almost like direction, on how to be in the world, like what freedom is. I think that there's room for that, too. There has to be room for that within the resistance—there has to be rest, and these portraits represent the act of resting, the type of resting that we should do in order to replenish ourselves and find joy and to live in joy.

DW: And Bisa, can you respond to that in relationship to the *Migration* series that you created, in terms of the light in the eyes [of the subjects]?

BB: It's similar to what Amy discussed. We're looking carefully at the photo for where the light is hitting and then—sometimes, though, with an old photo, there is no light hitting. So I'll have to look at somebody else's eyes to see. But the eyes are it.

DW: Do you look in the mirror?

BB: No. I should, but I don't.

DW: Because I see it. I see the light in your eyes, in terms of the way you create work.

DW: A question from the audience: How do we maintain the power of a picture? How do we retain the power in the midst of oversaturation? How do we deal with the use of selfie culture documenting our lives? You are all taking time to make and create work that celebrates [Black] history, life, representations of beauty.

BB: As for the oversaturation in the selfie culture: I think that those photos are actually important as well. We just absorb them so quickly. I read somewhere that our most dangerous thing is to give up our power because we don't realize we have any. The photos that we're taking so quickly and restoring are very important, and hopefully, they'll be able to be stored for future generations, if they are not printed out.

I think we are powerful—we just don't realize it.

AS: I think it's the *not printing out* part. A lot of pictures are taken [and forgotten], but they're not being archived on paper. They're going into a cloud. It's a moment, and then it evaporates. It's different than what we do [as artists]. It is all necessary; it all needs to exist. I don't see it as deleterious in any way.

DW: Looking at your work has made me think about the significance of photography and gesture, representation in terms of "How do we see beauty? How do we hold on to it? How do we hold on to joy in a tumultuous time?" You both shared in moments with us for the past three years and beyond, so thank you.

AS and BB: Thank you.

This conversation has been edited for length and clarity.

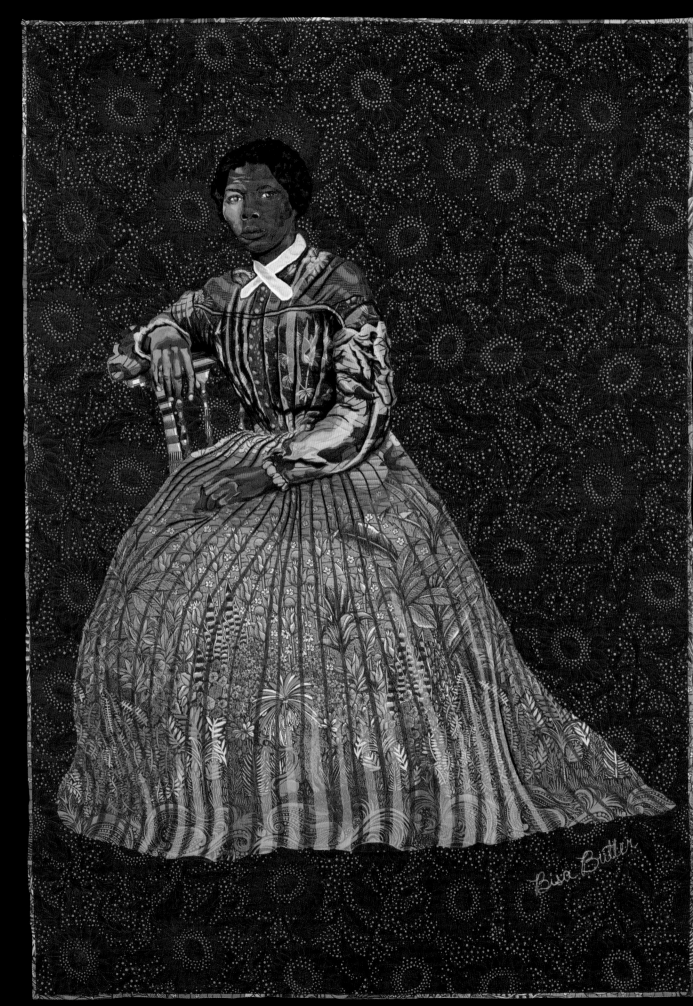

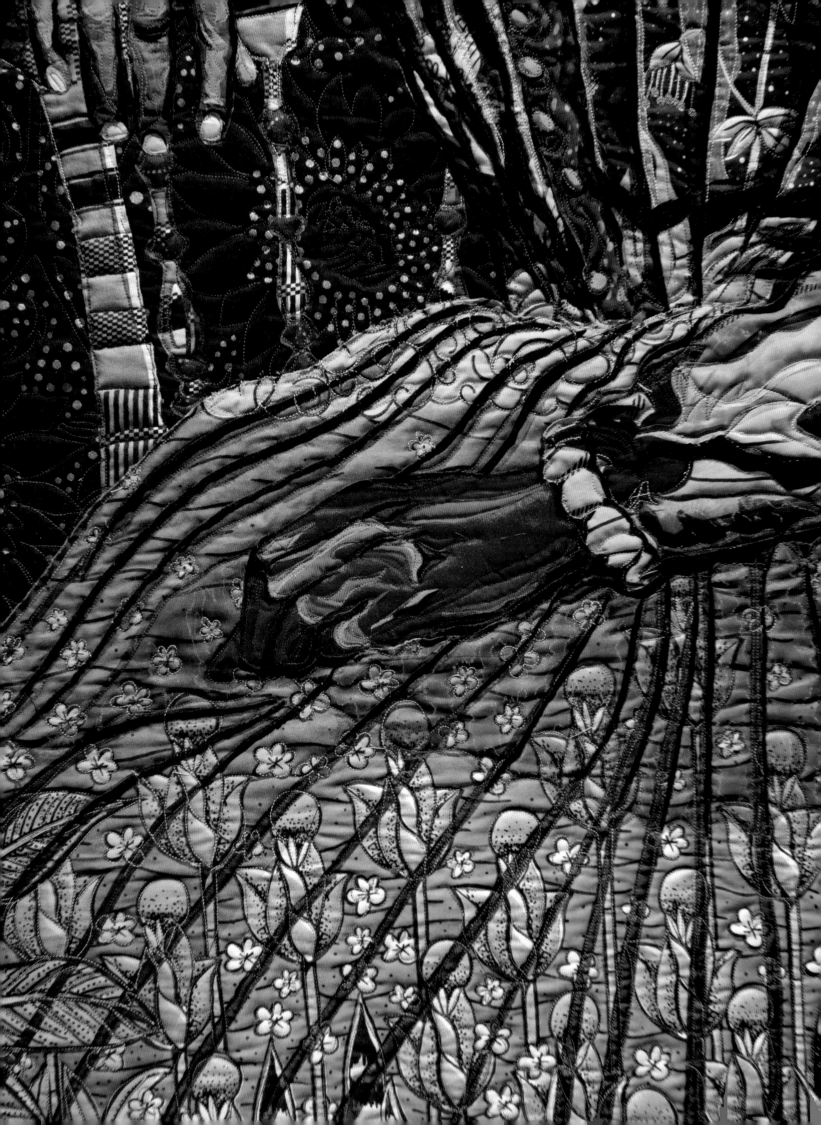

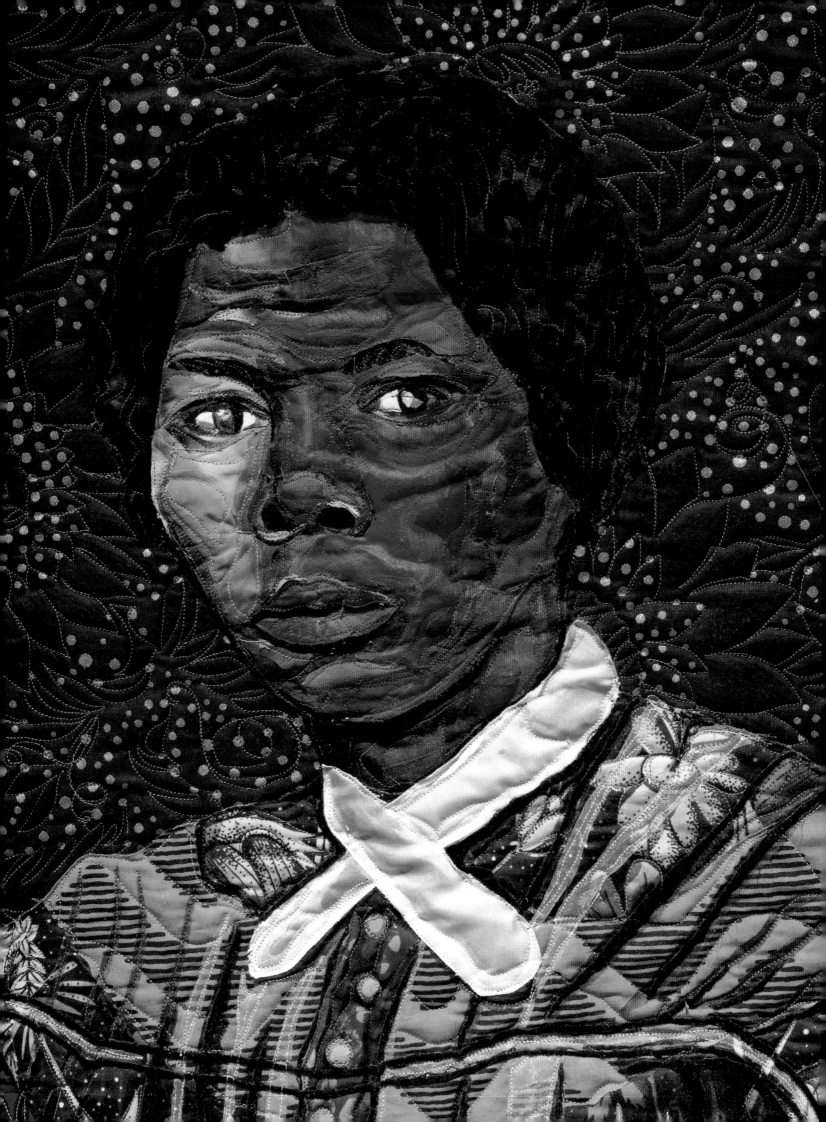

Wadsworth A. Jarrell Sr., *Revolutionary*, **1972**

Spencer Lewis, *Untitled*, 2021

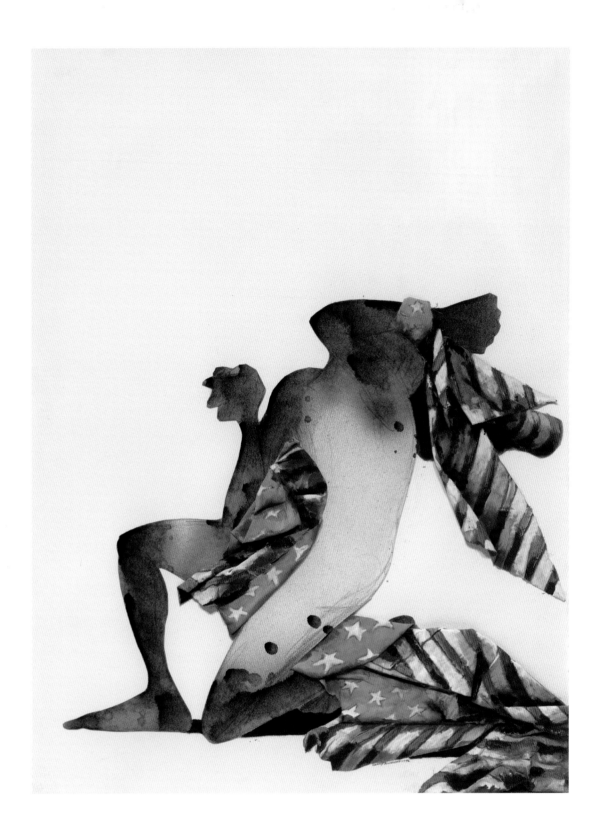

Benny Andrews, *Militant*, 1996

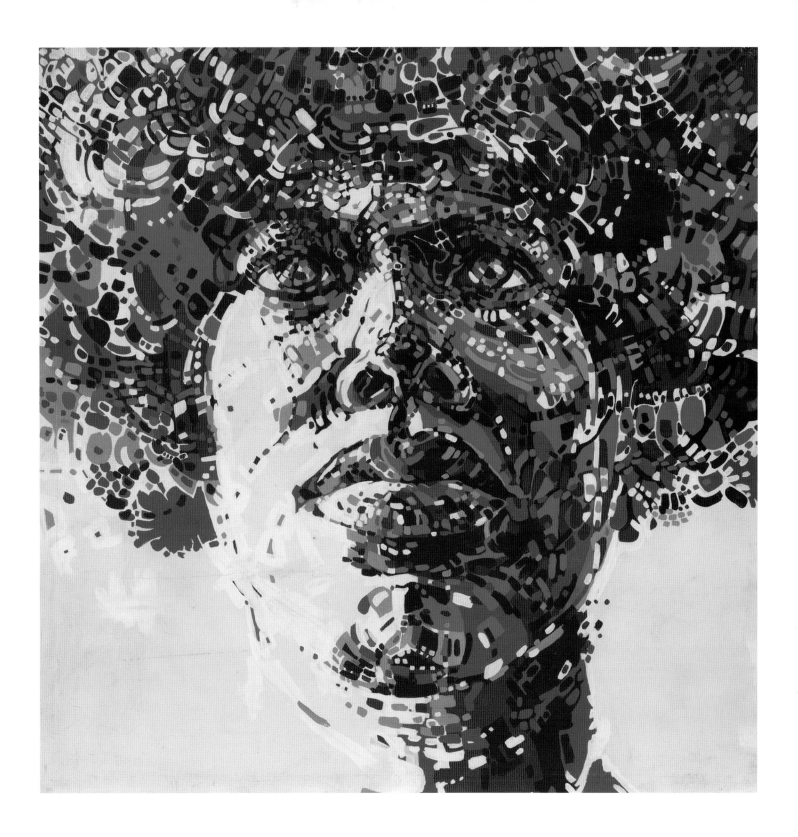

Nelson Stevens, *Arty* (centerpiece), 1970

Michael A. McCoy, *Untitled,* **2017**

Endia Beal, *Sabrina and Katrina*, 2015

Jeff Donaldson, *Wives of Sango,* **1971**

Carolyn Mims Lawrence, *Uphold Your Men*, ca. 1971

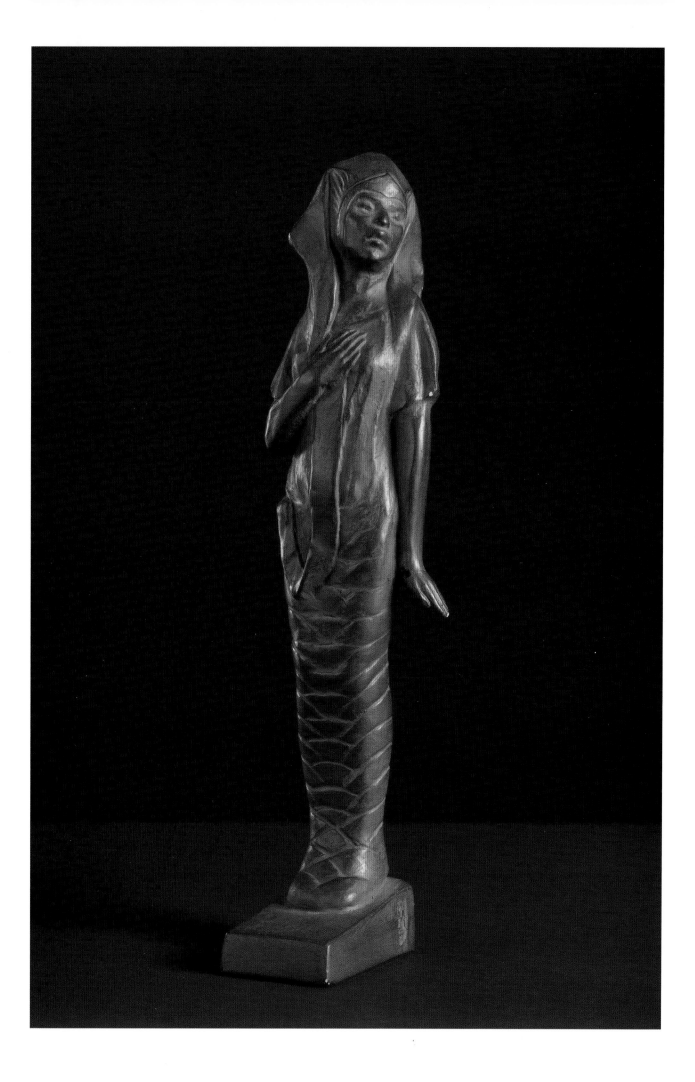

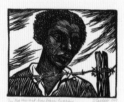

The day has not dear been known
when we need not get there...
J Catlett 1947

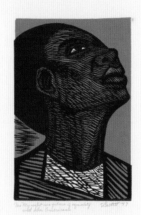

I have sought my future of equality
with other Americans.
J Catlett 47

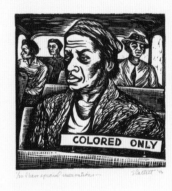

1/30 I have special reservations...
J Catlett 46

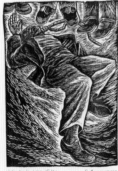

15/... and a special fear
for my loved ones.
J Catlett 46

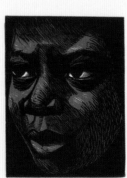

A/p 3/6 I am the black woman. Catlett 47

I have always worked hard
in America.
J Catlett 46

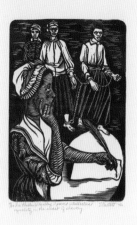

*...to be healthy, happy...spend intellectual
capacity in the cause of slavery.* E Catlett '46

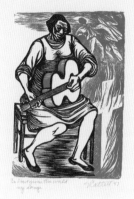

*In Sojourner the world
my strong.* E Catlett '47

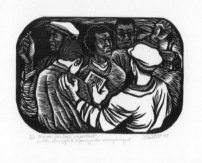

*... they who have been important
in the struggle to organize the unorganized.* E Catlett '47

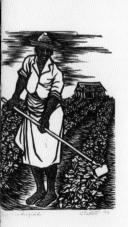

... in the fields. E Catlett '46

*...in her own
folded houses.* E Catlett '46

... special reservations ... E Catlett '46

12

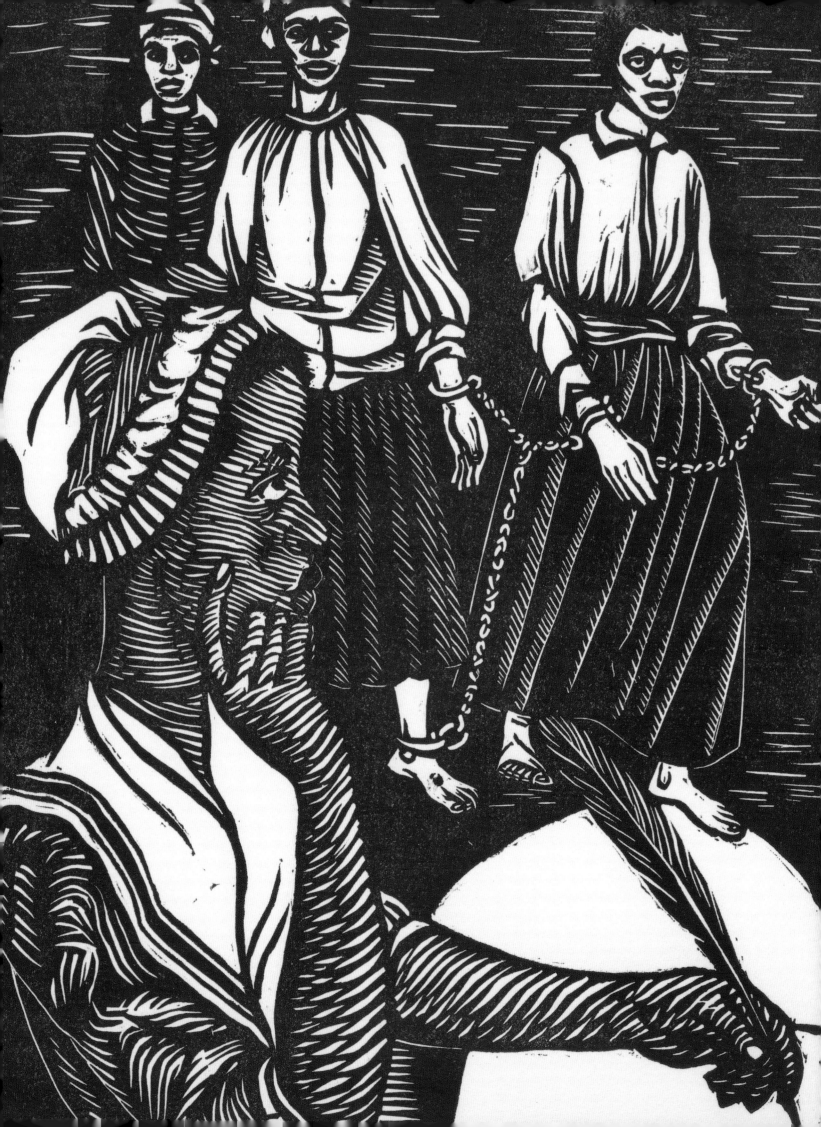

Mildred Thompson, *Untitled (Lynching of a Woman)***, 1963**

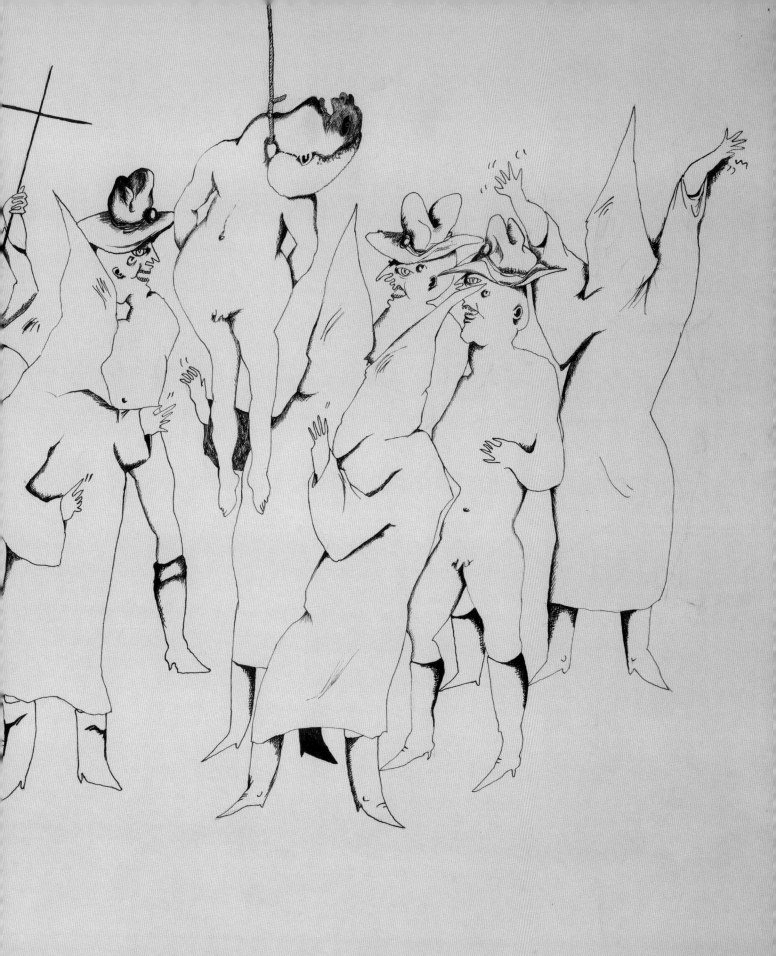

Colette Veasey-Cullors, *Insecurity Past, Insecurity Present,* and *Insecurity Future,* 2016; printed 2021

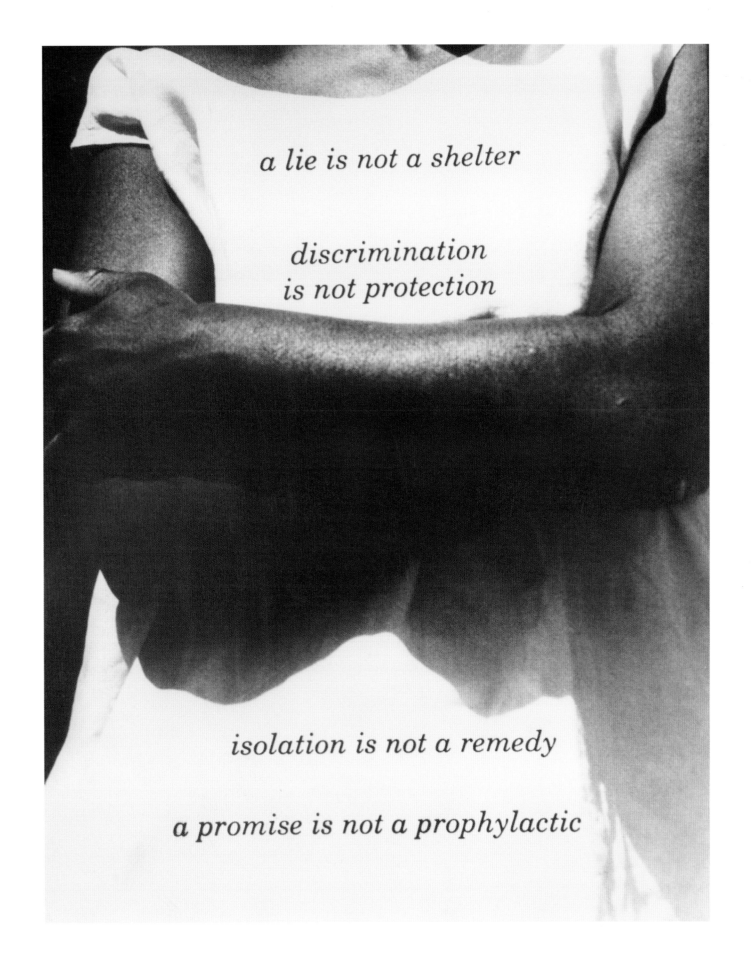

Lorna Simpson, *Untitled (a lie is not a shelter)*, 1989

Charles Alston, *Walking*, 1958

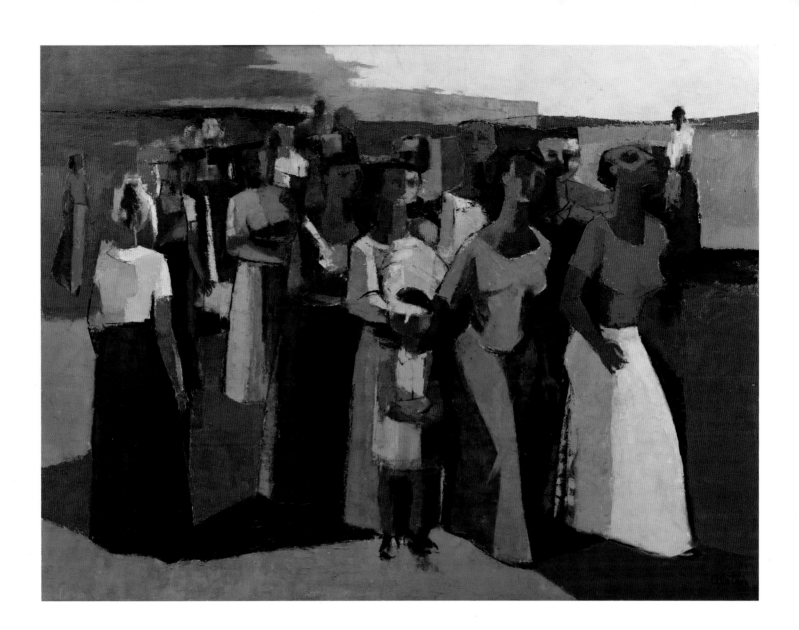

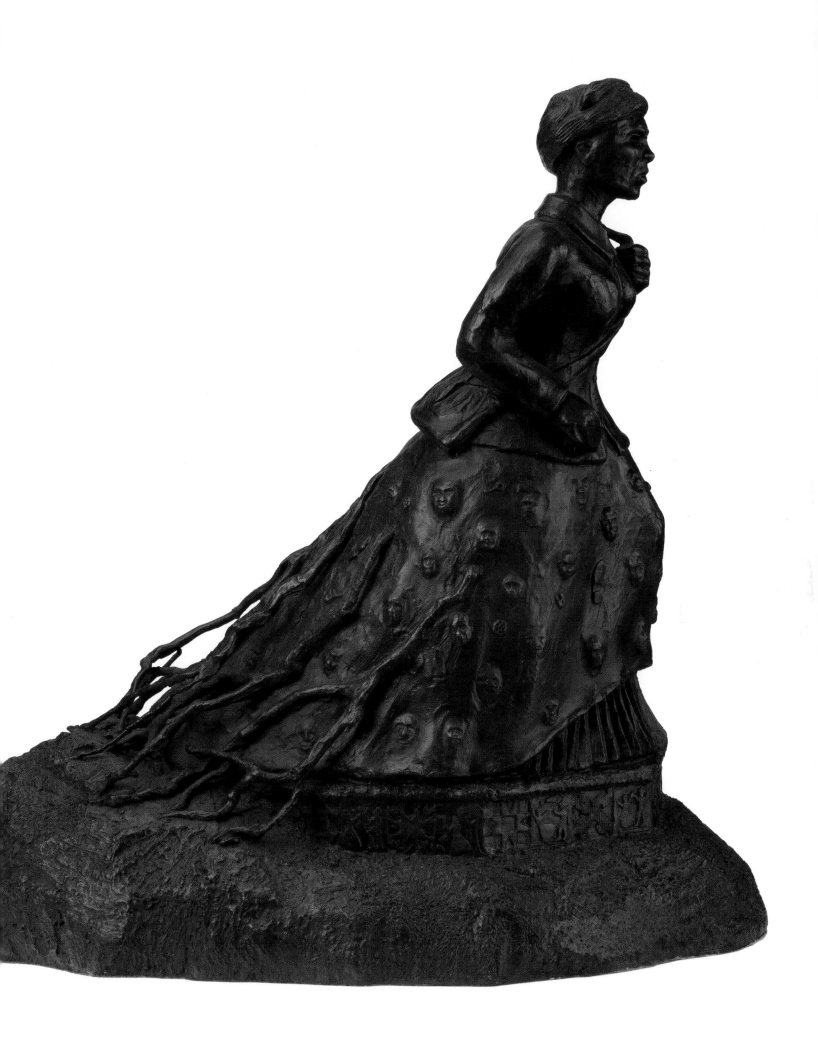

RESIL

Chase-Riboud, Cowar
Lee, Leonardo, Pecou,
Sherald, Thomas, Tow

ENCE.

ON REVERENCE AND SPIRITUAL RECKONINGS

Michelle D. Commander

A sense of calm emanates from Amy Sherald's portrait of Breonna Taylor, due in part to the sureness of Taylor's gaze and the monochromatic aquamarine palette (fig. 1). In seeking a spiritual connection with a "sitter" whose essence was felt, but who was not there in the physical realm, Sherald relied on informed speculation about Taylor to be able to capture her properly. Using photographs from Taylor's mother and recollections and ephemera from Taylor's other loved ones and friends, Sherald creates a captivating portrait of a young woman gone too soon.

Breonna Taylor had done nothing wrong—she had merely taken to her bed for her evening rest when the unthinkable happened: law enforcement officers shot into Taylor's apartment, piercing her prone body. Taylor's death on March 13, 2020, shook the United States and the world on the eve of twin pandemics—the COVID-19 health crisis and a quick, merciless succession of high-profile killings of unarmed Black Americans at the hands of police officers and vigilantes.

In a conversation with Bisa Butler and Deborah Willis (see pp. 100–7), Sherald later ruminated on the process of creating the portrait of Taylor, explaining the intentions behind her color selection and her desire to show proper reverence for Taylor's life: "I wanted you to feel that [Taylor] was floating inside of a space that you could be in as well as stand outside of, and just have your moment of solace." The stakes of the work were high: Sherald endeavored to render a precious life anew or as things might have been, should have been. Blue, the three artists agreed, is infinite.

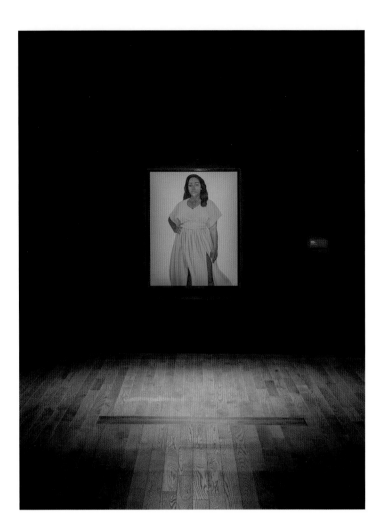

Indeed, the color blue is immense—it reminds one of the expanse of a clear sky that only appears to end when it meets sea or land. The horizon line is merely a trick of the eye, though, a limitation of perspective that advancements toward and/or the imagination can move beyond.

I first became enraptured with horizons while standing at the slave castles in Elmina and Cape Coast, Ghana, where I pondered the fates of untold numbers of African peoples who were carelessly and brutally stripped from their homelands and sent into what some might have considered to be a void (fig. 2). Looking out toward the vastness of the Atlantic Ocean, I began to imagine the terror that the women, men, and children must have felt aboard the cramped vessels after having spent weeks languishing in sweltering, dank slave dungeons, their bodies no longer their own. I thought of space and time and how they collapse in slavery's afterlife. There is progress and then there are unfortunate returns to the past, rendering Black life precarious.

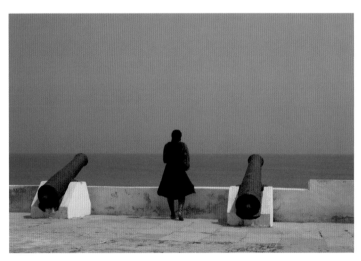

1 Amy Sherald's portrait of Breonna Taylor on view in the *Reckoning* exhibition, 2021.

2 Victoria Okoye (photographer), Michelle Commander overlooking the Atlantic Ocean from Cape Coast Castle, Ghana, 2013.

137

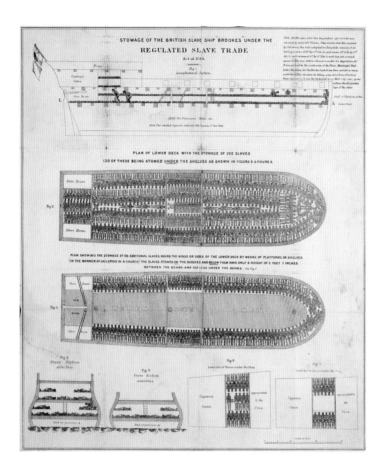

As I made these connections and thought of my own ancestors' journeys from sites not unlike these in Elmina and Cape Coast, the ocean seemed to bellow—as if it, too, knew and felt and was offering me solace through its sonic lamentation.

Over the course of the transatlantic slave trade, some four hundred thousand captives were brought to North America from the African continent and through the harrowing Middle Passage (fig. 3). Stripped from their homes, families, and cultures, these unfortunate souls would be forced into a new, brutal existence—one that depended on keeping enslaved people in their places. These conditions did not go unchallenged. Across the geographic spaces, enslaved people resisted at every turn, inaugurating a legacy of refusal that continues to shape our contemporary moment.

As marginalized groups in early America, both enslaved and free Black people had been forced to negotiate their insecure statuses under a prohibitive racialized order. South Carolina's Negro Code of 1740, for instance, contained a series of laws aimed at controlling the population of enslaved African Americans as well as delegating the rights and responsibilities of enslavers and white people more generally. Lawmakers were alarmed by the Stono Rebellion a year prior, in 1739, which saw a band of Kongo slaves attempt to march from South Carolina to freedom in Spanish Florida. They were unnerved by the audacity of the event and viewed an expansive code as necessary, as scores of colonists and Africans had died during the bloody rebellion. Along with prohibiting enslaved people from gathering with one another, learning to read and write, growing their own food, playing drums, or demonstrating any real control over their person or movement, there was the inclusion of an article whose ramifications in the eighteenth century and beyond are chilling:

> If any slave who shall be out of the house or plantation where such slave shall live, or shall be usually employed, or without some whiter person in company with such slave, shall *refuse to submit* or undergo the examination of *any white person*, it shall be lawful for any such white person to pursue, apprehend, and moderately correct such slave; and if any such slave shall assault and [strike] such white person, such slave may be *lawfully killed*.[1]

By deputizing white people in this way, the State of South Carolina racially codified one group's supremacy over others and set the stage for generations of surveillance and vigilante violence, especially as other slaveholding states took their cues from South Carolina

3 *Stowage of the British Slave Ship "Brookes" Under the Regulated Slave Trade Act of 1788.*

and implemented similar laws. Indeed, such codes established a racial order in the 1700s that extends well into the present, though such explicitly racist laws have been largely abolished.

To counter the surety of enslavers' financial speculations into transatlantic slavery and the industries that thrived directly or indirectly from the institution, African captives remained in self-propelled flight—from slave ships and away from the physical world, while others planned and actuated escapes from the restrictions of plantations. Oral narratives across the Atlantic World about "Flying Africans" chronicle Africans who, in rejection of journeys into uncertain futures, jumped from slave ships in hopes of returning spiritually to their homelands. Enslaved people maintained collective hopes for bright, liberated futures, refusing to allow the barbarity of the West to overcome them. It is this posture—the making a way out of no way, the quest for joy anyhow, the continued demands for equality and justice—that has sustained African Americans over the centuries as they have endeavored to survive. Indeed, demands for reckoning involve accounting for debts, reconciliation of and for innumerable losses. Reckonings necessitate acknowledgments of what was done and by whom and what is owed. They also involve calls for reverence for those whose sacrifices made our own being possible.

The structures built to sustain the institution of slavery have left imprints centuries later. As everyday Black laypeople, artists, activists, and those whose identities meet at those intersections know, the past is not yet past. Stephen Towns, the painter and fiber artist from Lincolnville, South Carolina, describes himself as a time traveler whose work bears witness to Black histories and cultures, assigning care and beauty for unsung people and circumstances. In his 2017 multi-panel *An Offering* series, Towns utilizes Christian iconography to remember and honor those who traversed and those who ultimately succumbed during the Middle Passage (fig. 4). At the top of each slave ship–shaped panel is a single haloed African subject with a white cloth draped across one shoulder or a dress in complementary styling. Each person is positioned against a golden background and flanked by blue butterflies, a species whose life cycles and complicated, yet deliberate, migratory patterns not only recall the turbulence of the Middle Passage, but also suggest hopefulness and the promises inherent in flight and transformation. The quilted and beaded lower half of each panel features an offering, three black hands holding candles in reverence and gratitude

4 Stephen Towns, *An Offering*, 2017.
5 Lola Flash, *Divinity*, 2020.

139

to the ancestral figures whose shadows are reflected into the quilted oceanic shades of blue below.

Lola Flash's 2020 self-portrait *Divinity* also references the slave ship icon, reimagining the physical space and the stifling nature of the vessels and the unequal worlds made by slavery (fig. 5). Flash created the portrait after Minneapolis, Minnesota, police officer Derek Chauvin viciously and quite literally took George Floyd's breath away, kneeling on his neck over the course of eight minutes, forty-six seconds. Flash's speculative work reads as decidedly Afrofuturist, and is part of their *syzygy, the vision* series. Flash is dressed as an astronaut, though their orange outfit is not a space suit but instead a prison uniform, bringing attention to the prison industrial complex's close relation to the institution of slavery. Atop their head is a red, white, and blue helmet. They stand just inside a wooden rowboat that has been situated upright against a red brick building. Behind the helmet's translucent blue visor, one can see that Flash's eyes are gazing skyward, perhaps to a deity or ancestor, and their shackled hands are clasped as if in prayer. "Can our truth-seekers lead us to the place where we are superhuman—shedding our black bodies of institutional 'isms,'" Flash asks in the series' concept note. "My soul," they continue, "is hopeful for a divine future where we are finally able to run anew, jumping in space from planet to planet, far away from the hash tag chatter and into a narrative of pure joy."[2]

Reckoning: Protest. Defiance. Resilience. is a profound and beautiful invitation for us to see and bear witness—not just to the pain under and through which Black people have languished, but the expansive ways that Black people and a range of artists have insisted on Black humanity and survival. Artists change how we see and how we reflect, bringing us closer, as Amy Sherald intimated as she discussed her longing for spiritual, reverential convenings. In their revisioning of famous spectacles of transatlantic violence and/or Black struggles, Black artists across disciplines and methods reframe which subjects are centered, how subjects return or reverse the gaze, and they invite us, if we're willing, to take an inward look at ourselves and the worlds and circumstances that have been made for us, those that we've made, and those we are making. A major through line of this exhibition is the ceaselessness of Black social protests across time and space. They remind us that reckonings have always been paramount in the United States. The questions that remain are: Who will we be? What actions will we take? And what commitments are we prepared to avow to build just futures?

Endnotes

1 William Goodell, *The American Slave Code in Theory and Practice: Its Distinctive Features Shown by Its Statutes, Judicial Decisions, and Illustrative Facts* (New York: American and Foreign Anti-Slavery Society, 1853), 306–7, https://quod.lib.umich.edu/m/moa/ABJ5059.0001.001. Emphasis in original.

2 Lola Flash, "syzygy, the vision," Lola FLASH, accessed October 30, 2023, http://www.lolaflash.com/syzygy.

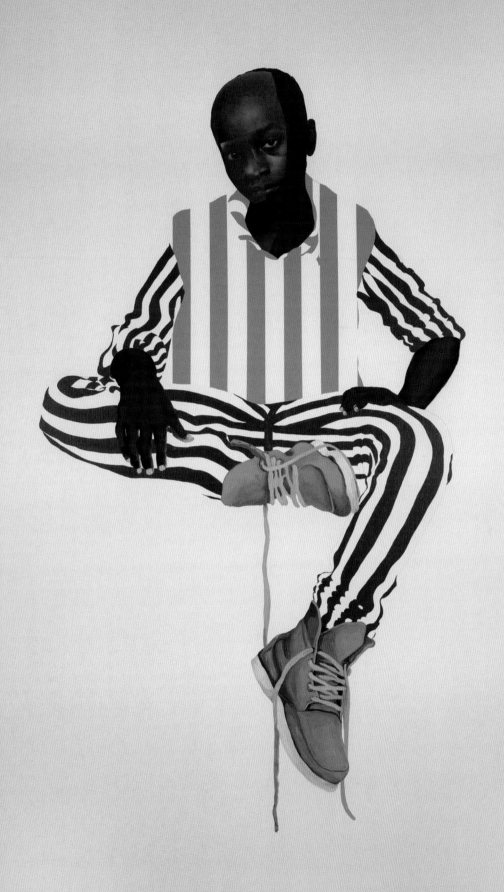

Adger Cowans, *SOWETO*, 1983

Shaun Leonardo, *Rodney King, Before BLM*, 2017

Zun Lee, *Untitled*, 2012, Billy Garcia and daughter Esmeralda
sharing a tender moment at a gas station, Bronx, New York;
from the series *Father Figure*

Lola Flash, *Back at You*, New York, New York, 2020;
from the series *syzygy, the vision*

Lola Flash, *Divinity*, Brighton, United Kingdom, 2020;
from the series *syzygy, the vision*

Lola Flash, *Milky Way*, Villas, New Jersey, 2021; from the series *syzygy, the vision*

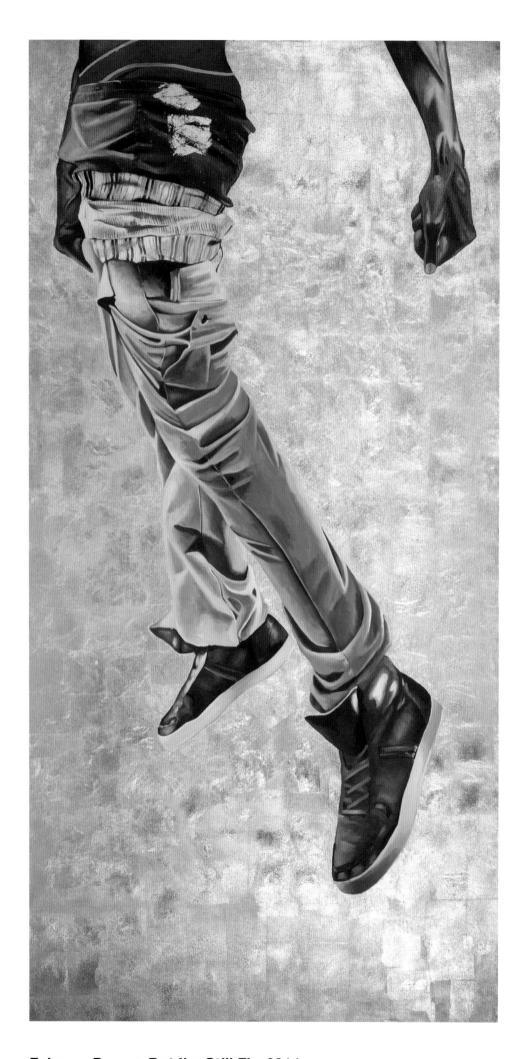

Fahamu Pecou, *But I'm Still Fly*, 2014

Kehinde Wiley, *Saint John The Baptist*, 2014

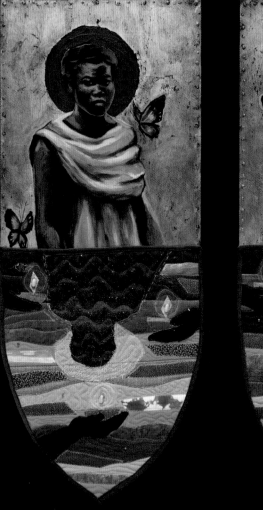
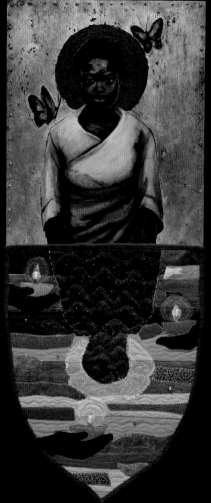
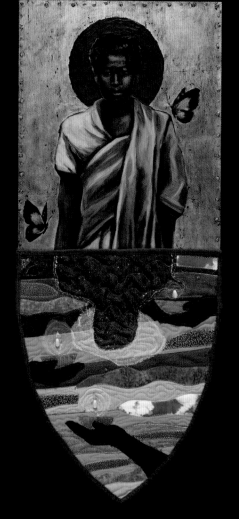

Stephen Towns, *An Offering*, 2017

156

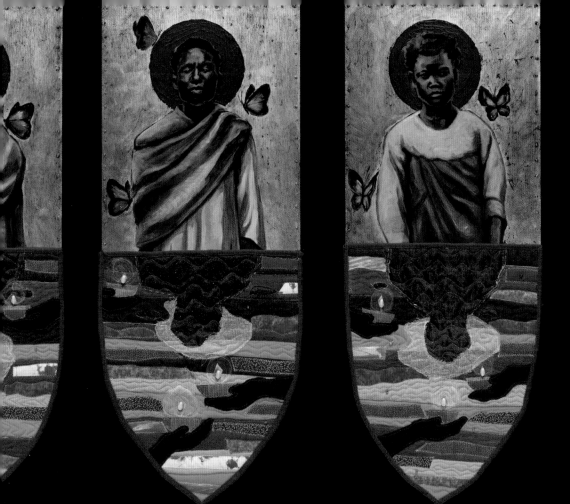
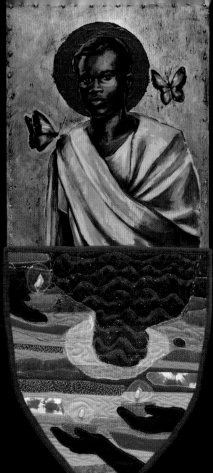

Barbara Chase-Riboud, *Tantra #1,* **1994**

159

Jefferson Pinder, *Mothership (Capsule)***, 2009**

Amy Sherald, *Grand Dame Queenie*, 2012

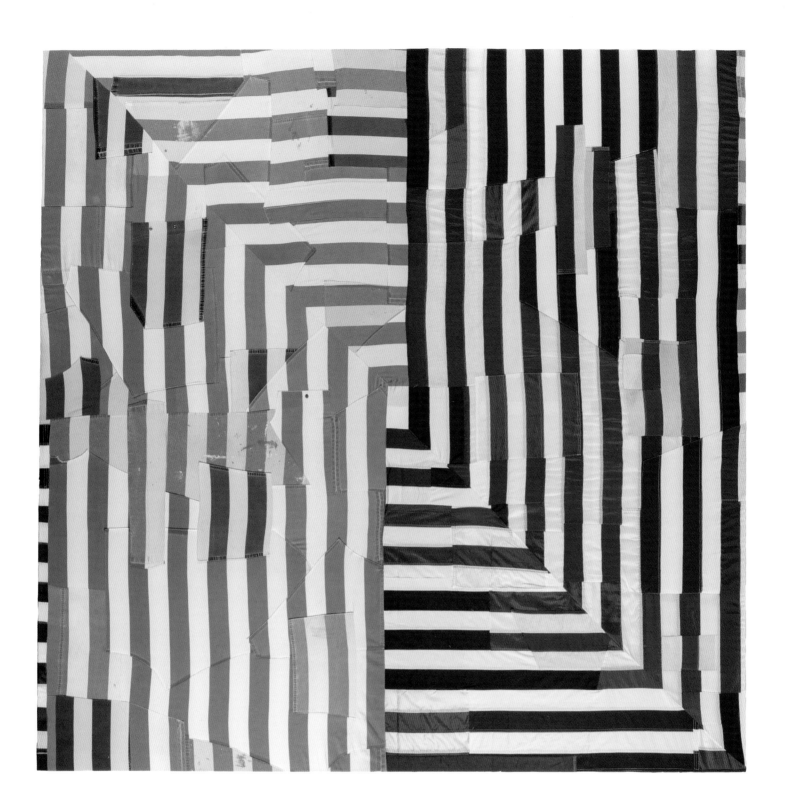

Hank Willis Thomas, *Spiral*, 2022

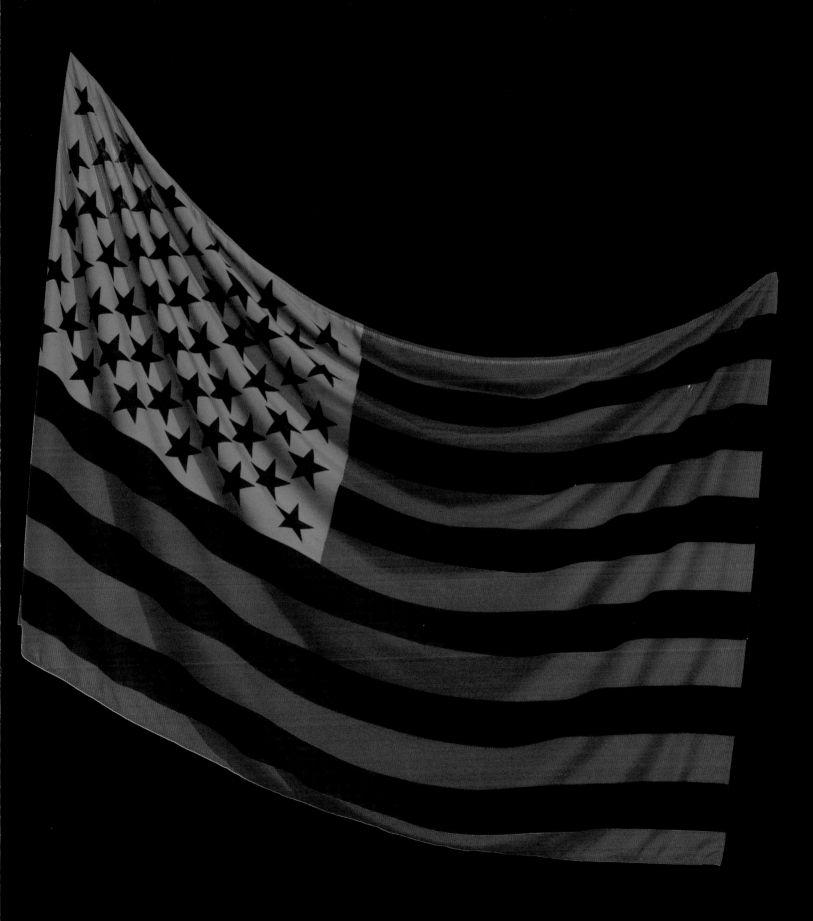

INSTALLAT

ION VIEWS

RECKONING

Protest. Defiance. Resilience.

Visual art has long provided its own protest, commentary, escape, and perspective for African Americans. The Black painters, sculptors, photographers, and textile artists featured here exemplify the tradition of exhibiting resilience in times of conflict, as well as the ritual of creation, and often, the defiant pleasure of healing.

This show arises out of the twin pandemics of COVID-19 and systemic racism, both of which impacted daily life for all Americans in 2020. This time has been called one of reckoning, as the world witnessed the killing of George Floyd and other African Americans at the hands of police, leading to some of the largest protests in U.S. history. Reckoning explores the ongoing struggles Black Americans have faced in their pursuit to enjoy the fundamental rights and freedoms promised in the Constitution to citizens of the United States.

Central to this exhibition taken from the museum's permanent collection are new acquisitions, including Bisa Butler's portrait of Harriet Tubman, David Hammons's homage to Michael Stewart, and Amy Sherald's posthumous portrait of Breonna Taylor, who has become a symbol of ongoing injustice and female power. Reckoning is a testament to how artists and photographers have used their voice to pay tribute to those we have lost, lifting up names such as Eric Garner, George Floyd, and Breonna Taylor at demonstrations and in communities online. The show journeys from defiance to acceptance, from racial violence and cultural resilience to grief and mourning, hope and change.

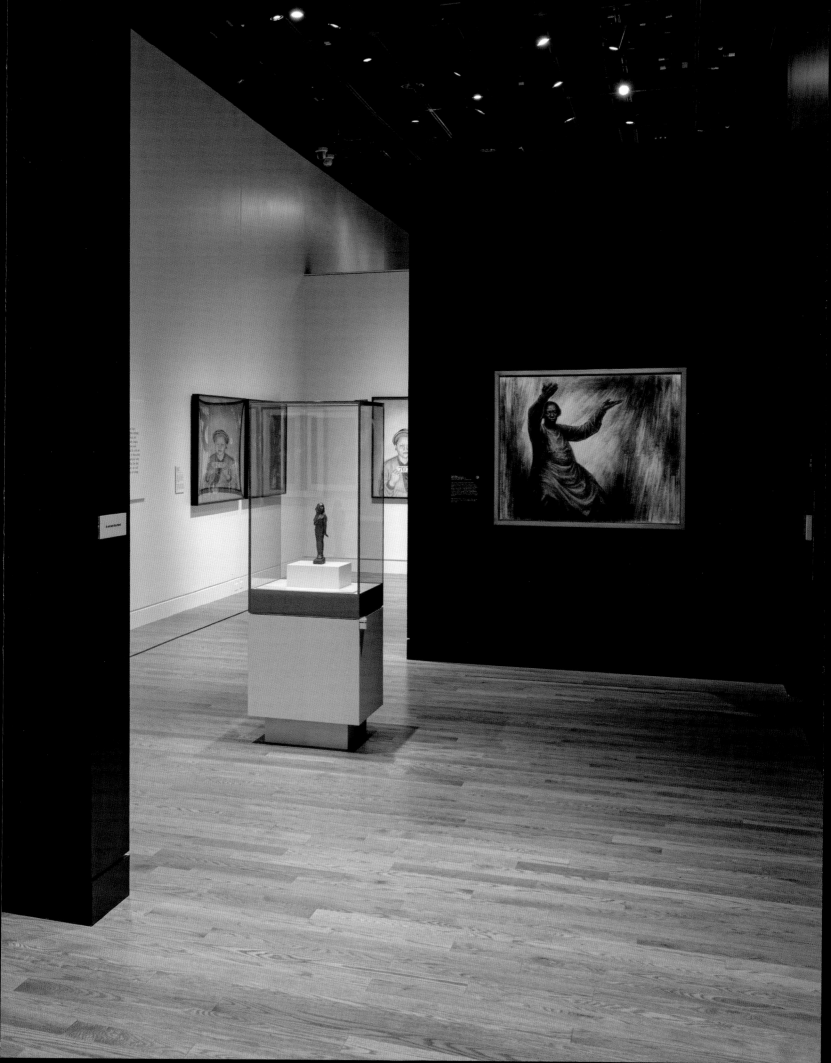

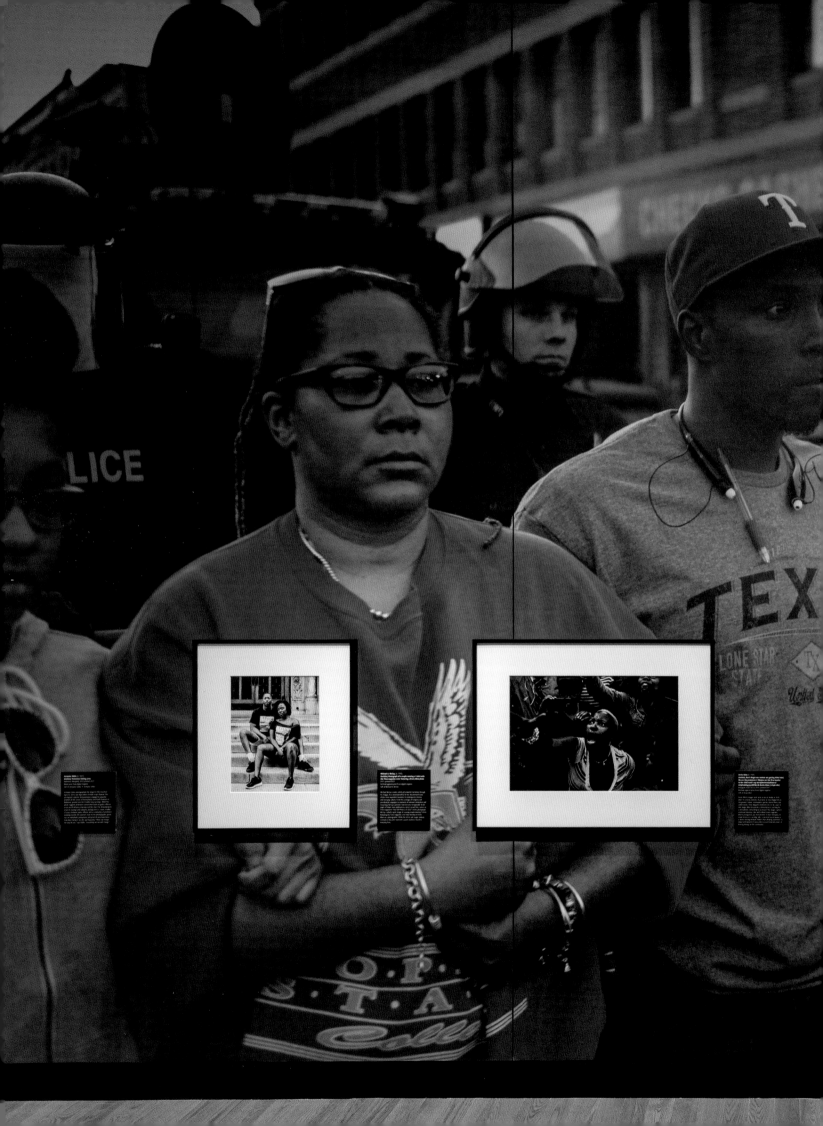

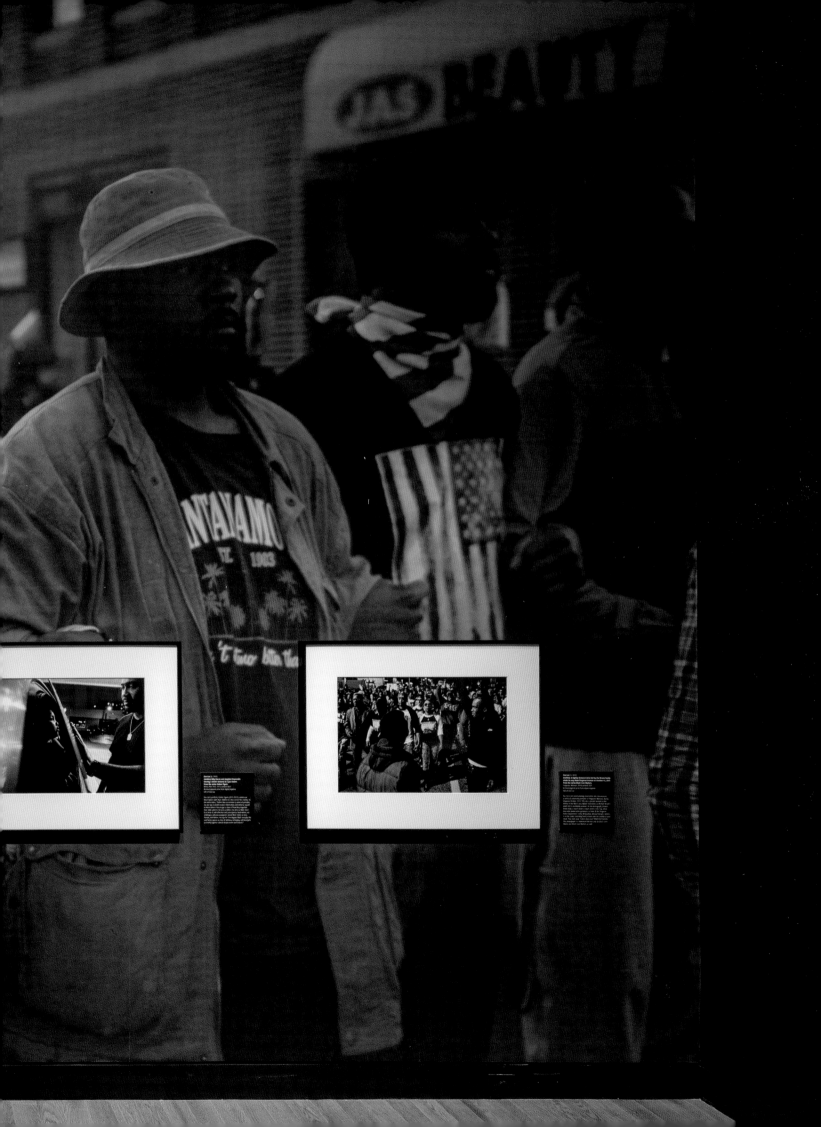

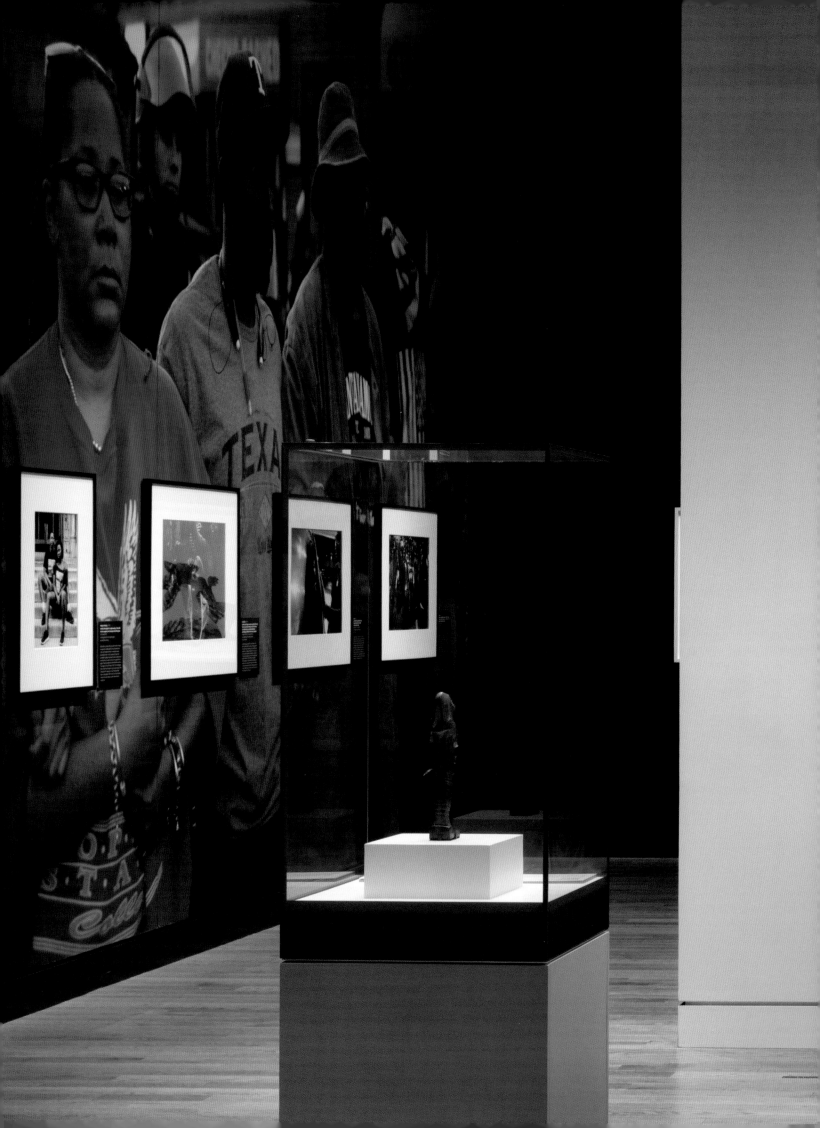

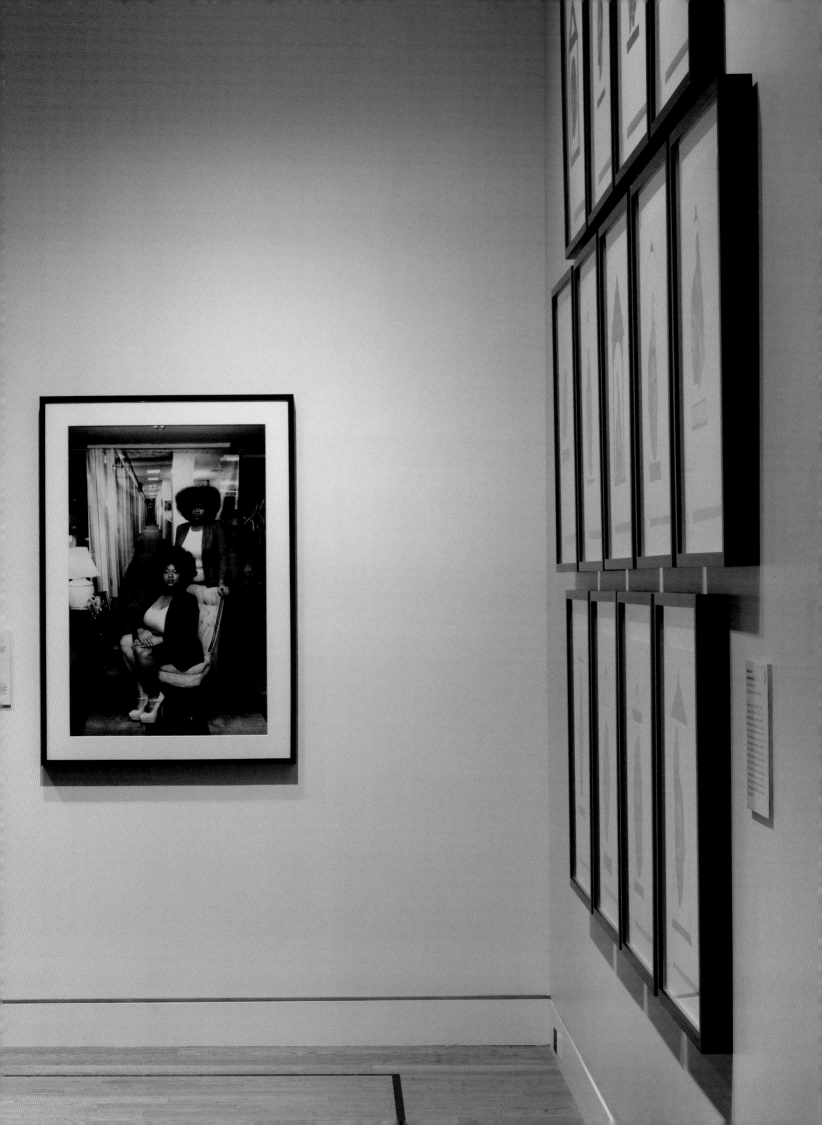

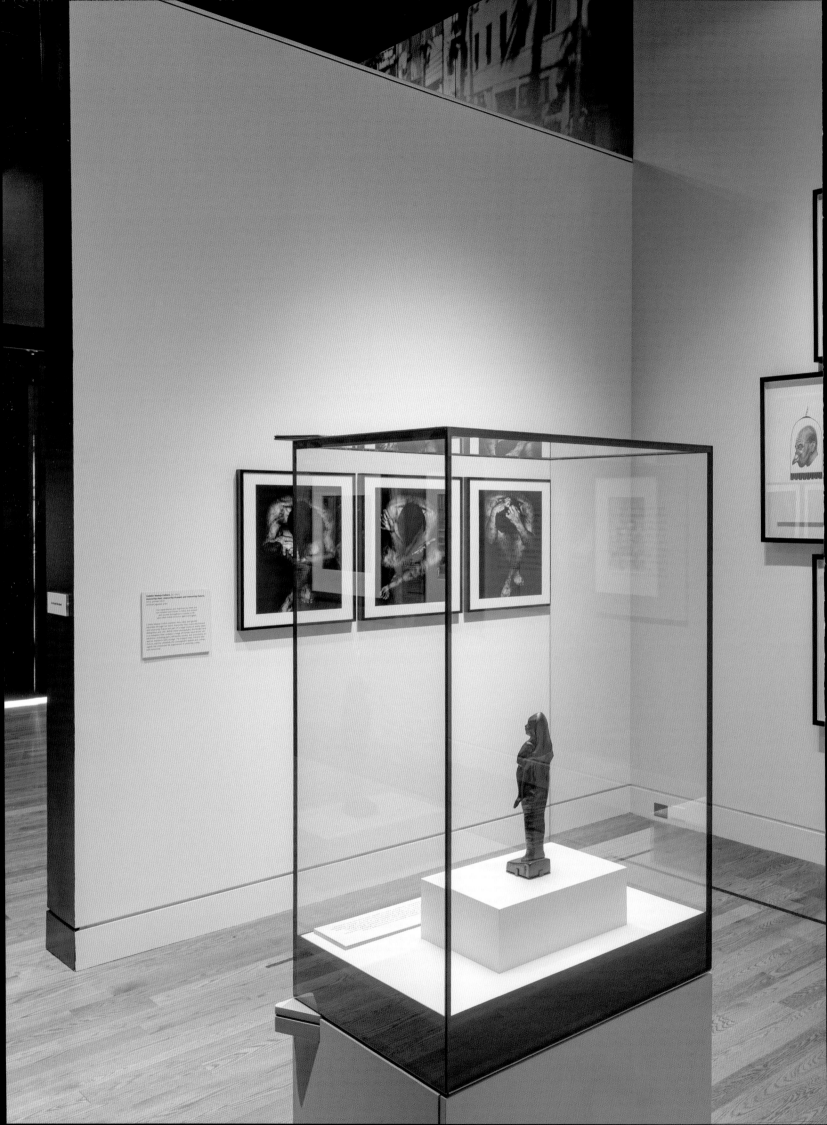

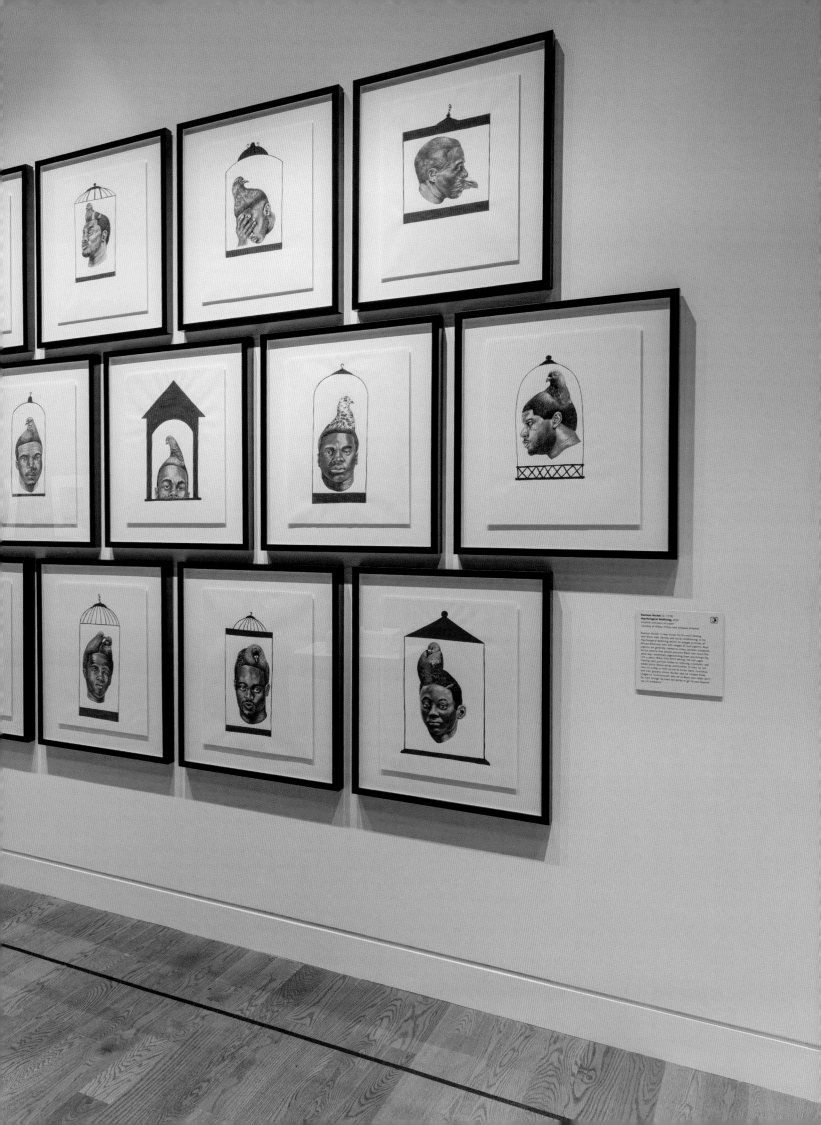

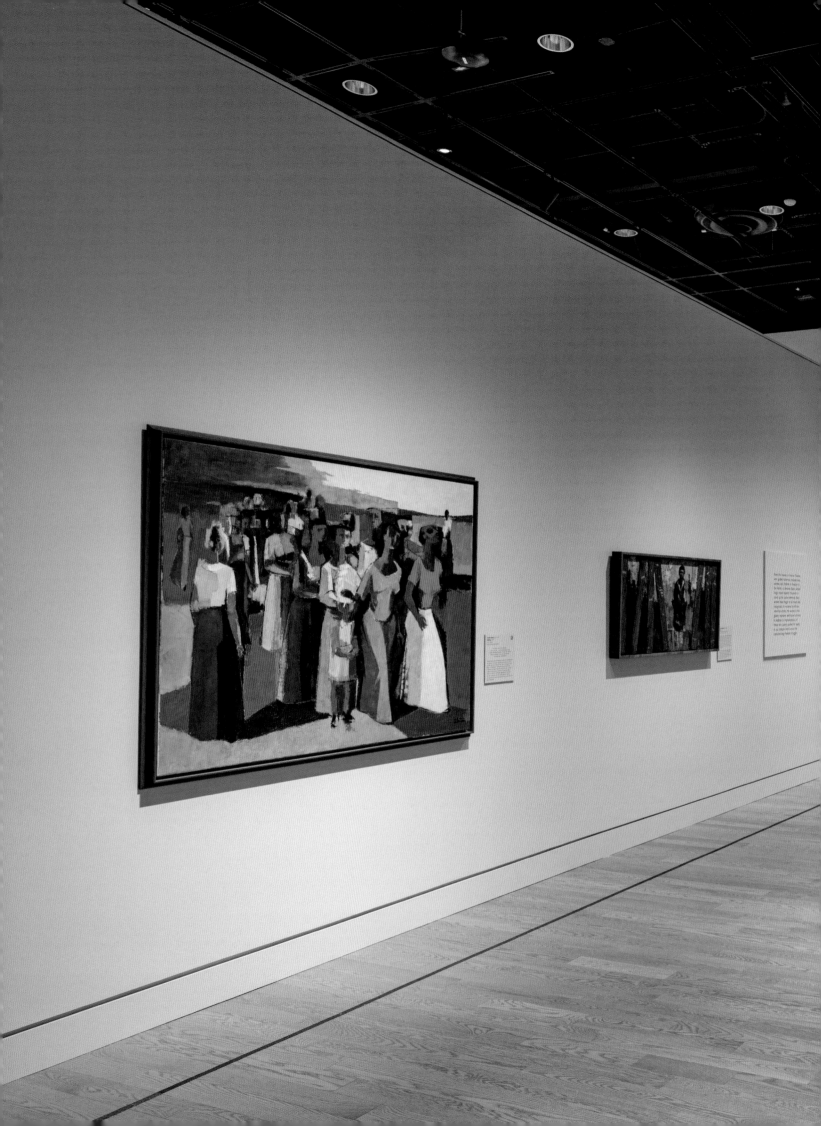

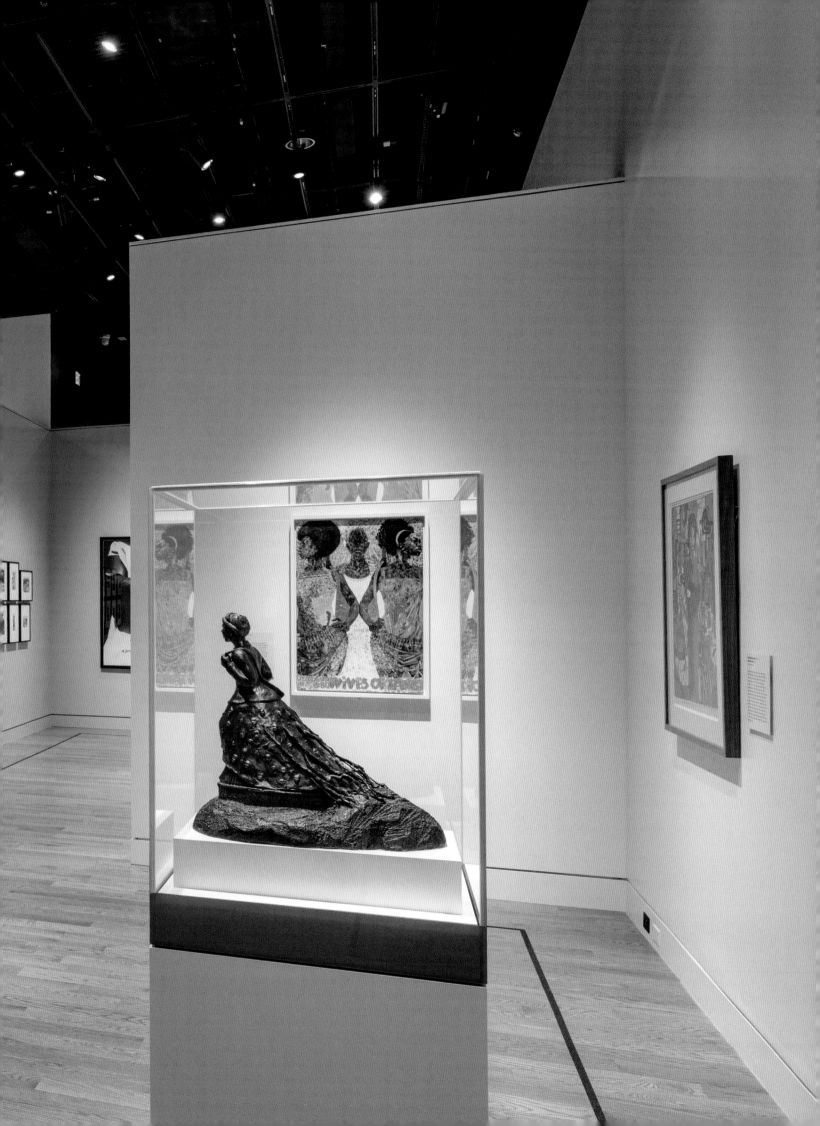

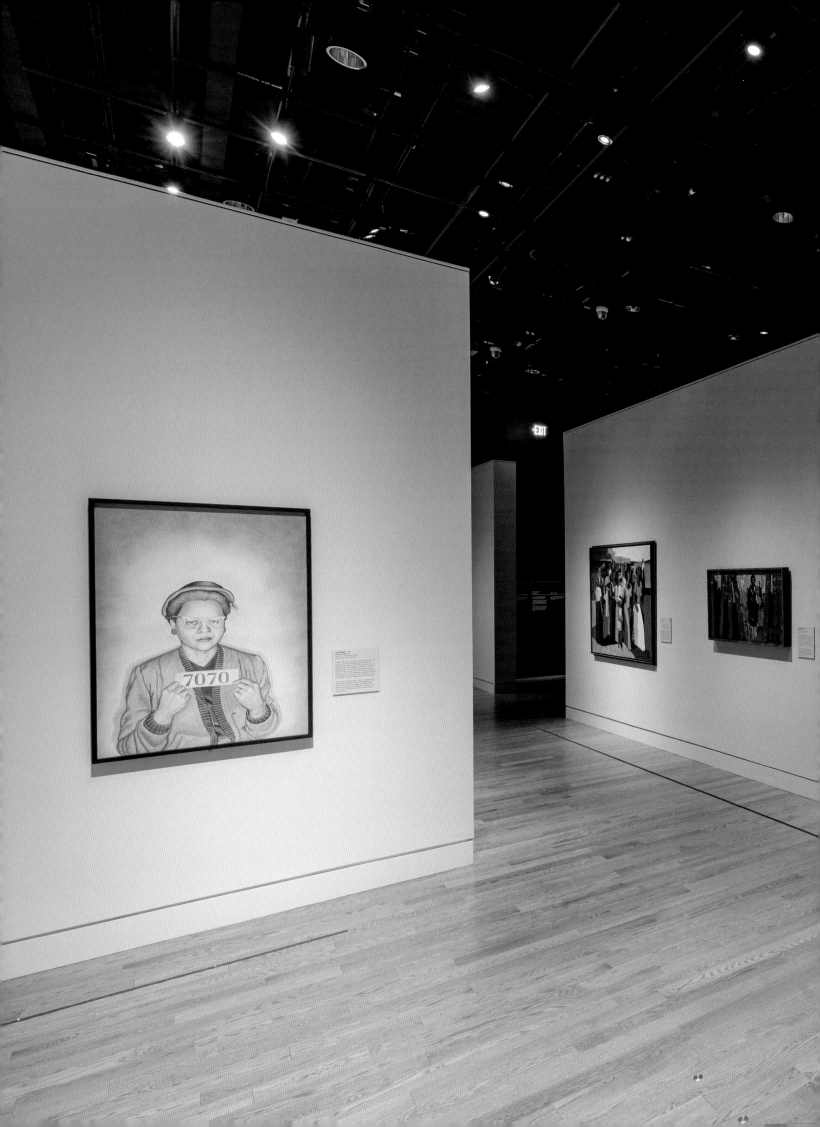

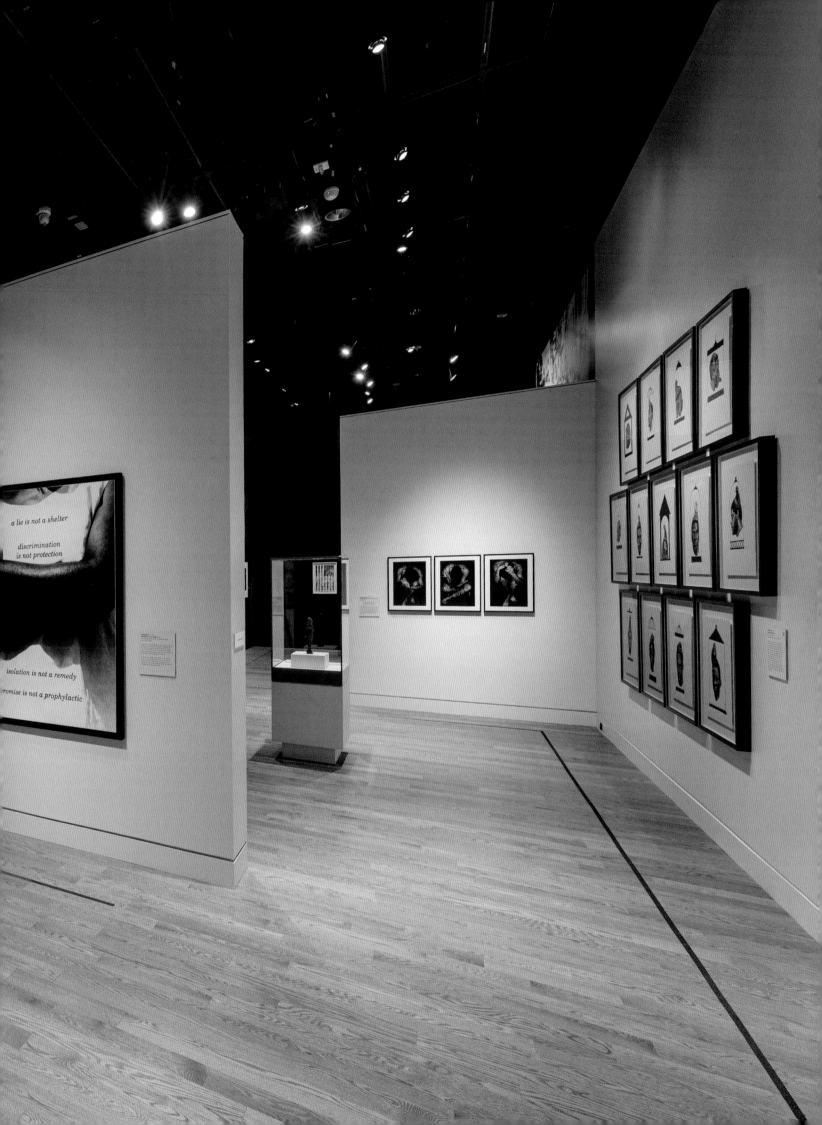

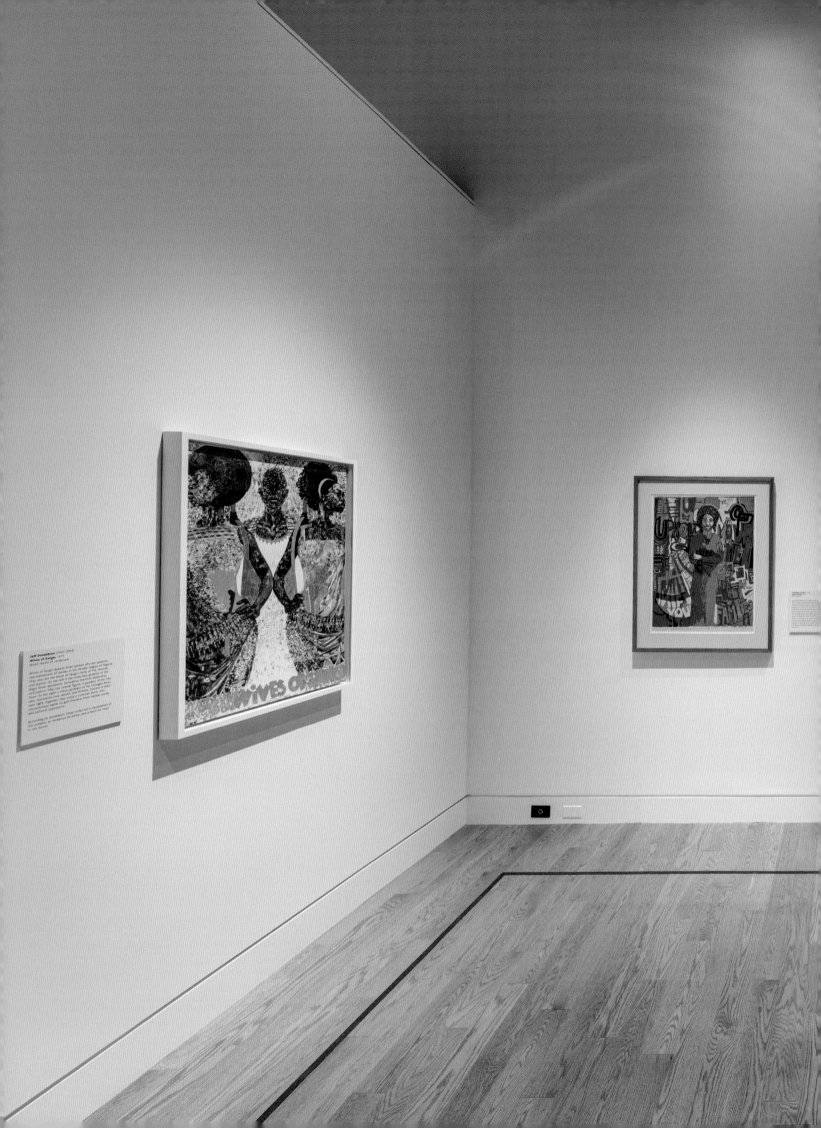

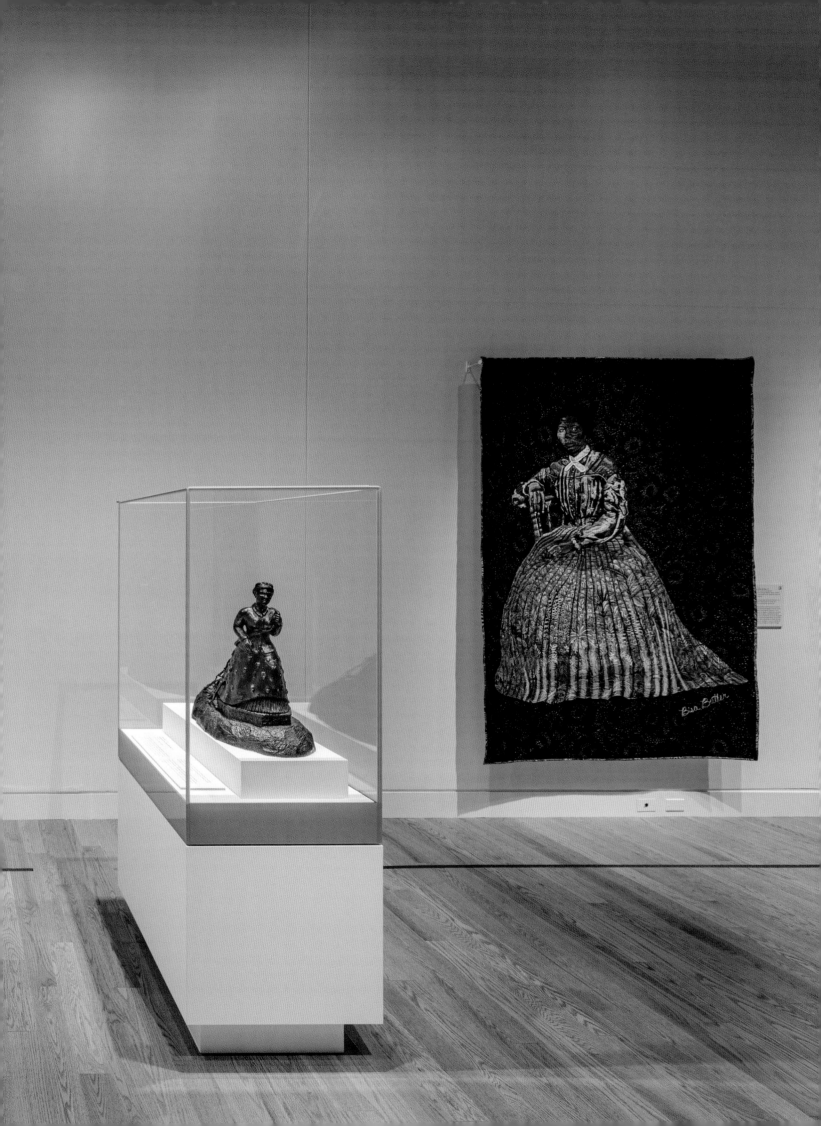

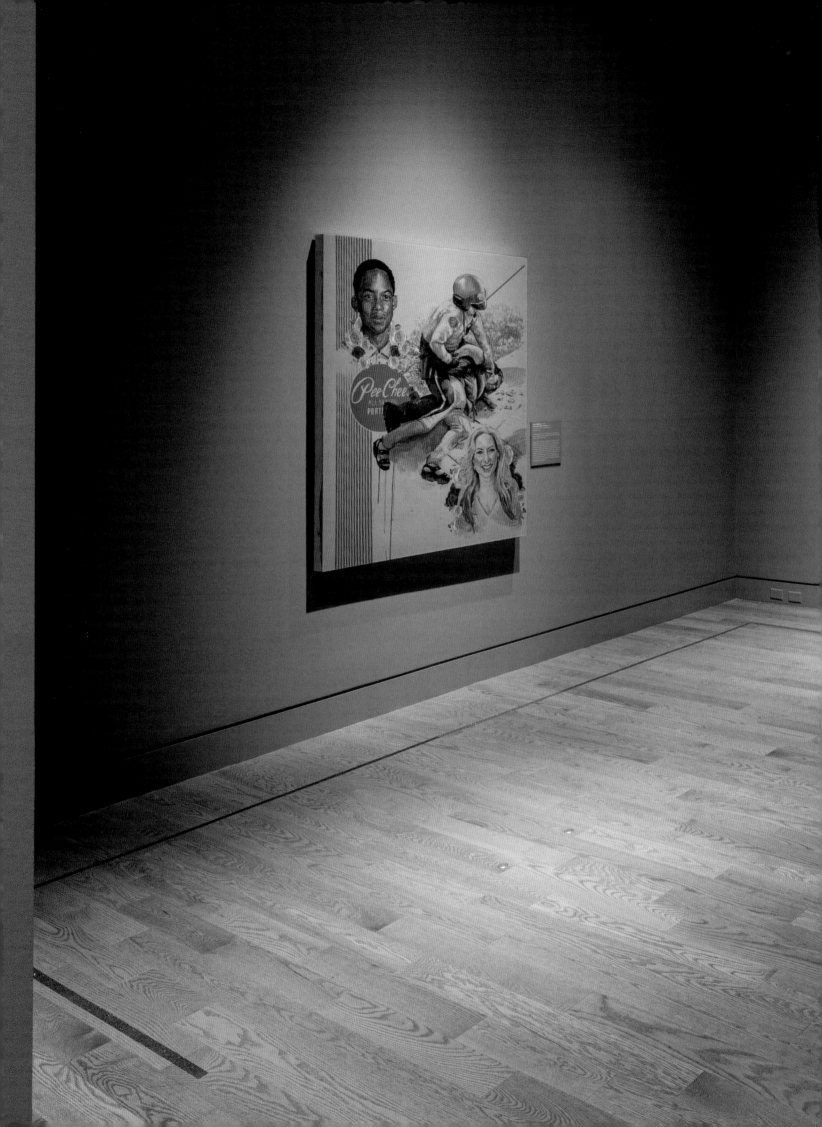

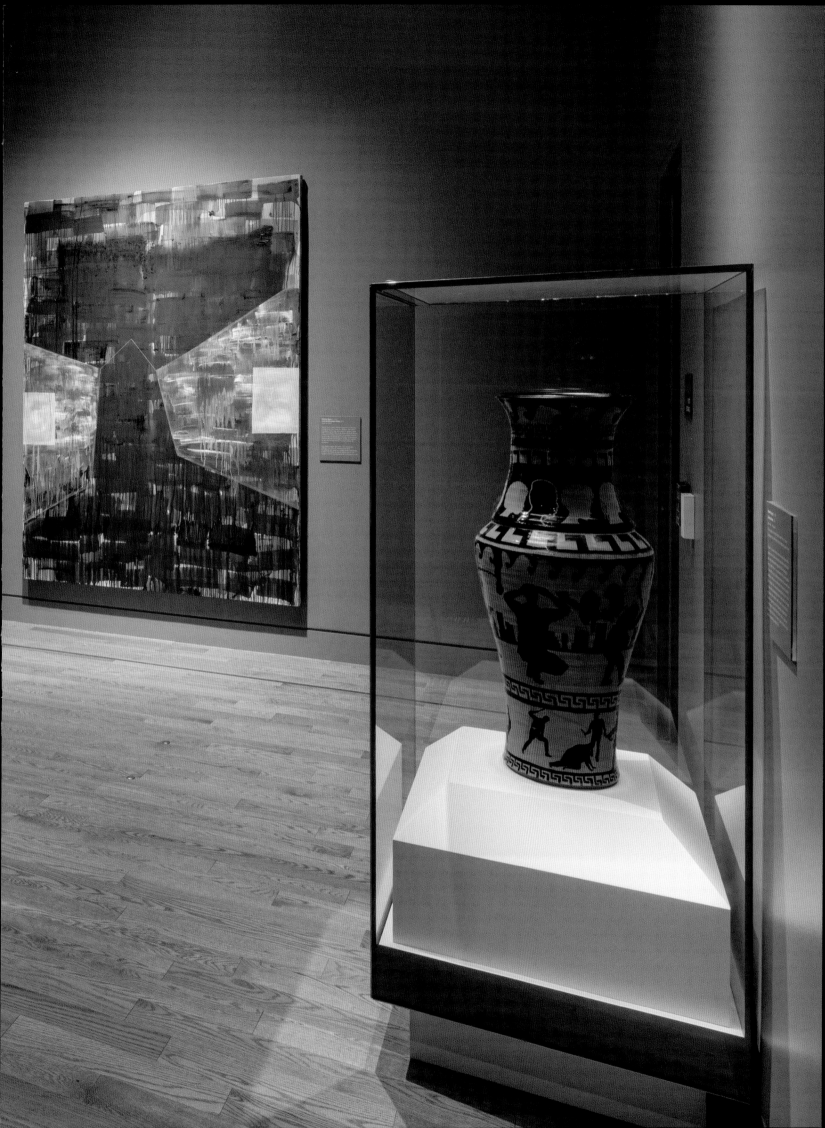

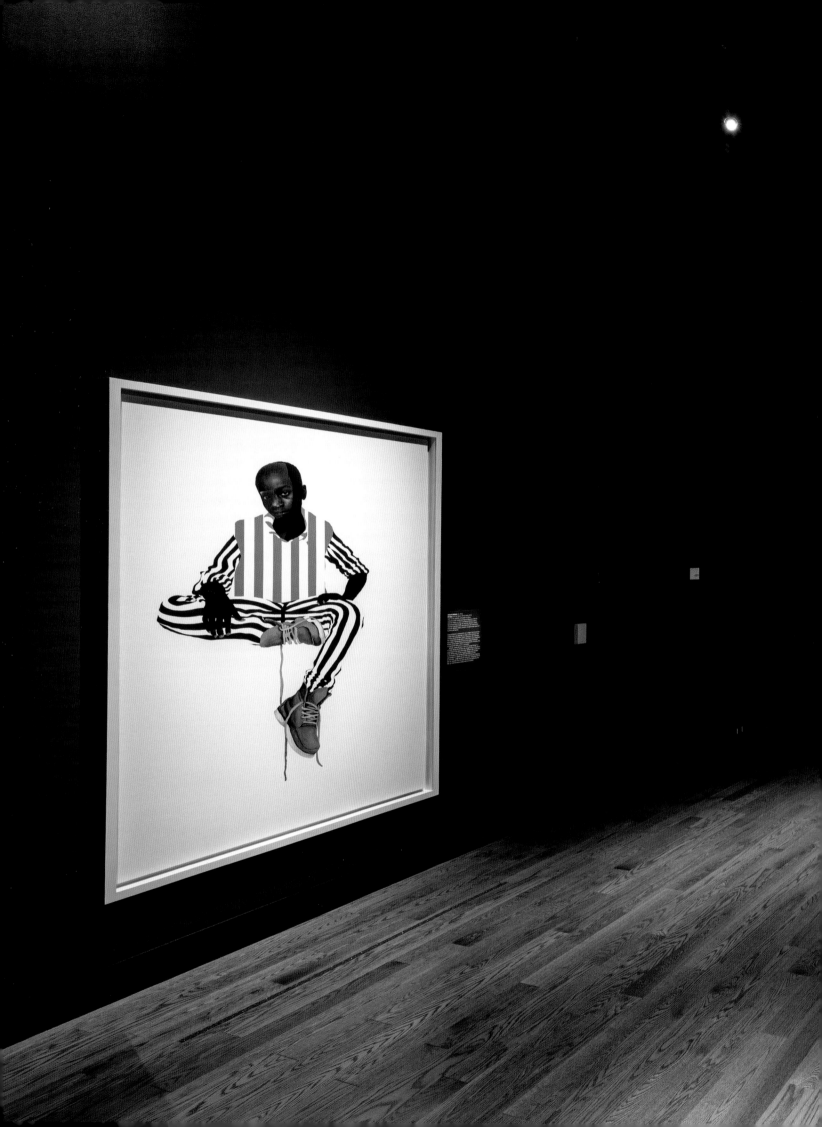

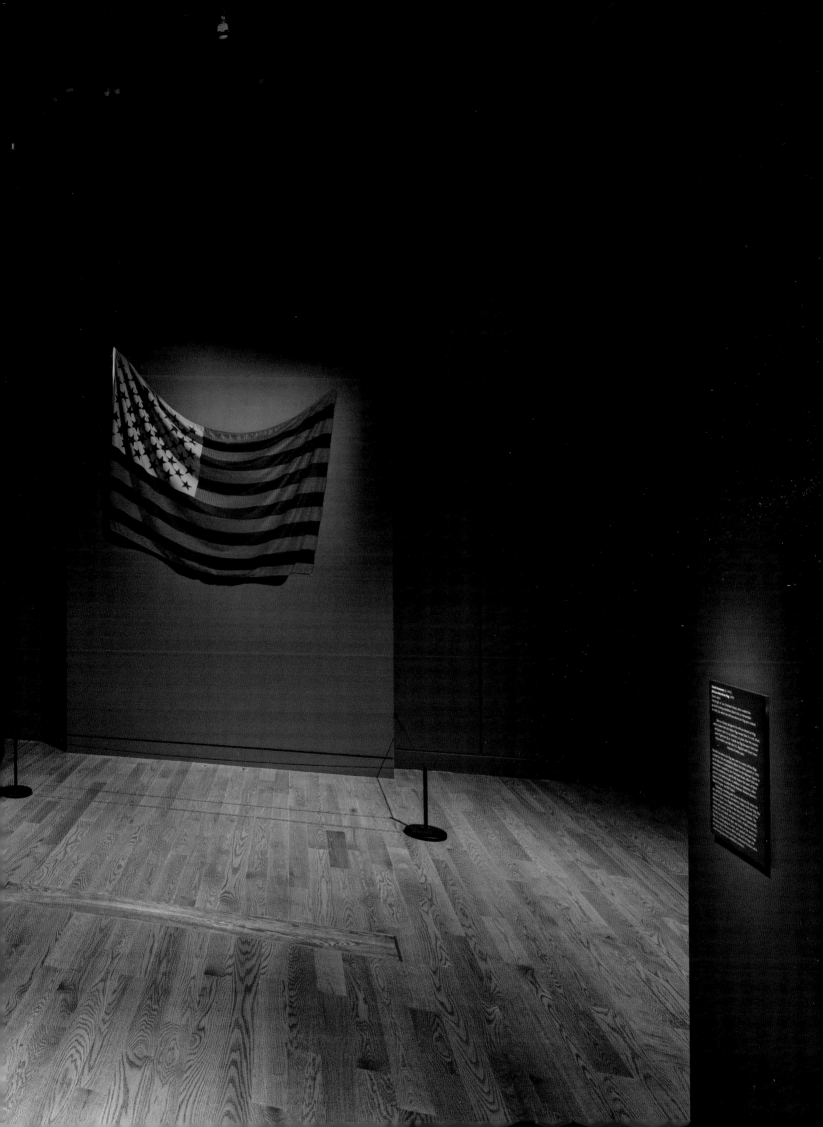

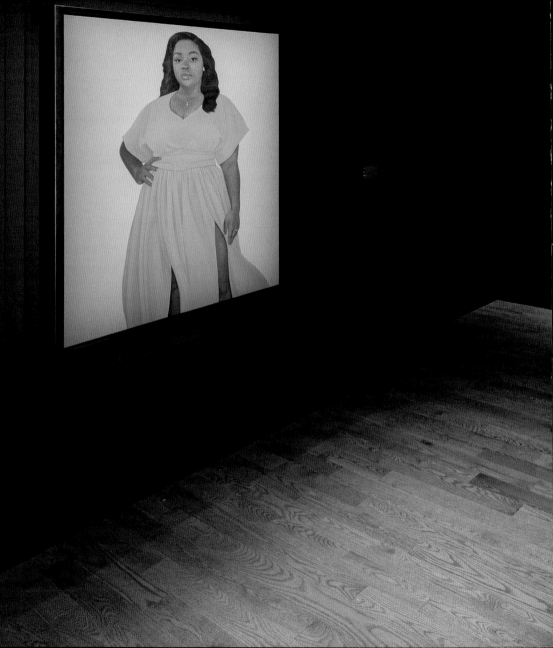

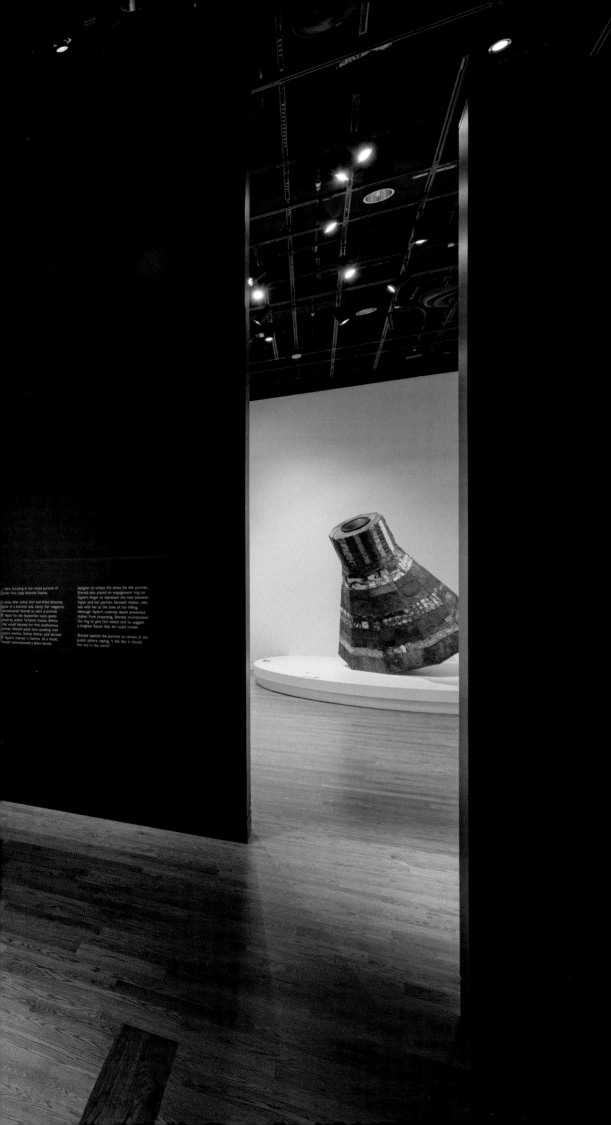

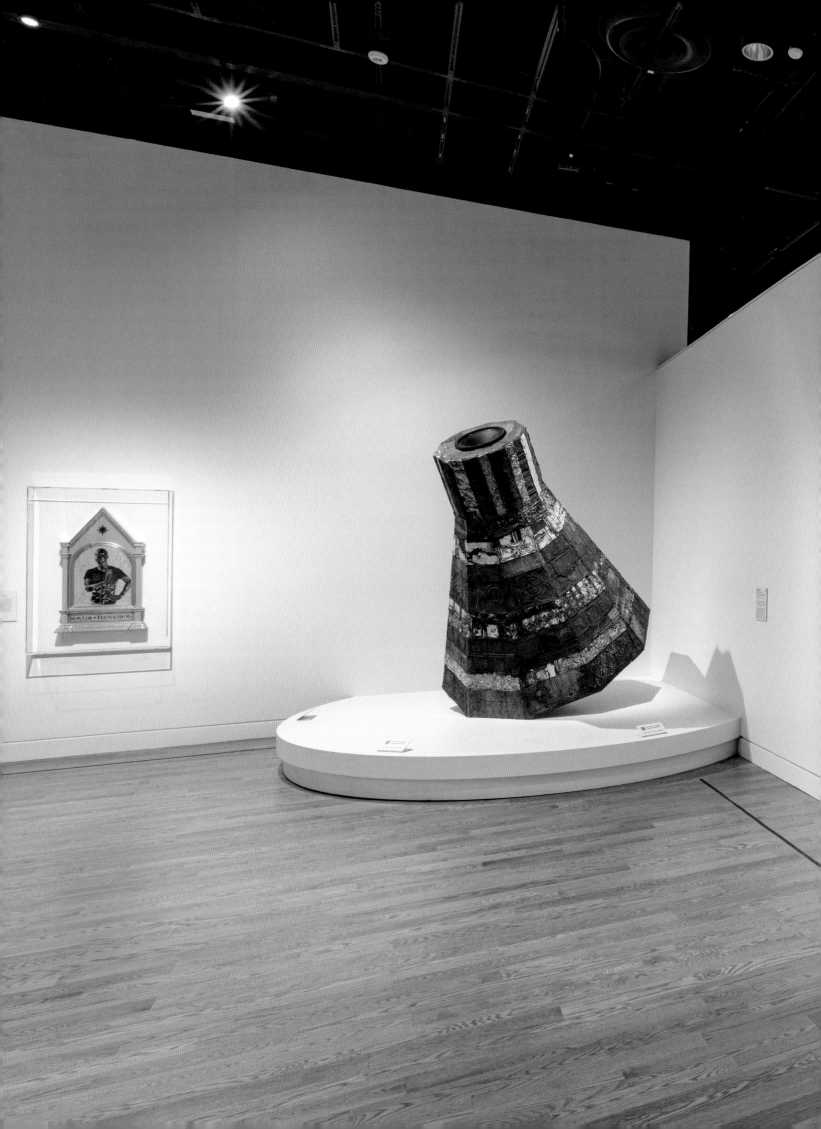

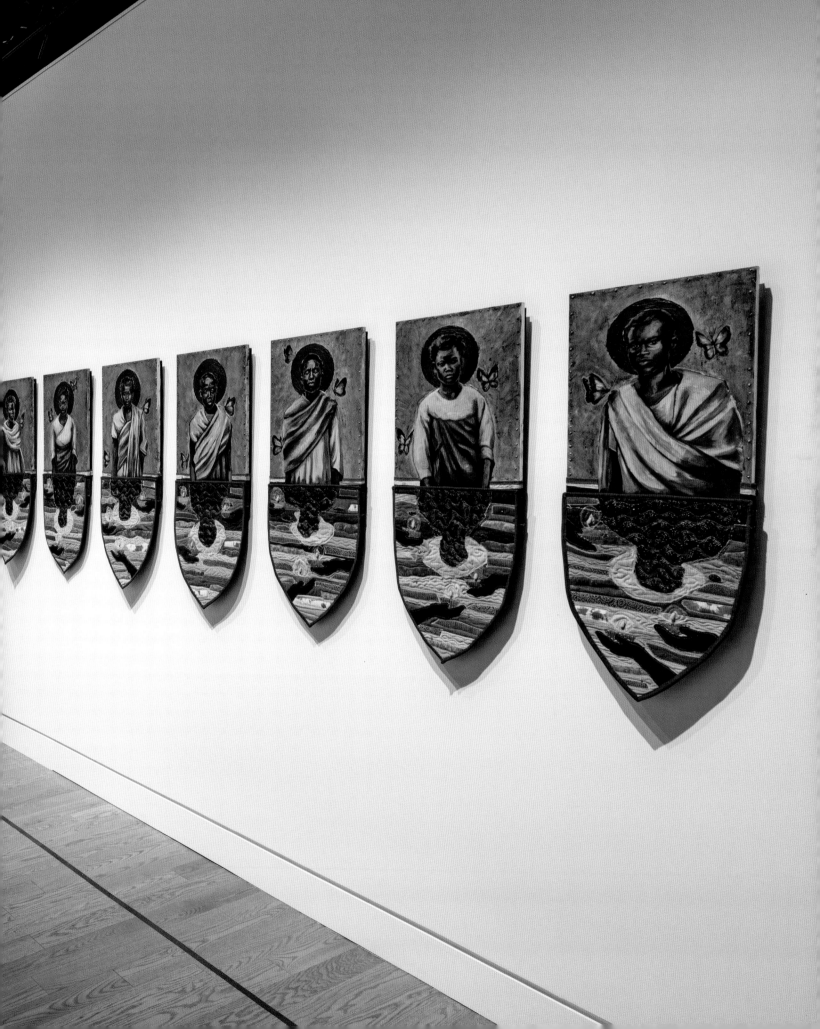

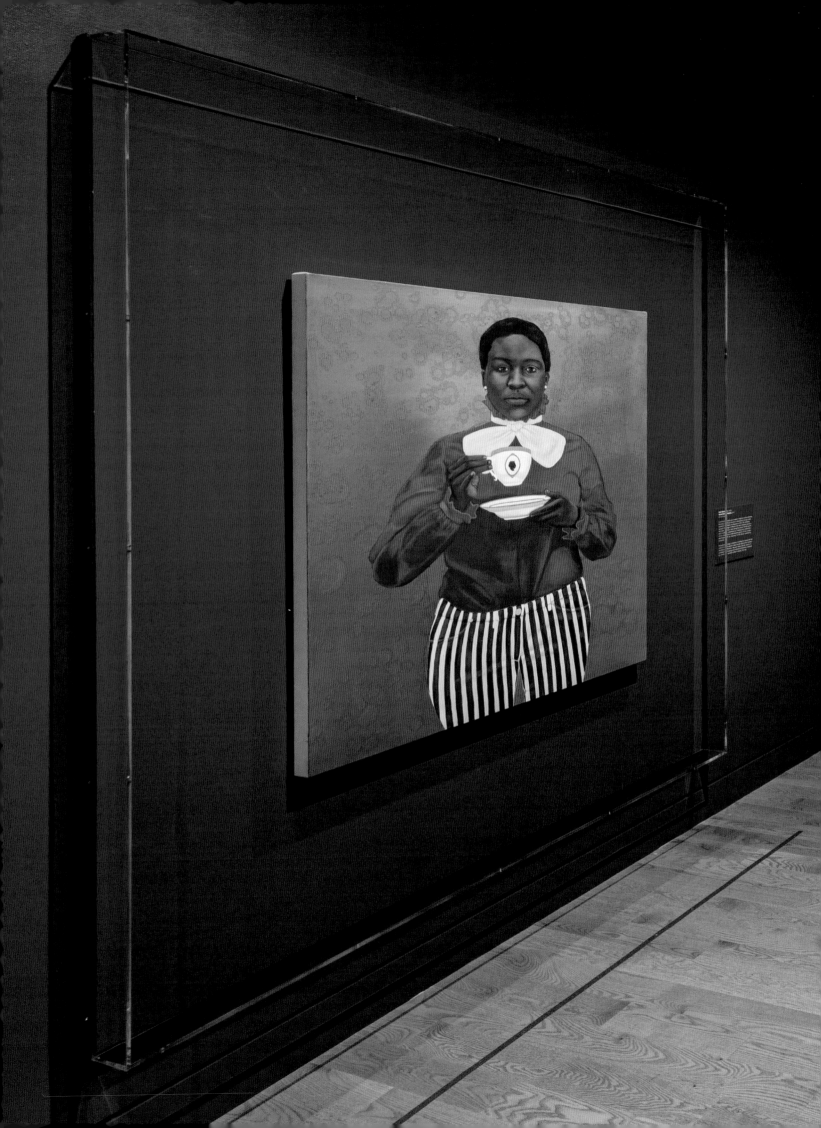

ILLUSTRA

TED INDEX

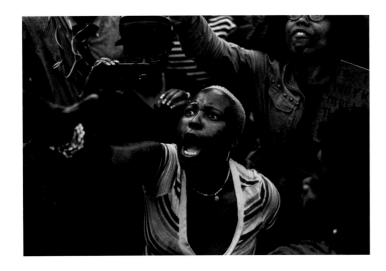

Pages 90–91
Devin Allen (b. 1989)
Untitled, 2015
Digital image
Gift of Devin Allen
© Devin Allen
2016.98.7

Don't forget our women are getting killed also / We are the protectors & Women are the first teacher to the child need i say more / #welovebaltimore / #ripfreddiegray #DVNLLN
—Devin Allen (@bydvnlln), Instagram, May 1, 2015

Devin Allen's images went viral on social media in 2015 when he posted portraits of protests as they happened on the ground. Online communities quickly shared them, and within weeks, *Time* magazine featured one on its cover. In this image, Allen documents a demonstrator reaching for a microphone, demanding to be heard. The image captures the emotional intensity. Like well-crafted Greek tragedies, Allen's protagonists are monumental in their humanity. He made history as a prodigy who conquered social media as a democratizing medium. Rather than allowing publishers to shape and interpret history, Allen proved that the power of history belongs to the community.

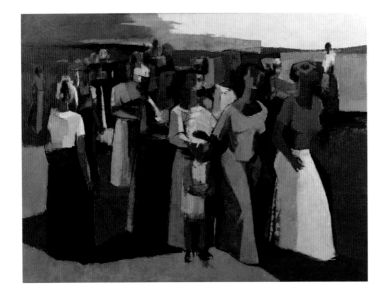

Page 131
Charles Alston (1907–1977)
Walking, 1958
Oil on canvas
48 × 64 in. (121.9 × 162.6 cm)
Gift of Sydney Smith Gordon
© Charles Alston Estate
2007.2

The idea of a march was growing. . . . It was in the air . . . and this painting just came. I called it Walking *on purpose. It wasn't the militancy that you saw later. It was a very definite walk—not going back, no hesitation.*

Charles Alston painted *Walking* two years after the Montgomery Bus Boycott. The Alabama boycott's success influenced the political and social protests of the 1960s, including the 1963 March on Washington.
　　The flattened planes of color and sculptural forms were inspired by Alston's interest in African sculpture and European modernism. This approach adds weight and power to the figures, suggesting the important but often overlooked role that women played as leaders, participants, and critical contributors to the success of the Civil Rights Movement.

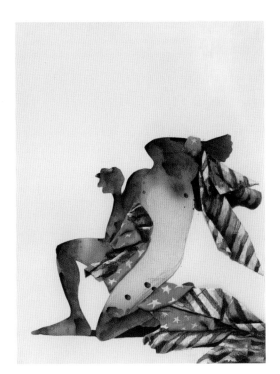

Page 114
Benny Andrews (1930–2006)
Militant, 1996
Oil on paper with adhesive and cloth
29 ¾ × 22 ⁹⁄₁₆ in. (75.5 × 57.3 cm)
Gift of the Benny Andrews Estate and Foundation
by courtesy of UNCF
© 2023 Estate of Benny Andrews / Licensed by VAGA at
Artists Rights Society (ARS), NY, Courtesy of Michael Rosenfeld
Gallery, LLC, New York, NY

Benny Andrews is best known as an artist, educator, and activist. *Militant* is an excellent example of Andrews's interest in placing themes of social justice into his art. His image of a man on bended knee recalls the figure of an enslaved man, bound in chains, created by Josiah Wedgwood during the 1780s for the London committee that organized the Society for the Abolition of the Slave Trade. Titled "Am I Not a Man and a Brother?," the image became a rallying cry for the abolitionist movement.

In Andrews's contemporary version of Wedgwood's image, the figure is swathed in two American flags. By doing so, he evokes themes of African American patriotism while challenging the notion that Black Americans are unworthy of enjoying the full benefits of being United States citizens.

Pages 50–51
Radcliffe Bailey (1968–2023)
Enroute, 2000
Acrylic, resin, and photo on paper
58 × 70 in. (147.3 × 177.8 cm)
Gift of Terry and Jennifer Weiss and family
© Radcliffe Bailey
2014.305ab

I find myself trying to deal with the history and the pains but also wanting to deal with the beauty. . . . I often work with layers, often with seven layers, because I never know when to finish, but a lot of the layers have to deal with some of the complexities with who we are as well.

Enroute is a multilayered exploration of memory, ancestral legacy, migration, and Black agency. It simultaneously references the route of the Middle Passage, where enslaved Africans traveled in bondage to the New World; the route on the Underground Railroad that enslaved people took in their quest for self-emancipation; and the great migration of Black Southerners to major industrial Northern cities to escape racial oppression and to pursue new opportunities and freedoms.

Pages 30–31
Jean-Michel Basquiat (1960–1988)
Untitled (Flag), ca. 1979–80
Watercolor, gouache, and typewriter ink on paper
3 ⅜ × 5 ¼ in. (8.6 × 13.3 cm)
From the Alexis Adler Archive
2019.92

Many artists, from Faith Ringgold to David Hammons, have incorporated the American flag as a symbol or a formal challenge, as patriotism or protest. Jean-Michel Basquiat interpreted this iconic American flag early in his career when he experimented with unconventional materials and ideas. Using composition notebook paper as his canvas, Basquiat typed rows and clusters of the letter X overlaid with red stripes. In the blue square, typically filled with stars representing all fifty states, he inserted a larger white X.

In Basquiat's flag, the letter "X" may refer to the X that many formerly enslaved people used to sign their mark, or the X that Black Muslims employed to reject their so-called slave names. X marks the spot, but it also can refer to the erasure of Black lives, or the Stars and Bars of the Confederate flag. Above all, the artist invokes the freedom of expression found in the paradox of liberty.

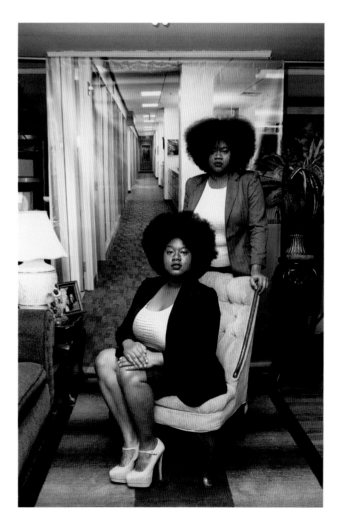

Page 117
Endia Beal (b. 1985)
Sabrina and Katrina, 2015
Archival pigment print
Edition, artist proof
40 × 26 in. (101.6 × 66 cm)
Museum purchase generously supported
by American Express
© Endia Beal
2023.19

Corporate America is intimidating, but my hope to succeed allows it to also be promising. I feel like I will have to fight twice as hard to exceed my competition for respect and wage.
— Sabrina, standing

I join the band of minority women in corporate America as a faceless heroine. I believe corporate has let go of its service toward humanity, and I feel obligated to supply it.
— Katrina, seated

The image of twins Sabrina and Katrina is part of a series titled *Am I What You're Looking For?* that explores race and diversity through the lens of African American women. Beal documents the struggles Black women endure in majority white corporations, as well as the confidence they display in the face of unconscious bias in the workplace.

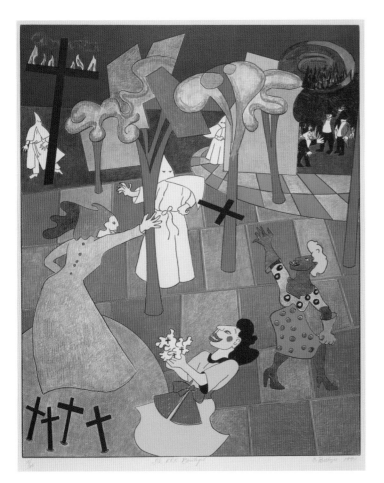

Page 92
Camille Billops (1933–2019)
The KKK Boutique, 1994
Color offset lithograph, Edition 14/100
30 × 21 ½ in. (76.2 × 54.6 cm)
Gift of Juanita and Melvin Hardy
© Camille Billops, Courtesy of the artist
and RYAN LEE Gallery, New York
2015.264.1

Camille Billops was a printmaker, sculptor, illustrator, archivist, educator, and filmmaker. *The KKK Boutique* was created in conjunction with the film *The KKK Boutique Ain't Just Rednecks* (1994), written and directed by her and husband, James V. Hatch. Like the film, Billops's print references the Ku Klux Klan, a white supremacist terrorist group founded in 1865 that employed murder, other violence, and intimidation to suppress voting rights, civil rights, and equality for African Americans and other marginalized groups. The film and the print explore the various ways that racism permeates society, from seemingly benign to the most virulent strains, and how those forms of hatred affect individuals and communities.

Page 88
Sheila Pree Bright (b. 1967)
Untitled, Hell You Talmbout / Janelle Monáe, Atlanta, 2015
From the series *#1960Now*
Digital image
Gift of Sheila Pree Bright
© Sheila Pree Bright
2021.56.1

Sheila Pree Bright is best recognized for crafting compelling images that examine the meaning of Americanism and democracy. Working through diverse photographic forms ranging from digital prints to murals on the sides of buildings, Bright is both an observer and a participant in the communities that populate her images. While celebrating the presence and power of the people caught in the click of her lens, Bright elevates our understanding of democracy by documenting the lived experiences of Americans who raise their voices from the ground. The images shown here are from Bright's project *#1960Now*, a portfolio of photographs that document Black Lives Matter as a movement of diverse ideas, communities, and cultures.

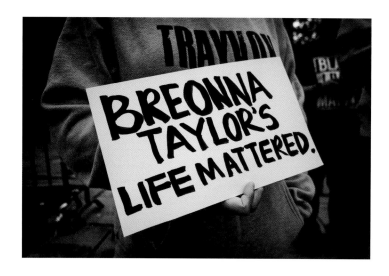

Page 89
Sheila Pree Bright (b. 1967)
The People's Uprising, Justice for Breonna Taylor, Atlanta, 2020
From the series *#1960Now*
Digital image
Gift of Sheila Pree Bright
© Sheila Pree Bright
2021.56.3

Sheila Pree Bright's images often feature women, as in this photograph of a woman wearing a "TRAYVON" sweatshirt while holding a sign that reads "BREONNA TAYLOR'S LIFE MATTERED." Bright celebrates the central role that women historically have played in organizing protests and leading demands for social change. In this photograph, demonstrators protest the decision by a Kentucky grand jury not to indict any former police officers in connection to the shooting death of Breonna Taylor (just one for shots that went into a neighboring apartment). At the rally, as Bright recalls, "I felt the trauma within the women's voices when they spoke; it was very emotional, fierce, and sobering."

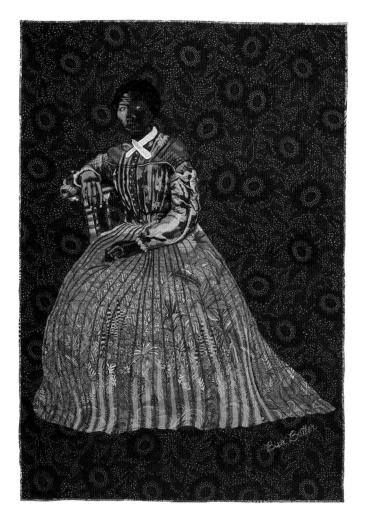

Pages 109–11
Bisa Butler (b. 1973)
I Go To Prepare A Place For You, 2021
Cotton, silk and velvet, quilted and appliquéd
90 ¾ × 64 ½ in. (230.5 × 163.8 cm)
Purchased through the American Women's History Initiative Acquisitions Pool, administered by the Smithsonian American Women's History Initiative
© Bisa Butler
2021.38

We are still in the same fight that Harriet Tubman is in—the fight for Black people to be free and to be treated equally under the law.

Bisa Butler is an American fiber artist known for her quilted portraits inspired by historical photographs. This work is based upon the earliest known photograph of Underground Railroad conductor and abolitionist Harriet Tubman (p. 102). Butler interprets and transforms this iconic portrait—newly discovered and added to the museum's collection in 2017, as shared with the Library of Congress—through her use of printed African-based fabrics, such as Vlisco Dutch wax and Kente cloth, and intricate techniques. By doing so, she reveals Tubman's complexity as a person, including her African ancestry, bravery, and legacy as an agent of change.

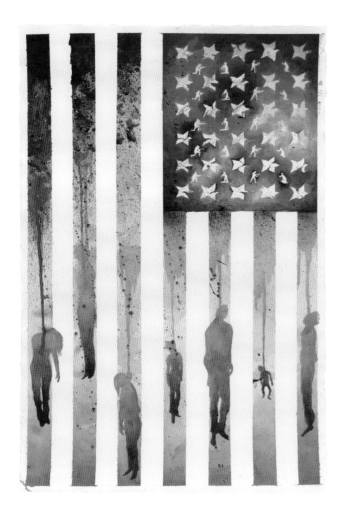

Page 87
Patrick Campbell (b. 1990)
New Age of Slavery, 2014
Watercolor on paper
22 ½ × 15 ¼ in. (57.2 × 38.7 cm)
© Patrick Campbell Art and Illustration
2015.99

Patrick Campbell's painting, with its bold stripes featuring bodies hanging from nooses, and cracked stars with people falling, pleading, or wielding weapons in between, went viral in December 2014. Earlier that month, a New York grand jury ruled "no reasonable cause" to indict the officer whose chokehold on Eric Garner led to Garner's death. This decision came on the heels of a grand jury decision in November not to charge the officer who shot and killed Michael Brown in Ferguson, Missouri. In response, Campbell used art to illustrate his disbelief. When he posted the image on social media, others who shared his disappointment and anger spread the image across the Internet. By the time Freddie Gray protests ignited in Baltimore in April 2015, Campbell's watercolor was a symbol of a movement.

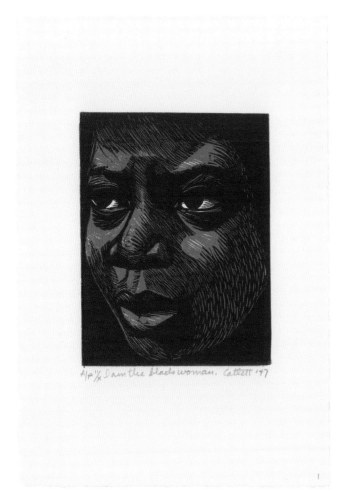

Page 122
Elizabeth Catlett (1915–2012)
I Am the Black Woman, 1947; printed 1989
From the series *The Black Woman* (formerly *The Negro Woman*)
Linoleum print on paper
Sheet: 9 ¹¹⁄₁₆ × 6 ⅝ in. (24.6 × 16.8 cm)
Gift of Winifred Hervey
© 2023 Mora-Catlett Family / Licensed by VAGA
at Artists Rights Society (ARS), NY
2017.21.1

I wanted to show the history and strength of all kinds of Black women. Working women, country women, great women in the history of the United States.

Elizabeth Catlett was a versatile sculptor and printmaker committed to making art that promoted women, family, community, and equality. In 1946, she received a Julius Rosenwald Foundation Grant to travel and study in Mexico City. There, she worked with the Taller de Gráfica Popular (People's Graphic Arts Workshop), a printmaking collective primarily dedicated to the production of sociopolitical art. During her stay, she completed *The Negro Woman* (now retitled *The Black Woman*). This narrative series of prints embodies a first-person perspective of Black women, imparting a sense of intimacy and resilience as the viewer navigates a variety of images relating to resilience, heroism, and the ongoing struggle for racial justice.

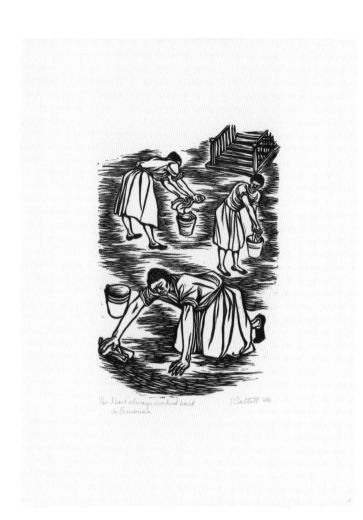

Page 122
Elizabeth Catlett (1915–2012)
I Have Always Worked Hard in America, 1946; printed 1989
From the series *The Black Woman* (formerly *The Negro Woman*)
Linoleum print on paper
Sheet: 15 × 11 ¼ in. (38.1 × 28.6 cm)
Gift of Winifred Hervey
© 2023 Mora-Catlett Family / Licensed by VAGA
at Artists Rights Society (ARS), NY
2017.21.2

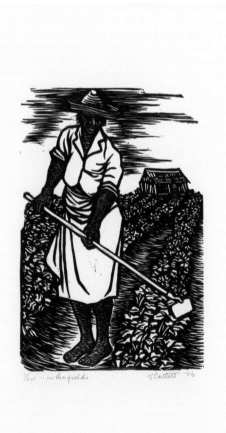

Page 123
Elizabeth Catlett (1915–2012)
. . . in the Fields, 1946; printed 1989
From the series *The Black Woman* (formerly *The Negro Woman*)
Linoleum print on paper
Sheet: 15 ⅛ × 11 ¼ in. (38.4 × 28.6 cm)
Gift of Winifred Hervey
© 2023 Mora-Catlett Family / Licensed by VAGA
at Artists Rights Society (ARS), NY
2017.21.3

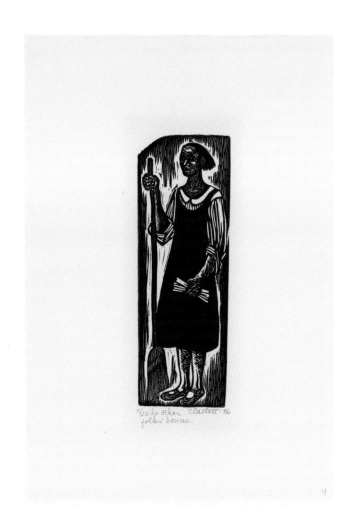

Page 123
Elizabeth Catlett (1915–2012)
In Other Folks' Homes, 1946; printed 1989
From the series *The Black Woman* (formerly *The Negro Woman*)
Linoleum print on paper
Sheet: 11 ¼ × 7 ½ in. (28.6 × 19.1 cm)
Gift of Winifred Hervey
© 2023 Mora-Catlett Family / Licensed by VAGA
at Artists Rights Society (ARS), NY
2017.21.4

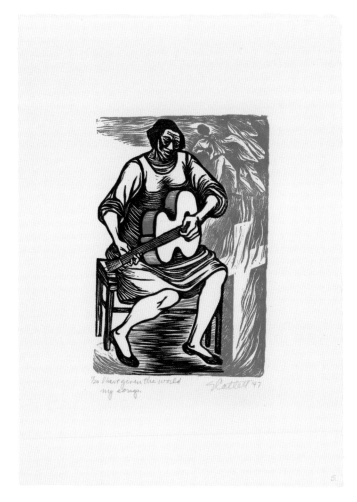

Page 123
Elizabeth Catlett (1915–2012)
I Have Given the World My Songs, 1947; printed 1989
From the series *The Black Woman* (formerly *The Negro Woman*)
Linoleum print on paper
Sheet: 13 ½ × 9 ⁹⁄₁₆ in. (34.3 × 24.3 cm)
Gift of Winifred Hervey
© 2023 Mora-Catlett Family / Licensed by VAGA
at Artists Rights Society (ARS), NY
2017.21.5

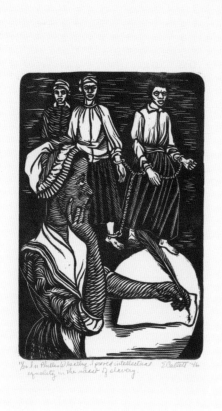

Pages 123 and 124
Elizabeth Catlett (1915–2012)
*In Phillis Wheatley I Proved Intellectual Equality
in the Midst of Slavery*, 1946; printed 1989
From the series *The Black Woman* (formerly *The Negro Woman*)
Linoleum print on paper
Sheet: 15 × 11 ¼ in. (38.1 × 28.6 cm)
Gift of Winifred Hervey
© 2023 Mora-Catlett Family / Licensed by VAGA
at Artists Rights Society (ARS), NY
2017.21.8

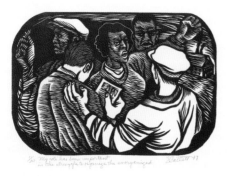

Page 123
Elizabeth Catlett (1915–2012)
*My Role Has Been Important in the Struggle to
Organize the Unorganized*, 1947; printed 1989
From the series *The Black Woman* (formerly *The Negro Woman*)
Linoleum print on paper
Sheet: 11 ¼ × 15 ¹⁄₁₆ in. (28.6 × 38.3 cm)
Gift of Winifred Hervey
© 2023 Mora-Catlett Family / Licensed by VAGA
at Artists Rights Society (ARS), NY
2017.21.9

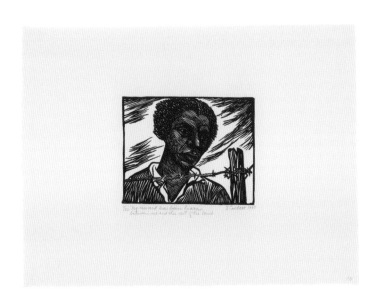

Page 122
Elizabeth Catlett (1915–2012)
My Reward Has Been Bars between Me and the Rest of the Land,
1947; printed 1989
From the series *The Black Woman* (formerly *The Negro Woman*)
Linoleum print on paper
Sheet: 11 ⅛ × 15 in. (28.3 × 38.1 cm)
Gift of Winifred Hervey
© 2023 Mora-Catlett Family / Licensed by VAGA
at Artists Rights Society (ARS), NY
2017.21.10

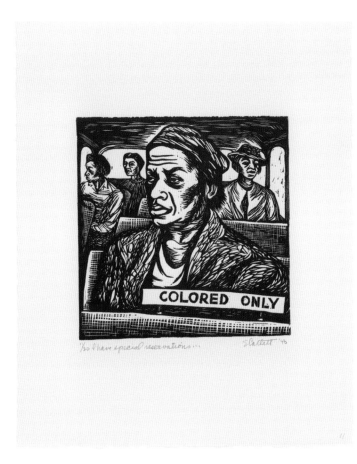

Page 122
Elizabeth Catlett (1915–2012)
I Have Special Reservations, 1946; printed 1989
From the series *The Black Woman* (formerly *The Negro Woman*)
Linoleum print on paper
Sheet: 12 ⁵⁄₁₆ × 10 ⅛ in. (31.3 × 25.7 cm)
Gift of Winifred Hervey
© 2023 Mora-Catlett Family / Licensed by VAGA
at Artists Rights Society (ARS), NY
2017.21.11

Page 123
Elizabeth Catlett (1915–2012)
Special Houses [Special Reservations], 1946; printed 1989
From the series *The Black Woman* (formerly *The Negro Woman*)
Linoleum print on paper
Sheet: 7 ⅝ × 10 ³⁄₁₆ in. (19.4 × 25.9 cm)
Gift of Winifred Hervey
© 2023 Mora-Catlett Family / Licensed by VAGA
at Artists Rights Society (ARS), NY
2017.21.12

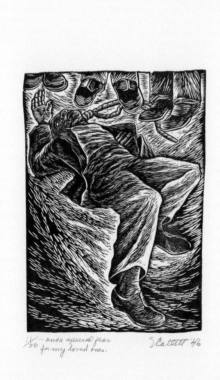

Page 122
Elizabeth Catlett (1915–2012)
And a Special Fear for My Loved Ones, 1946; printed 1989
From the series *The Black Woman* (formerly *The Negro Woman*)
Linoleum print on paper
Sheet: 15 ⅛ × 11 ⁵⁄₁₆ in. (38.4 × 28.7 cm)
Gift of Winifred Hervey
© 2023 Mora-Catlett Family / Licensed by VAGA
at Artists Rights Society (ARS), NY
2017.21.13

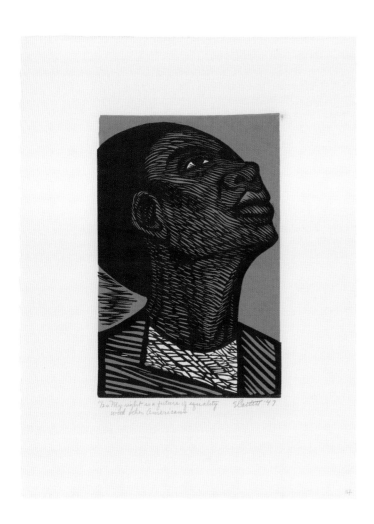

Pages 122 and 125
Elizabeth Catlett (1915–2012)
My Right Is a Future of Equality with Other Americans, 1947;
printed 1989
From the series *The Black Woman* (formerly *The Negro Woman*)
Linoleum print on paper
Sheet: 15 × 11 ¼ in. (38.1 × 28.6 cm)
Gift of Winifred Hervey
© 2023 Mora-Catlett Family / Licensed by VAGA
at Artists Rights Society (ARS), NY
2017.21.14

Page 158
Barbara Chase-Riboud (b. 1939)
Tantra #1, 1994
Polished bronze and silk
79 × 52 × 32 in. (200.7 × 132.1 × 81.3 cm)
Gift of Roger and Caroline Ford
© Barbara Chase-Riboud
2014.62

Esteemed author and artist Barbara Chase-Riboud is celebrated for her unique abstract sculptures that combine traditional as well as nontraditional materials, such as bronze, silk, rayon, cotton, and wool. She states, "I decided to use silk like you would use clay, sculpting it . . . because silk is such a strong material and it's practically indestructible, like bronze is indestructible."

Tantra #1 is part of a tripartite series that invokes the Hindu goddess Shakti, whose various manifestations include creativity, female energy, cosmic consciousness, and power. The term *tantra* has numerous and complex meanings within Hindu and Buddhist traditions. Within the context of Chase-Riboud's work, tantra may allude to doctrines associated with rituals, disciplines, meditation, and sexual practices composed as dialogues between Shakti and her male consort, Shiva.

Page 144
Adger Cowans (b. 1936)
SOWETO, 1983
Etching on paper
33 ⅛ × 23 ⅞ in. (84.1 × 60.6 cm)
© Adger Cowans
2013.146.1

Adger Cowans is a member of AfriCOBRA (African Commune of Bad Relevant Artists), a collective dedicated to creating positive and culturally relevant art for African Americans and other Africans in the diaspora. In 1977, the group created and exhibited a series of artworks in protest of the 1976 massacre of hundreds of high school students in Soweto, South Africa. Police officers attacked the students while they peacefully protested the mandatory replacement of native tongues with Afrikaans and English as the primary instructional languages.

 Cowans created *SOWETO*, an etching made after his original 1977 painting of the same name. He incorporated the phrase "SO WE TO" to represent the unified struggle of human beings, over time and place, against the forces of racism and oppression.

Page 118
Jeff Donaldson (1932–2004)
Wives of Sango, 1971
Paint, foil, and ink on cardboard
36 ¼ × 25 9/16 in. (92 × 65 cm)
Courtesy of Jameela K. Donaldson
© Jeff Donaldson
2017.33.1

Wives of Sango depicts three women who are symbolic representations of deities in the Yoruba religion of Nigeria. They also are the wives of Sango—deity of fire, thunder, and justice. On the left is the orisha Oya, goddess of the Niger River, dynamism, tornadoes, feminine leadership, and justice. Oba, the central figure, is goddess of the Oba River. To the right is Osun, goddess of the Osun-Osogbo River, who represents love, wealth, and fertility. Distinct in their own right, together they share a common bond: the revolutionary battle to gain freedom from mental, social, and political oppression.

 According to Donaldson, these orishas are a visualization of the present, an invitation to action, and a basis for hope in the future.

208

Page 49

Torkwase Dyson (b. 1973)
I Can't Breathe (Water Table), 2018
Acrylic on canvas
96 × 72 in. (243.8 × 182.9 cm)
Courtesy of the Artist and Davidson Gallery
© Torkwase Dyson
2018.77

Torkwase Dyson's work is informed by geometry, architecture, and abstraction. She is known for creating art that explores how people of color have negotiated, and continue to negotiate, spatial order. *I Can't Breathe* refers to the phrase that Eric Garner desperately uttered eleven times while held in a prohibited chokehold by police officer Daniel Pantaleo until Garner fell unconscious and eventually died. Even though the incident was captured on video and officially deemed a homicide, Pantaleo was not indicted.

 Part of Dyson's *Water Table* series, *I Can't Breathe* was exhibited in her 2018 solo exhibition *Dear Henry*. The exhibition was created as a visually symbolic letter/homage to Henry "Box" Brown, an enslaved African American who escaped to freedom by shipping himself to Philadelphia in a crate in 1849.

Page 93

Victor Ekpuk (b. 1964)
Union of Saint and Venus, 2012
Acrylic, plastic rhinestones, and glass on Masonite
72 × 42 in. (182.9 × 106.7 cm)
© Victor Ekpuk
2019.23

Union of Saint and Venus is inspired by a rumored relationship between Pope Clement VII and an enslaved woman named Simonetta da Collevecchio, resulting in the birth of Alessandro de Medici (the Duke of Florence and Penne).

 Ekpuk's painting critiques the Catholic Church's role in perpetuating the slave trade and how it benefited from this cruel institution. Twin papal staffs entering the body of a prostrate black woman signify this disturbing connection between the church and the African continent. The pope's papal miter is decorated with gems, slave sale posters, and excerpts from the *Dum Diversas*, a 1452 decree issued by Pope Nicholas V that sanctioned the practice of conquering, subjugating, and enslaving Muslim Arabs and pagans—in this case, non-Christian Africans.

Page 150
Lola Flash (b. 1959)
Back at You, New York, New York, 2020
From the series *syzygy, the vision*
Archival pigment print
22 ½ × 33 ¾ in. (57.2 × 85.8 cm)
Purchased through the American Women's History Initiative Acquisitions Pool, administered by the Smithsonian American Women's History Initiative
© Lola Flash
2021.57.5

Throughout the self-portrait series *syzygy, the vision*, photographer Lola Flash (they/them) dons a space helmet, an orange prison uniform, and handcuffs. "Heavy on my mind is America's mass incarceration and the question of breaking free," Flash writes of the series, which also reflects their personal experiences with the police. Flash was arrested in 2008 "for walking while Black." Their teaching license was suspended, leaving them unemployed for six months. Although *syzygy, the vision* began as a response to Afrofuturism, it expanded with the COVID-19 pandemic and George Floyd's killing to include themes of mass incarceration and Black Lives Matter. Like much of Flash's work, the images confront issues of racism, sexism, homophobia, transphobia, classism, and ageism.

Page 151
Lola Flash (b. 1959)
Divinity, Brighton, United Kingdom, 2020
From the series *syzygy, the vision*
Archival pigment print
33 ¾ × 22 ⁹⁄₁₆ in. (85.7 × 57.3 cm)
Purchased through the American Women's History Initiative Acquisitions Pool, administered by the Smithsonian American Women's History Initiative
© Lola Flash
2021.57.6

Pages 152–53
Lola Flash (b. 1959)
Milky Way, Villas, New Jersey, 2021
From the series *syzygy, the vision*
Archival pigment print
22 ½ × 30 ¹/₁₆ in. (57.2 × 76.3 cm)
Purchased through the American Women's History Initiative Acquisitions Pool, administered by the Smithsonian American Women's History Initiative
© Lola Flash
2021.57.7

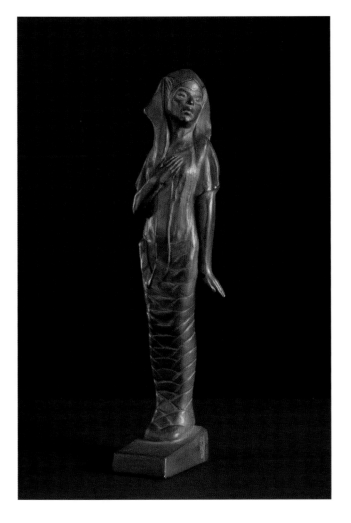

Page 121
Meta Vaux Warrick Fuller (1877–1968)
Ethiopia, 1921
Painted plaster
13 × 3 ½ × 3 ⅞ in. (33 × 8.9 × 9.8 cm)
Gift of the Fuller Family
© Meta Vaux Warrick Fuller
2013.242.1

Meta Vaux Warrick Fuller's *Ethiopia* is widely considered the first Pan-Africanist artwork created in the United States. It provides a visual embodiment of the New Negro Movement—an era during the 1920s characterized by an increased recognition of artistic and cultural production by Black people, and a consciousness of racial heritage and pride.

W. E. B. Du Bois and James Weldon Johnson commissioned Fuller to create *Ethiopia* for the "Americans of Negro Lineage" section in the America's Making Exposition. An image of the sculpture appears on the Americans of Negro Lineage page in the exhibit's publication, describing it as "A Symbolic Statue of the EMANCIPATION of the NEGRO RACE." Fuller's work links the cultural achievements of ancient Egypt, as well as the Ethiopian resistance to colonial rule, to a narrative of African American struggle and achievement, using the past to guide and critique the present.

Page 86
Jermaine Gibbs (b. 1975)
Untitled, April 25, 2015
Protesters linking arms, Baltimore
Digital image
Gift of Jermaine Gibbs
© Jermaine Gibbs
2016.61.16

Jermaine Gibbs photographed this image on April 25, 2015, two days before Freddie Gray's funeral. The photograph captures demonstrators engaged in peaceful protest at the corner of Pennsylvania and North Avenues in Baltimore, ground zero for uprisings after the death of Freddie Gray while in police custody. While the photo suggests that protesters turned their backs to police officers as an act of defiance, that was not the case. They stood in courage and solidarity, linking arms to create a buffer of peace between police officers and a community of protesters standing outside the camera's view. As the photographer points out, an individual's perspective determines how art, life, and humanity are interpreted. "When we change the way we see," says Gibbs, "everything we see will change."

Page 53
David Hammons (b. 1943)
The Man Nobody Killed, 1986
Stenciled paint and collage printed on commercially printed cardboard, edition of 200
11 × 8 ½ in. (27.9 × 21.6 cm)
© David Hammons
2021.19

The Man Nobody Killed pays homage to the life and protests around the death of Michael Stewart, an artist and model who was arrested by the New York City Transit Police for writing graffiti on a subway station wall. Stewart was brutally beaten outside the subway station and again outside the police station. Witnesses saw officers beat him with billy clubs, kick him, and choke him with a nightstick. His injuries were so severe that he was transported to Bellevue Hospital, where he arrived hog-tied and without a pulse. Hospital staff revived him, but he remained in a coma and died of his injuries thirteen days later. His death became the subject of protests and work by fellow artists, including Jean-Michel Basquiat and Keith Haring. No officers were charged in his death.

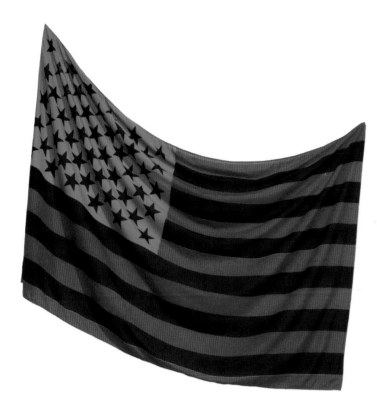

Page 165
David Hammons (b. 1943)
African-American Flag, 1990
Dyed cotton
56 ½ × 85 in. (143.5 × 215.9 cm)
Partial gift of Jan Christiaan Braun, who curated the ground-breaking exhibition *Black USA*, in Amsterdam in 1990, for which the *African-American Flag* was created. Museum purchase supported by The Ford Foundation and the Andrew W. Mellon Foundation
© David Hammons
2022.7

> *Marcus Garvey designed the African American flag, which looked like the Italian flag, except that it is red, black, and green. But it is so abstract, so pure, that the masses were frightened by it. I made my flag because I felt that they needed one like the U.S. flag but with black stars instead of white ones.*

African-American Flag was one in a series of five flags created for the art exhibition *Black USA* that opened in 1990 at the Museum Overholland, located on the Museumplein (Museum Square) in Amsterdam. Curated by Jan Christiaan Braun, *Black USA* was the first exhibition to specifically feature the work of Black artists in the Netherlands. In addition to Hammons, other featured artists included Benny Andrews, Romare Bearden, Martin Puryear, and Bill Traylor.

Following a meeting with Braun to discuss his vision for the exhibition, Hammons decided to create a full-size flag that would be flown on a flagpole located on the grounds of the square, across from the U.S. Consulate. The colors and symbols of his now-iconic artwork symbolically merge the red, black, and green colors of Marcus Garvey's Pan-African flag and the Stars and Stripes of the American flag. His commingling of colors and symbols of both flags simultaneously references Black pride and heritage and the ways African Americans have celebrated freedom while confronting America's unfulfilled promises.

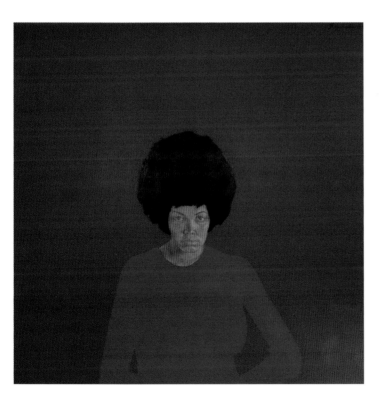

Pages 96–97
Barkley L. Hendricks (1945–2017)
Miss Brown to You, 1970
Oil and acrylic on linen canvas
48 × 48 in. (121.9 × 121.9 cm)
Gift of the National Endowment for the Arts
© Barkley L. Hendricks. Courtesy of the Estate of Barkley L. Hendricks and Jack Shainman Gallery, New York
2023.3

Barkley L. Hendricks revolutionized portraiture through his stylized realist and postmodern images of African Americans. He began painting life-size portraits as his primary medium to address the lack of Black representation in the American art canon. Hendricks chose his models from his family, friends, people he met on the street, and himself. This portrait of Suzanne Brown exemplifies his personal relationship with the sitters he painted. The title references his relationship to Brown, as well as the song "Miss Brown to You," first recorded by Billie Holiday in 1935. Although many interpret his works as political statements, he maintained that they are not motivated by politics, stating, "My paintings were about people that were a part of my life. . . . If they were political, it's because they were a reflection of the culture we were drowning in."

Pages 36–37
Alvin Carl Hollingsworth (1928–2000)
Trapped, 1965
Oil, acrylic, and mixed media on Masonite
24 × 47 ¹³⁄₁₆ in. (61 × 121.5 cm)
Gift in honor of Dr. and Mrs. Henry A. Collins
© Alvin Carl Hollingsworth 1965
2011.157

Alvin Hollingsworth's *Trapped* addresses the detrimental effect of redlining on urban African American communities. The U.S. government developed the process of redlining in the 1930s, when the New Deal's Home Owners' Loan Corporation created color-coded maps of American cities. Colors were used to assess lending and insurance risks based on the racial makeup of a geographic area. Affluent white neighborhoods were marked with green, while poor African American neighborhoods were outlined in red.

The red wooden slats attached to the painting's surface form a metaphorical fence, referencing the lack of opportunity this system created. When businesses refused to invest in urban areas, it led to unemployment, devaluation of property, and the inability of residents to relocate. *Trapped* is part of Hollingsworth's 1960s *Cry City* series.

Page 112
Wadsworth A. Jarrell Sr. (b. 1929)
Revolutionary, 1972
Screenprint on paper
37 ½ × 31 in. (95.3 × 78.7 cm)
© Wadsworth Jarrell
2010.3.1

> *I have given my life to the struggle. My life belongs to the struggle. If I have to lose my life in the struggle, well, then, that's the way it will have to be.*
> — Angela Davis

Revolutionary is a tribute to political and social activist Angela Davis. The portrait is formed through a complex and dynamic arrangement of color and words. The words were taken from speeches given by Davis for the Soledad Brothers Defense Committee and an interview published in the September 11, 1970, issue of *Life* magazine. The image was inspired by Dan O'Neil's photograph, also featured in the magazine.

The letter "B," repeated throughout the composition, simultaneously represents the word "Bad" and the phrase "Black is beautiful."

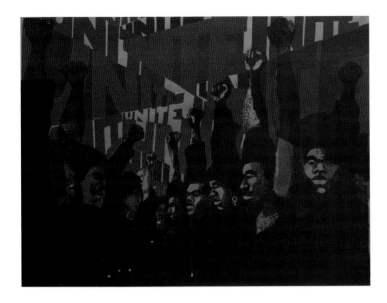

Pages 78–79
Barbara Jones-Hogu (1938–2017)
Unite, 1971
Screenprint
22 ½ × 30 in. (57.2 × 76.2 cm)
© Estate of Barbara Jones-Hogu,
Courtesy of Lusenhop Fine Art
2008.13

To build a nation, you need everybody to work together. You know? Everybody must come together and work together.

Chicago-based artist Barbara Jones-Hogu was a founding member of the African Commune of Bad Relevant Artists (AfriCOBRA), a group seeking to create positive and culturally relevant art for the urban Black community. Jones-Hogu's use of lettering in print designs, illustrated by her dynamic repetition of the word "unite," was an important component of AfriCOBRA's early visual aesthetic. The closed raised fist, used here to represent cohesion of purpose within the Black Arts and Black Power movements during the late 1960s and the 1970s, has been adopted by various movements and organizations to represent solidarity and resistance.

Page 119
Carolyn Mims Lawrence (b. 1940)
Uphold Your Men, ca. 1971
Color screenprint
30 × 24 in. (76.2 × 61 cm)
2014.130.4

Carolyn Mims Lawrence was an early member of the African Commune of Bad Relevant Artists (AfriCOBRA), an American artist collective founded in 1968. AfriCOBRA's primary mission was "the liberation of Black people through the arts." The group espoused several visual and philosophical principles, including the promotion of positive aspects of African and African American history and culture. *Uphold Your Men* is an excellent example of AfriCOBRA's interest in reflecting Black beauty and heritage through imagery. For example, the woman in Lawrence's print wears her hair in the afro style, and her necklace is adorned with an ankh, an ancient Egyptian symbol that means life. Her incorporation of bold, graphic text also emphasizes the importance of unity within African American communities, in this instance, the essential role Black men occupy within the family unit.

Jacob Lawrence (1917–2000)
L'Ouverture, 1986
From the series *The Life of Toussaint L'Ouverture*
Color screenprint
32 ¹⁄₁₆ × 21 ¹⁵⁄₁₆ in. (81.5 × 55.8 cm)
© 2023 The Jacob and Gwendolyn Knight Lawrence
Foundation, Seattle / Artists Rights Society (ARS), New York
2008.12.1

If at times my productions do not express the conventionally beautiful, there is always an effort to express the universal beauty of man's continuous struggle to lift his social position and to add dimension to his spiritual being.

Jacob Lawrence was a teenager when he was first introduced to African American history. His thirst for knowledge of Black history prompted him to create a series of works documenting the lives and contributions of notable figures such as the Haitian revolutionary Toussaint L'ouverture (ca. 1743–1803), who led the Haitian independence movement (1791–1804) during the French Revolution.

In 1938, Lawrence created a series of forty-one narrative panels documenting the life and accomplishments of L'ouverture. Later, he culled fifteen images from his original series to create a series of prints, dating from 1986 to 1997.

Jacob Lawrence (1917–2000)
Contemplation, 1993*
From the series *The Life of Toussaint L'Ouverture*
Color screenprint
32 ¹⁄₁₆ × 22 ⅛ in. (81.5 × 56.2 cm)
© 2023 The Jacob and Gwendolyn Knight Lawrence
Foundation, Seattle / Artists Rights Society (ARS), New York
2008.12.4

** This work was featured in the exhibition but is not included in the plates.*

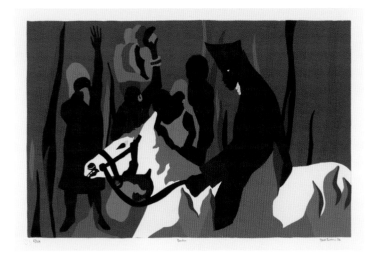

Page 77
Jacob Lawrence (1917–2000)
Dondon, 1992
From the series *The Life of Toussaint L'Ouverture*
Color screenprint
22 × 32 1/16 in. (55.9 × 81.5 cm)
© 2023 The Jacob and Gwendolyn Knight Lawrence
Foundation, Seattle / Artists Rights Society (ARS), New York
2008.12.5

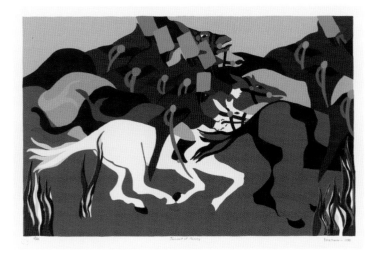

Page 76
Jacob Lawrence (1917–2000)
Toussaint at Ennery, 1989
From the series *The Life of Toussaint L'Ouverture*
Color screenprint
22 × 32 1/16 in. (55.9 × 81.5 cm)
© 2023 The Jacob and Gwendolyn Knight Lawrence
Foundation, Seattle / Artists Rights Society (ARS), New York
2008.12.7

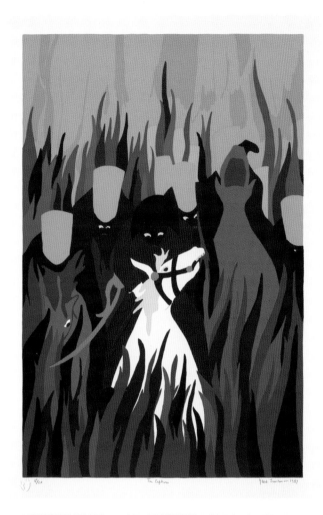

Page 75
Jacob Lawrence (1917–2000)
The Capture, 1987
From the series *The Life of Toussaint L'Ouverture*
Color screenprint
32 1/16 × 22 in. (81.5 × 55.9 cm)
© 2023 The Jacob and Gwendolyn Knight Lawrence
Foundation, Seattle / Artists Rights Society (ARS), New York
2008.12.11

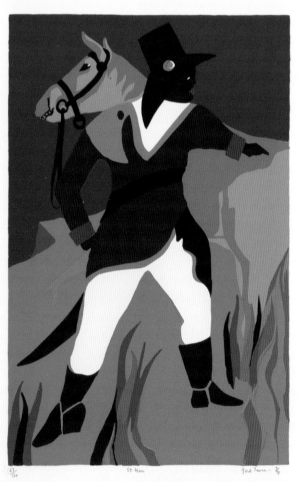

Page 75
Jacob Lawrence (1917–2000)
St. Marc, 1994
From the series *The Life of Toussaint L'Ouverture*
Color screenprint
32 1/8 × 22 1/8 in. (81.6 × 56.2 cm)
© 2023 The Jacob and Gwendolyn Knight Lawrence
Foundation, Seattle / Artists Rights Society (ARS), New York
2008.12.12

Page 73
Deana Lawson (b. 1979)
An Ode to Yemaya, 2019
Pigment print
75 ⅞ × 60 ½ in. (192.7 × 153.7 cm)
© Deana Lawson
2022.16

Deanna Lawson is a photographer whose work explores themes of intimacy, family bonds, sexuality, Black aesthetics, and Afro-Caribbean spirituality. *An Ode to Yemaya* exemplifies her interest in exploring Afro-Caribbean spirituality and religion, specifically the Brazilian-based religion Condomblé.

Lawson created this photograph while visiting Salvador, Brazil. It references Yemaya of the Condomblé religion, a powerful deity who presides over womanhood, fertility, family, and protection of children. In *An Ode to Yemaya*, Lawson captures an image of her daughter, in garb reminiscent of a religious carnival costume, and a woman she met in Salvador. Although they are unrelated, the configuration of the young girl and older woman evokes a familial and protective relationship between child and elder.

Page 149
Zun Lee (b. 1969)
Untitled, 2012
Billy Garcia and daughter Esmeralda sharing a tender moment at a gas station, Bronx, New York
From the series *Father Figure*
Digital image
Gift of Zun Lee
© Zun Lee
2016.52.13

Zun Lee's portfolio *Father Figure* (2011–18) centers on Black fathers with their children in cities across the country. As the artist states, "Rather than accumulate a series of portraits, my aim was to build trusted relationships and immerse myself in these fathers' lives to get a sense of how they negotiate their daily spheres not just as fathers but also as Black men." As a form of self-reflection and participatory observation, Lee challenges cultural assumptions about Black males as men, friends, and fathers. He says he "investigates Black everyday life and family spaces as sites of intimacy, belonging, and insurgent possibility against cultural displacement and erasure."

Page 81
Zun Lee (b. 1969)
Untitled, October 11, 2014
A nightly demonstration led by the Brown family winds
its way down Ferguson Avenue, Ferguson, Missouri
From the series *Black Love Matters*
Digital image
Gift of Zun Lee
© Zun Lee
2016.52.20

Zun Lee is an award-winning visual artist who documented a series
of community portraits in Ferguson, Missouri, during October 2014.
This was a pivotal moment in the history of the Black Lives Matter
movement, as a police officer's killing of Michael Brown led to
worldwide protests. In this photograph, Brown's family leads a
march down a major street in the city, where they later joined other
protesters in front of the Ferguson Police Department. Lezley
McSpadden, Michael Brown's mother, is in the center, marching
hand in hand with her husband, Louis Head. They both wear T-shirts
that read "INNOCENT BLOOD." This photograph is a statement
that not only do Black Lives Matter, but Black Love Matters as well.

Page 148
Shaun Leonardo (b. 1979)
Rodney King, Before BLM, 2017
Charcoal on paper with mirrored tint on frame
30 × 45 in. (76.2 × 114.3 cm)
Purchased with funds provided by the Smithsonian Latino
Initiatives Pool, administered by the Smithsonian Latino Center
© Shaun Leonardo
2021.44

*It's in the tactility of charcoal, the slow rendering of the image,
and viewer's reflected image within the mirrored tint, that a
person is absorbed by the drawing and invited to sit with the
image differently.*

Shaun Leonardo's *Rodney King, Before BLM*, 2017 challenges how
media selections shape cultural memory and consciousness. The
rate by which we are bombarded and distracted by media images
reduces life events and history to flashes of select photographs
and headlines. Leonardo explores the extent to which we are
complicit. As the artist explains, "By forcing one to question how
they previously perceived these images of state-sanctioned violence,
and thus implicate the way we see and receive these images, an
opening is created that turns our looking into bearing witness."

Page 113
Spencer Lewis (b. 1979)
Untitled, 2021
Oil, acrylic, ink, and enamel on jute
96 ¾ × 68 ¼ in. (245.7 × 173.4 cm)
© Spencer Lewis
2022.15

Spencer Lewis is an artist best known for his abstract and colorful paintings executed on cardboard or jute (a plant fiber used to make burlap). His work explores the process of gestural painting expressed through heavily worked pigmented strokes and tactile canvases. Although his work is largely abstract, Lewis imbues the brown foundations of his canvases with a multiplicity of meanings. "I loved both the cardboard, and now jute, for being brown," he says. "Both surfaces Brown like me. I think of the brown paper bag test, and just one drop of blood, and 3/5ths of a person. . . . I don't need to define brown, but a friend mentioned that the works made him think of 'passing.' . . . It was such a brilliant insight, and for now I'll leave it at that."

Pages 40–41
Roberto Lugo (b. 1981)
Ghetto Krater, 2018
Terracotta, china paint
36 ⅝ × 17 ⅛ in. (93 × 43.5 cm)
Purchased with funds provided by the Smithsonian Latino Initiatives Pool, administered by the Smithsonian Latino Center
© Roberto Lugo
2019.53

A krater is a ceramic vessel common in ancient Greece whose purpose was to dilute wine. Kraters were often painted black and orange and featured images from Greek mythology or history. *Ghetto Krater* is a continuation of this Greek tradition of storytelling. Lugo's contemporary version of the vessel draws attention to the various manifestations of violence, including police brutality, that disproportionately affect people of color in economically disadvantaged urban communities. His interest in exploring these subjects stems in part from his personal experience growing up in the Philadelphia neighborhood of Kensington. A self-described "ghetto-potter," Lugo says his decision to become a ceramist gave him direction and purpose, essentially saving his life.

Page 39
Patrick Martinez (b. 1980)
Flower Memorial Pee Chee, 2017
Acrylic, ink, and stickers on panel (wood)
60 1/16 × 47 5/8 in. (152.6 × 121 cm)
Anonymous Gift
© Patrick Martinez
2019.100

Flower Memorial Pee Chee illustrates the tragic effects of police brutality for three individuals—Jordan Edwards, Joaquina Valencia, and Justine Damond.

Edwards was fifteen when he was killed by a police officer in Balch Springs, Texas, while sitting unarmed in a car with four friends. The officer was sentenced to fifteen years in prison. Valencia was wrestled to the ground in Riverside County, California, and arrested for selling flowers without a vendor's license. She sued the county Sheriff's Department, claiming she was unlawfully targeted because of her race. Damond, an Australian American, was shot and killed by a police officer after she called 911 to report the possible assault of a woman in an alley behind her house. The officer was found guilty of third-degree murder and second-degree manslaughter.

Page 116
Michael A. McCoy (b. 1982)
Untitled, 2017
Digital image
Gift of Michael A. McCoy
© Michael A. McCoy
2021.41

Michael McCoy creates subtle yet powerful narratives through his images. As a photojournalist, he has documented some of the most important moments in contemporary history and everyday culture. From his coverage of Congress and presidential campaigns to moments of national celebration and mourning, McCoy's portraits have become recognizable in the pages of major news publications, which earned him a place in *Time* magazine's "Top 100 Photos of 2020." In this photograph, McCoy crafted a quiet image of a young couple wearing T-shirts featuring the *Time* magazine cover that introduced Devin Allen as a photographer. While the shirts and couple embody resistance, they also represent a quiet resilience found in everyday lives.

Pages 84–85
Tommy Oliver (b. 1984)
Untitled, June 3, 2020
Cedric the Entertainer, LA protests,
Hollywood Boulevard, Los Angeles
Digital image
Gift of Tommy and Codie Oliver
© Tommy Oliver
2021.31.23

Photographer Tommy Oliver is an award-winning producer and cinematographer in television and film. Best known for his 2020 documentary *40 Years a Prisoner* on HBO, his docuseries *Black Love* (2017–22) on OWN, and his feature film *The Perfect Guy* (2015), Oliver challenges audiences to question their assumptions about race, gender, and family. The film *Kinyarwanda* (2011), which Oliver co-produced, weaves together narratives of resilience during the 1994 genocide in Rwanda. It won the Sundance Film Festival's award for World Cinema Drama and was recognized as one of the top ten films of 2011, including by critic Roger Ebert and BET.

George Floyd's death was followed by more than a week of protests in June 2020, in Los Angeles. As demonstrated by the images presented here, Tommy Oliver captured the epic power of individuals and the expansive power of communities.

Pages 82–83
Tommy Oliver (b. 1984)
Untitled, June 6, 2020
Michael B. Jordan, LA protests,
Hollywood Boulevard, Los Angeles
Digital image
Gift of Tommy and Codie Oliver
© Tommy Oliver
2021.31.56

Page 80
Tommy Oliver (b. 1984)
Untitled, June 7, 2020
Janaya Khan, LA protests,
Hollywood Boulevard, Los Angeles
Digital image
Gift of Tommy and Codie Oliver
© Tommy Oliver
2021.31.65

This photograph is part of a broader portfolio of images taken during one of the largest Black Lives Matter rallies, in Los Angeles on June 7, 2020. According to some estimates, one hundred thousand demonstrators attended the rally, with crowds stretching for more than a mile down Hollywood Boulevard. Tommy Oliver, who was on the front lines of protests on a truck that led the march that day, used his cinematographer's eye to document that moment in history. As Oliver says, media has "the power to inspire, the power to incite, the power to challenge."

Page 154
Fahamu Pecou (b. 1975)
But I'm Still Fly, 2014
Acrylic on canvas
120 × 60 in. (304.8 × 152.4 cm)
© Fahamu Pecou
2015.69

Grave representations of Black men act like a force of gravity, restricting their mobility. We meet Black youth with fear and loathing, limiting their potential with tragic stats and stories of death. But I'm Still Fly *offers an alternative narrative, one that locates the tension between aspiration and limitation. . . . This piece asks: What if we believed in the abilities of our Black boys more than we lamented their identity? What if we taught them that they could transcend their so-called limitations? What if we encouraged them to fly?*

Pecou's painting features the fashion trend "saggin," where underwear is worn above sagging pants. The style was popular among younger African American males and often perceived by others as a negative marker of social status.

Pages 46–47
Howardena Pindell (b. 1943)
Separate But Equal: Apartheid, 1987
Mixed media: acrylic, vinyl tape, faux rhinestones,
caulking, wood, nails, zircon, silicone sealant on canvas
30 × 28 × 7 in. (76.2 × 71.1 × 17.8 cm)
© 1987 Howardena Pindell. Courtesy of the artist
and Garth Greenan Gallery, New York
2012.80

Howardena Pindell created *Separate But Equal* in protest of
apartheid—South Africa's rigid, racially segregated caste system
created by the country's white citizens. It established and maintained
wealth and privilege while depriving the Black majority of their
civil, economic, and political rights. The system's implications are
revealed through the use of color, words, and found objects. In
the white section, Pindell incorporates words such as "Barbaric,"
"Parasitic," and "Profit." In the middle section, terms include
"Endless Labor," "Pass Book," and "0 Votes." The lower section,
ripped from and tenuously reconnected to the rest of the canvas,
contains the words "Malnutrition," "Death," and "Torture." Each
section, combined with the rhinestones, nails, and painted gold
frame, deftly reveals the tension, danger, and violence prevalent
during this dark era.

Page 159
Jefferson Pinder (b. 1970)
Mothership (Capsule), 2009
Wood, salvaged tin, and chrome rim
92 ½ × 75 × 86 in. (235 × 190.5 × 218.4 cm)
Gift of Henry Thaggert III in memory of Burnell P. Thaggert
© Jefferson Pinder
2013.234

*We grew up when NASA was in its golden age. Remember, the
first interracial kiss on television was in outer space on
Star Trek. Science fiction fantasy . . . is, in part, a spiritual place
that African Americans have always inhabited.*

Jefferson Pinder constructed this sculpture with wood salvaged from
President Barack Obama's 2009 inaugural platform and ceiling tin
from a gutted Baltimore house. Referencing the past, present, and
future, *Mothership* symbolizes the transportation and transformation
of Black people toward new and uncharted territory, concepts
underscored by the work's shape—NASA's Mercury spacecraft—and
its name, derived from singer-songwriter George Clinton's stage
prop, the Mothership.

Page 94
Mavis Pusey (1928–2019)
Recarte, ca. 1968
Oil on canvas
63 × 45 ¼ in. (160 × 115 cm)
Conservation funded by grant from the
Bank of America Art Conservation Project
© Mavis Pusey Estate
2012.13.2

> *My work consists of geometrical forms in a variety of geometrical configurations. These forms are based on buildings around the Manhattan area. I am inspired by the energy and the beat of the construction and demolition of these buildings— the tempo and movement mold into a synthesis, and for me, become another aesthetic of abstraction.*

During her career, Mavis Pusey experimented with and combined a variety of aesthetic styles, including Cubism, Constructivism, Futurism, and geometric abstraction, which resulted in her unique form of artistic expression. A truly international artist, Pusey was born in Jamaica and lived in Paris, London, and New York. She submitted *Recarte* to the prestigious Pollock-Krasner Foundation in 1968 and was awarded a financial grant.

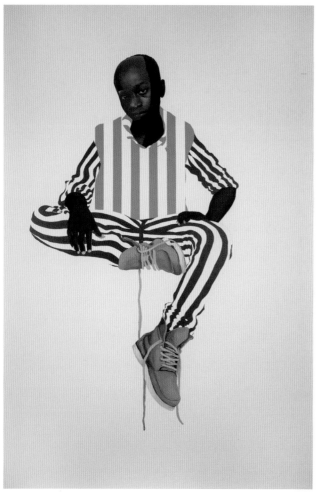

Page 143
Deborah Roberts (b. 1962)
80 days, 2018
From the series *Nessun Dorma*
Paper, acrylic, graphite, and pastel on canvas
72 ¼ × 48 ⅛ in. (183.5 × 122.2 cm)
Collection of the Smithsonian National Museum of African American History and Culture and National Portrait Gallery, Museum purchase through the American Women's History Initiative Acquisition Pool, administered by the Smithsonian American Women's History Initiative and generously supported by American Express
© Deborah Roberts
2022.35

Deborah Roberts is renowned for her collages that incorporate multiple layers and meanings to create a more expansive and inclusive view of the Black cultural experience. She challenges the criminal lens through which society often views young Black boys, whose "well-being and futures are equally threatened because of the double standard of boyhood and criminality that is projected on them at such a young age."

Roberts created *80 days* in honor of George Stinney Jr., a fourteen-year-old boy who became the youngest person executed in a U.S. prison. In the space of about eighty days (between March and June 1944), Stinney was unjustly arrested, charged, tried, and executed for the murder of two young white girls, without proper representation or appeals on his behalf. Seventy years following his execution, a judge vacated his conviction, ruling that Stinney had not received a fair trial, because he was not effectively defended and his Sixth Amendment rights had been violated.

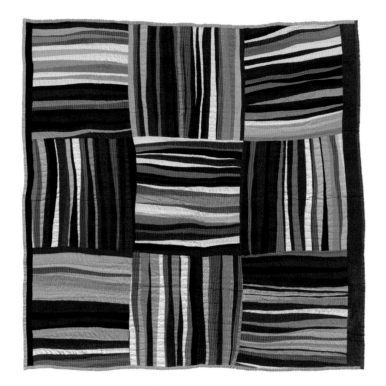

Page 95
Avis Collins Robinson (1954–2023)
Mensie Lee Pettway (b. 1939)
Andrea Pettway Williams (b. 1973)
Sharecropper's Masterpiece, 2008
Quilted corduroy, velvet, batting, and cotton
87 ⅜ × 86 × ⅝ in. (221.9 × 218.4 × 1.6 cm)
Gift of Avis, Eugene, Aaron and Lowell Robinson,
in memory of Edward and Annie R. Collins
© Avis Collins Robinson
2015.277

Robinson began working with quilters from Gee's Bend, Alabama, formerly known as the Freedom Quilting Bee, in the 1980s. In 2006, she partnered with master quilters Mensie Lee Pettway and Andrea Pettway Williams to create *Sharecropper's Masterpiece*. Robinson designed and produced the top layer of the quilt; then Pettway and Williams sewed together the top, batting, and back layer. The title evokes the complexity of forces that are brought to bear when the artistic impulse converges with the severity of financial need to create strikingly beautiful but economically useful items for the everyday.

Robinson devoted herself to creating artworks that address the ongoing tensions around race, gender, and oppression in the United States. She draws on her ancestral heritage to create "poetry made out of fabric," hand-dyeing and hand-sewing the textiles, often using all-natural fibers.

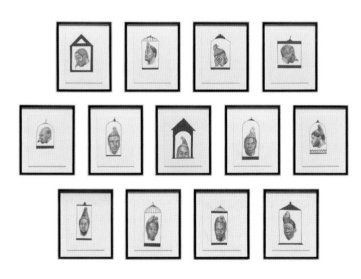

Pages 32–35
Rashaun Rucker (b. 1978)
Psychological Redlining, 2020
Graphite and paint on paper
Each: 23 ¾ × 18 in. (60.3 × 45.7 cm)
Partial gift of Arthur Primas and Jumaane E. N'Namdi
and museum purchase
© Rashaun Rucker
2023.107.1–.13

Rashaun Rucker is best known for his work dealing with Black male identity and social conditioning. In his *Psychological Redlining* series, he merges portraits of African American men with images of rock pigeons. Rock pigeons are generally viewed as urban, unclean nuisances. Rucker asserts that people perceive Black men much the same way—essentially pigeonholing them psychologically into a space where they don't belong. The red cage framing each portrait relates to redlining, a systemic real estate policy demarcating communities of color by red lines on a map to limit access to home loans, insurance, and even grocery stores. Rucker says he created these images to "communicate why we as Black men often don't fly, even though we have the ability to go far and beyond our circumstance."

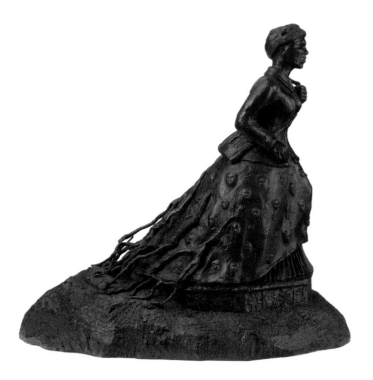

Pages 132–33
Alison Saar (b. 1956)
Swing Low: Harriet Tubman Memorial, 2007
Cast bronze
22 ½ × 12 × 24 in. (57.2 × 30.5 × 61 cm)
Gift of Mimi and Werner Wolfen
© Alison Saar
2011.63

This maquette of *Swing Low: Harriet Tubman Memorial* is the model of a sculpture erected in the historically Black community of Harlem, in Manhattan, amid plantings native to New York and Maryland, Tubman's home state. The work depicts Tubman marching toward the American South like a locomotive, her petticoats pushing aside all resistance. The roots trailing her dress symbolize enslaved people uprooting themselves on their journey toward freedom, and Tubman's role in uprooting the slave system itself.

On her portrayal of Tubman, Saar says, "I wanted not merely to speak of her courage or illustrate her commitment but to honor her compassion. And in this monument, I hope that the spirit of Harriet Tubman will inspire compassion in all of us here and for generations to come."

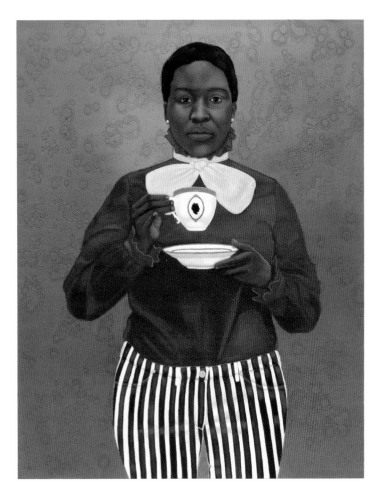

Page 161
Amy Sherald (b. 1973)
Grand Dame Queenie, 2012
Oil on canvas
54 ⅛ × 43 in. (137.5 × 109.2 cm)
© Amy Sherald
2013.20

Amy Sherald is best known for her portraits of African Americans, notable for her use of grayscale to paint skin tones as a way of challenging the concept of color as race, including in her noted portrait of former First Lady Michelle Obama.

Grand Dame Queenie was created in response to the exhibition *Revealing the African Presence in Renaissance Europe*, which opened at the Walters Art Museum in 2012. The exhibition surveyed the images of Africans who were enslaved, served as merchants, and were rulers during the period. Sherald asserts that in order to comprehend our contemporary construction of race, one needs to understand the genesis of the concept, which began with the "discovery" of the African continent by Europeans. Through her painting's symbolism, including the teacup with the cameo of a Black woman's head, Sherald explores the construct and history of Blackness. "My work delves into the aspects of assimilation, role-playing, and existential dichotomies contained by a developing narrative of Black identity," she says.

Pages 69–71
Amy Sherald (b. 1973)
Breonna Taylor, 2020
Oil on canvas
54 × 43 in. (137.2 × 109.2 cm)
Smithsonian National Museum of African American History and Culture, purchase made possible by a gift from Kate Capshaw and Steven Spielberg / The Hearthland Foundation and the Speed Art Museum, Louisville, KY, purchase made possible by a gift from the Ford Foundation
© Amy Sherald
2021.117

I don't think I thought about the viewer so much as I thought about her family when I was making this portrait . . . but when you're speaking about violence against women and police brutality, she's become a face for that movement.

In 2020, after police shot and killed Breonna Taylor in a botched raid, *Vanity Fair* magazine commissioned Sherald to paint a portrait of Taylor for the September issue, guest-edited by author Ta-Nehisi Coates. Before what would become her first posthumous portrait, Sherald spent time speaking with Taylor's mother, Tamika Palmer, and learned of Taylor's interest in fashion. As a result, Sherald commissioned a Black female designer to create the dress for the portrait. Sherald also placed an engagement ring on Taylor's finger to represent the love between Taylor and her partner, Kenneth Walker, who was with her at the time of her killing. Although Taylor's untimely death prevented Walker from proposing, Sherald incorporated the ring to give him solace and to suggest a brighter future that art could invoke.

Sherald wanted the portrait to remain in the public sphere, saying, "I felt like it should live out in the world." It is now co-owned by the National Museum of African American History and Culture and the Speed Museum in Louisville, Kentucky, Taylor's hometown.

Page 129
Lorna Simpson (b. 1960)
Untitled (a lie is not a shelter), 1989
Gelatin silver print
59 × 48 in. (149.9 × 121.9 cm)
Gift of Billy E. Hodges
© Lorna Simpson. Courtesy of the artist and Hauser & Wirth
2009.2

A pioneer in conceptual photography and film, Lorna Simpson is best known for her large-scale photographic images of women, accompanied by enigmatic words and phrases. The subjects of her works often reference societal issues such as identity, gender, discrimination, and race. In the case of *Untitled (a lie is not a shelter)*, Simpson engages all of the above.

Created for the Art Against AIDS project in 1989, *Untitled* speaks to the lack of information, prevention, and treatment of HIV and AIDS among Black women and women of color during an era when it was primarily recognized and treated as a disease that afflicted gay white males.

Pages 42–43
Merton Simpson (1928–2013)
Confrontation 28A, 1966
Confrontation 28AA, 1966
Oil on canvas
Each: 39 ½ × 59 ½ in. (100.3 × 151.1 cm)
Partial gift of the Estate of Merton Simpson
© Estate of Merton Simpson
2015.175ab

In 1963, painter and arts activist Merton Simpson joined the artist collective Spiral as a founding member. This African American artist collective was established in part to improve the position and agency of Black artists and people in American society. Two years later, he participated in Spiral's only art exhibition. His contribution to the show became the genesis of his *Confrontation* series.

"I'm painting what I think I see: ugly people fighting ugly people," Simpson says. "I see wrongness on either side. I just think that it's an ugly thing. I want to paint it as that. And I think if people can see it, and frown upon it enough, it might make them think, 'Am I really part of this? Then I should want to do something about it.'"

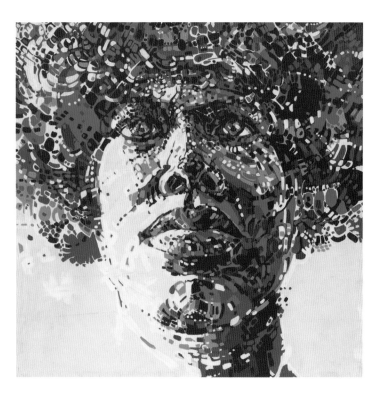

Page 115
Nelson Stevens (1938–2022)
Arty (centerpiece), 1970
Acrylic on canvas
50 × 50 in. (127 × 127 cm)
© Nelson Stevens
2016.73

Arty is the centerpiece of Nelson Stevens's triptych *Unity*, and it was inspired by the archetypal Christian altarpieces from the Byzantine era. Stevens replaced the traditional white religious figures with an image of a young Black woman. To elevate African Americans to a position of reverence and respect, he painted this composition using the technique of forced perspective: the viewer occupies a position of supplicant, or child, looking up to what Stevens calls the "hero's position."

Stevens was an early member of the African Commune of Bad Relevant Artists, or AfriCOBRA, a collective formed in 1968 to create uplifting art relevant to Black communities. His triptych was displayed in the group's first exhibition, *AFRICOBRA I: Ten in Search of a Nation*, at the Studio Museum in Harlem in 1970.

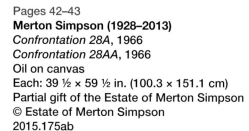

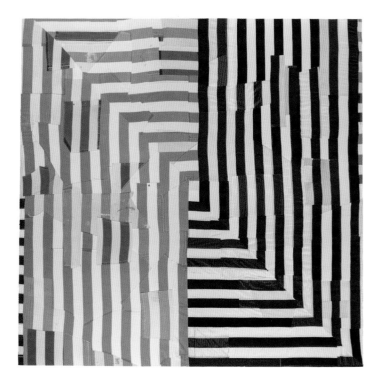

Page 162
Hank Willis Thomas (b. 1976)
Spiral, 2022
Cotton and synthetic cloth
99 × 102 ¾ in. (251.5 × 261 cm)
Museum purchase generously supported
by American Express
© Hank Willis Thomas. Courtesy of the artist
and Jack Shainman Gallery, New York
2023.106

The thing about America: liberty, justice, equality are all terms that come to mind but, for millions of Americans throughout its entire history as a nation, that has never really been true.

Spiral combines fabric from the United States flag with cloth from decommissioned prison uniforms, visually conflating the Stars and Stripes with the bars of imprisonment. This symbolic connection undercuts the false promise of liberty for all Americans, beginning with the continuing legacy of enslavement under the Constitution to the contemporary prison industrial complex and its disproportionate impact on African American men.

The cotton in the fabric of the flags and the prison uniforms also pays homage to the backbreaking work of cotton harvesting produced by many people of African descent in the southern United States.

Page 45
Lava Thomas (b. 1958)
Euretta F. Adair, 2018
Conté pencil and graphite on paper
47 × 33 ¼ in. (119.4 × 84.5 cm)
Gift of Cheryl and Charles Ward
© Lava Thomas
2021.55

Euretta F. Adair was one of more than eighty African American activists who were arrested for planning and participating in the Montgomery Bus Boycott (1955–56). Adair served on the executive board of the Montgomery Improvement Association, founded in 1955 by Black ministers and community leaders four days after the arrest of Rosa Parks for refusing to vacate her seat to a white passenger on a Montgomery city bus. The organization's mission was to oversee the boycott, improve race relations, and uplift the general tenor of the community.

Lava Thomas's drawing of Adair is one of twelve portraits in her series *Mugshot Portraits: Women of the Montgomery Bus Boycott*. Drawn from actual mug shots of female activists, these portraits highlight the commitment and bravery of the unsung women of the movement, whose sacrifices ensured today's freedoms.

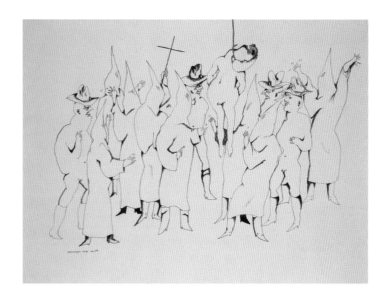

Pages 126–27
Mildred Thompson (1936–2003)
Untitled (Lynching of a Woman), 1963
Pen and ink on paper
18 × 24 in. (45.7 × 61 cm)
© Mildred Thompson Estate
2020.57.2

In her 1892 publication *Southern Horrors: Lynch Law in All Its Phases,* civil rights activist Ida B. Wells described the insidious nature of sexual and mob violence perpetrated against Black women throughout the South. Wells recounted in disturbing detail the horrific instances where Black women were stripped naked, raped by one or multiple white men, hanged, and mutilated. Between 1880 and 1930, more than 130 African American women were murdered by lynch mobs; countless others were sexually assaulted without legal recourse. Although Wells's organization and many other African American women and women's groups fought to obtain justice, the sheer number of Black women who were victimized and killed through mob violence was too often overlooked.

 With this powerful work, Mildred Thompson directly depicts this history in all its horror.

Pages 156–57
Stephen Towns (b. 1980)
An Offering, 2017
Each approximately: 40 × 16 × 1 ¾ in. (101.6 × 40.6 × 4.4 cm)
Mixed media
© Stephen Towns
2019.25.1ab, 2019.25.2ab, 2019.25.4ab, 2019.25.5ab, 2019.25.6ab, 2019.25.7ab, 2019.25.8ab

All of my work is rooted in my growing up in the Deep South. My work is in direct response to issues permeating African American culture, issues such as loss of ancestral roots, slavery, class, education, skin tone, and religion. I create beauty despite misfortunes in life.

The subject of *An Offering* was inspired by Marcus Rediker's 2007 book, *The Slave Ship: A Human History*. The full series of eight panels pays homage to West African people who were uprooted from their families and forced to endure the brutality of the Middle Passage and enslavement. The shape of each panel recalls the iconic eighteenth-century British slave ship the *Brookes* (p. 138). The candles represent an offering to these ancestors in a gesture of gratitude and solace.

*Our experiences and reactions to them are not isolated and
frozen in time, but instead are carried throughout a course, a life,
and oftentimes reoccur again and again.*

Colette Veasey-Cullors explores race, class, and gender identities
through her work. *Insecurity Past, Insecurity Present,* and *Insecurity
Future* are part of a larger series of works titled *Metaphors and
Life*. Within these photographs, the female form is a metaphor that
contains a range of human experiences and emotions, including
pain, self-doubt, anxiety, and uncertainty, as well as resilience and
courage. The triptych *Past, Present,* and *Future* and the emotions
the photographs explore and convey signify the emotional life
experiences of yesterday, today, and tomorrow.

*I'm gonna take everything I do about power and desire—and
use the tropes of the slave narrative or the slave romance, like
the antebellum romance, as the way to talk about these themes,
because this is something that clearly won't go away. It will just
keep being an unaddressed bugaboo in American culture.*

Kara Walker is best known for her silhouetted images of an imagined
antebellum past. The title of this print both references and subverts
President Abraham Lincoln's Emancipation Proclamation, issued
on January 1, 1863, during the third year of the Civil War. The
proclamation declared that all enslaved people who were in states
that rebelled against the Union "are, and Henceforward shall be free."

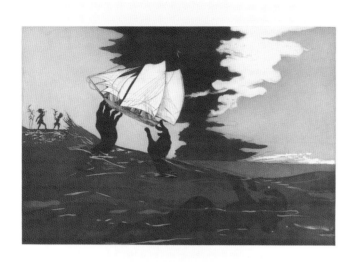

Kara Walker (b. 1969)
no world, 2010
Etching with aquatint, sugar-lift, spit-bite,
and drypoint on paper
30 ⅜ × 39 ¾ in. (77.2 × 101 cm)
© Kara Walker
2014.130.7

The work of Kara Walker is at once seductive, beautiful, provocative, and polarizing. She is best known for her use of the artistic convention of the Victorian silhouette to create images that skim the boundaries between the real and imaginary in the cultural minefield of sexual exploitation, slavery, and race.

Walker's print *no world* is one of six created for the series *An Unpeopled Land in Uncharted Waters*. The title, *no world*, plays on the concept of the United States as a "New World," or a place of new beginnings for the majority of those who have immigrated to its shores. For the ship's African cargo, this "New World" is not a place of hope, but rather a destination of pain, struggle, and lifelong bondage.

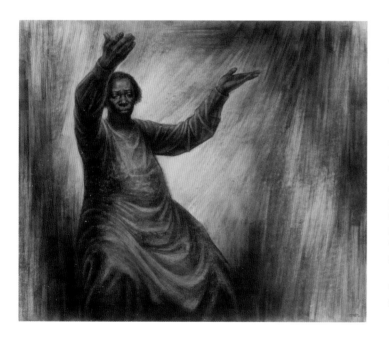

Pages 54–55
Charles White (1918–1979)
Move On Up a Little Higher, 1961
Charcoal and Wolff crayon on illustration board
40 ¼ × 48 in. (102.2 × 121.9 cm)
© 1961 The Charles White Archive
2009.6

Charles White's drawing *Move On Up a Little Higher* interweaves themes of religion, music, visual art, and the struggle for civil rights. The title refers to a gospel song by William Herbert Brewster in the early 1940s. Brewster stated that he wrote the song to "inspire Black people to move up higher," a dangerous message that could be sung, but not openly said, in the segregated South. Following the release in 1948 of Mahalia Jackson's recording of the composition, "Move On Up a Little Higher" became an iconic song within the Civil Rights Movement.

White's drawing reveals the immense power of Black women within the church, as well as in the struggle for race and gender equality.

Page 155
Kehinde Wiley (b. 1977)
Saint John the Baptist, 2014
Gold leaf and oil paint on wood panel, metal
40 × 24 × 4 ⅛ in. (101.6 × 61 × 10.5 cm)
Gift of the Martin Z. Margulies Foundation, Miami, FL
© Kehinde Wiley
2017.105

Kehinde Wiley has often drawn inspiration from images that reflect the past but speak to the present. The idea for this painting likely comes from Leonardo da Vinci's painting *Saint John the Baptist* (1513–16), included in the collection of the Musée du Louvre in Paris. This work is included in Wiley's series *A New Republic*, which portrays contemporary portraits of men and women that riff on specific paintings by old masters to raise questions about race, gender, and the politics of representation. Wiley's elevated and intimate portrait also draws attention to the absence of African Americans from historical and cultural narratives.

CONTRIBUTOR BIOS

AARON BRYANT, PH.D. is curator of photography at the Smithsonian's National Museum of African American History and Culture. At the NMAAHC, Bryant curated the exhibition *City of Hope: Resurrection City & The 1968 Poor People's Campaign*, which received the Smithsonian Secretary's Research Prize, in 2019, and is currently traveling the United States with plans to travel abroad in 2025. He has lectured at institutions such as Duke, Johns Hopkins, Oxford, Cambridge, Harvard, the British Museum, and the Metropolitan Museum of Art and has traveled with the U.S. State Department to lecture at universities and cultural institutions in Madrid, Seville, and Barcelona, Spain. Prior to the Smithsonian, Bryant curated the art collection at Morgan State University's James E. Lewis Museum of Art.

BISA BUTLER is an award-winning artist known for her vibrantly stunning, larger-than-life-size quilted portraits of the African diaspora that captivate viewers around the world. In 2022, Butler was awarded a Gordon Parks Foundation Fellowship and has received an Honorary Doctor of Letters from Bloomfield College. Butler's work was the focus of a solo exhibition at the Art Institute of Chicago in 2020. Many institutions and museums have acquired Butler's work, including the Smithsonian's National Museum of African American History and Culture, the Renwick Gallery of the Smithsonian American Art Museum, the Museum of Fine Arts, Boston, the Art Institute of Chicago, the Los Angeles County Museum of Art, and many others.

MICHELLE D. COMMANDER, PH.D. is deputy director of the Smithsonian's National Museum of African American History and Culture. A scholar of slavery and memory, Black geographies and mobility, and the speculative arts, Commander is the author of *Afro-Atlantic Flight: Speculative Returns and the Black Fantastic* and *Avidly Reads: Passages*, and editor of the anthology *Unsung: Unheralded Narratives of American Slavery & Abolition*. Recently, she served as the consulting curator for the Metropolitan Museum of Art's exhibit *Before Yesterday We Could Fly: An Afrofuturist Period Room*. A prior Ford Foundation Fellow and Fulbright Scholar (Ghana), Commander is an elected member of the American Antiquarian Society.

TULIZA FLEMING, PH.D. is supervisory curator of visual art at the Smithsonian's National Museum of African American History and Culture. During her tenure, she played a critical role in building the Museum's art collection and served as lead curator for the exhibition *Reckoning: Protest. Defiance. Resilience* (2021) and the inaugural exhibition *Visual Art and the American Experience* (2016). She also curated *Clementine Hunter: Life on Melrose Plantation* (2018), and co-curated *Ain't Nothing Like the Real Thing: How the Apollo Theater Shaped American Entertainment* (2010). Prior to her current position, she was the associate curator of American art at the Dayton Art Institute in Ohio, where she organized exhibitions such as *The Glass of Louis Comfort Tiffany* and *Monet and the Age of American Impressionism*.

AMY SHERALD. Born in Columbus, Georgia, and now based in the New York City Area, Amy Sherald documents contemporary African American experience in the United States through arresting, intimate portraits. Sherald engages with the history of photography and portraiture, inviting viewers to contemplate accepted notions of race and representation, and to situate Black life in American art. Sherald was the first woman and first African American to ever receive the grand prize in the 2016 Outwin Boochever Portrait Competition from the National Portrait Gallery in Washington, DC. In 2018, Sherald was selected by First Lady Michelle Obama for her official portrait, commissioned by the National Portrait Gallery. She is also a recipient of the Smithsonian Ingenuity Award, and her work is included in the collections of the Smithsonian's National Museum of African American History and Culture and the National Portrait Gallery, among many others.

DEBORAH WILLIS, PH.D. is University Professor and chair of the Department of Photography & Imaging at the Tisch School of the Arts at New York University, where she teaches courses on photography and imaging, iconicity, and cultural histories visualizing the black body, women, and gender. She is also the director of NYU's Center for Black Visual Culture/Institute for African American Affairs. Willis is a celebrated photographer, acclaimed historian of photography, and MacArthur and Guggenheim Fellow whose research and publications examine photography's multifaceted histories, visual culture, contemporary women photographers, and beauty.

KEVIN YOUNG is the Andrew W. Mellon Director of the Smithsonian's National Museum of African American History and Culture. Prior to joining the Smithsonian, Young served as the director of the Schomburg Center for Research in Black Culture. A professor for two decades, he began his career in museums and archives while serving as curator and Candler Professor at Emory University from 2005 to 2016. Young is the author of fifteen books of poetry and prose, most recently *Stones*, short-listed for the T. S. Eliot Prize; *Blue Laws: Selected & Uncollected Poems 1995–2015*, long-listed for the National Book Award; and *Emile and the Field,* named one of the best children's books of 2022 by the *New York Times*. His nonfiction book *Bunk* was also long-listed for the National Book Award, a finalist for the National Book Critics Circle Award for criticism, and named on many "best of" lists for 2017. Young is the editor of nine other volumes, most recently the acclaimed anthology *African American Poetry: 250 Years of Struggle & Song*. He is a member of the American Academy of Arts and Sciences, the American Academy of Arts and Letters, and the Society of American Historians, and was named a chancellor of the Academy of American Poets in 2020.

ACKNOWLEDGMENTS

Reckoning is a curatorial project and a provocation. The exhibition originated amid twinned pandemics—a moment of great urgency in which Americans were experiencing and/or witnessing innumerable losses of life and facing critical questions about the very state of our union.

We are grateful for the curatorial vision of the National Museum of African American History and Culture's Andrew W. Mellon Director, Kevin Young, who conceptualized the exhibition and worked closely with co-curators Dr. Tuliza Fleming, Supervisory Curator of Visual Art, and Dr. Aaron Bryant, Curator of Photography, to take on the difficult task of examining a profound period of living history that they were experiencing in real time. Their brave research and creative insight resulted in the creation of a gallery space that has enabled hundreds of thousands of visitors to bear witness, feel a sense of solace, and better understand Black artists and activists' calls for a national reckoning. Within these pages, I join Director Young and Drs. Bryant and Fleming in offering further historical context and insightful analyses to complement what they so beautifully achieved in this exhibition.

We are indebted to many individuals and teams. The exhibition itself took shape as Carlos Bustamante, the Museum's Associate Director for Project Management and Planning; Andy Medalie, the exhibition's project manager; and Mike Biddle, the exhibition's designer, came on board, listening carefully as the curators articulated the themes and stakes of the project. With great care, creativity, and unprecedented swiftness, the exhibition came to fruition. We appreciate them as well as our colleague Michèle Gates Moresi, Assistant Director for Collections, and her staff, who worked tirelessly on matters regarding acquisition, cataloguing, collections management, conservation, digitization, installation, and registration to make the exhibition and this catalogue possible.

I cannot say enough about how much it has meant to have our publications manager Douglas Remley's leadership on this project. We thank him for being a patient and steadfast supporter of our work, maintaining schedules, editing content, serving as a sounding board, and offering us solid recommendations at every turn. Several divisions across the Museum have been instrumental in welcoming and engaging diverse audiences about *Reckoning*, including the Office of Visitor and Guest Services, the Office of Public Affairs, the Office of Digital Strategy and Engagement, the Office of Advancement, and the Education Department. We extend our gratitude to them as well as to Debora Scriber-Miller, Laura Voss, Pauline Lopez, Dontez Henderson, Walter Larrimore, and Josh Weilepp, who supported the publications team as the project took shape and expanded. My predecessor Kinshasha Holman Conwill, Deputy Director Emerita, helped build both the Museum's visual art collection and the publications program prior to her retirement. We so appreciate her leadership across the Museum, particularly the firm publications foundation she established during her tenure at the Museum.

What a wonderful experience it has been to work with the Rizzoli team on this catalogue. We express our sincere thanks to Charles Miers, Margaret Chace, and Isabel Venero for enthusiastically embracing our vision and allowing us to lean into it creatively. After introducing us to the

talented designer Elizabeth Karp-Evans from Pacific, they have remained thoughtful and engaged partners as we considered each aspect of the publication. From selecting essay themes to carefully determining object placement and the layout of each page, these collaborative sessions resulted in a catalogue that offers images and commentary to prompt readers' contemplation and reflection on America's past, present, and future.

We acknowledge and celebrate the artists whose works make up our exhibition and assist us in making sense of our times. We remain in awe of, and in gratitude to, our artist talk participants—Bisa Butler, Amy Sherald, and Deborah Willis—for the creative insight shared in their discussion and for the ways that their bodies of work bear witness and offer avenues for us to reflect on ourselves and on the just worlds we want to make. The transcript reproduced here was taken from the inaugural program in the *Simmons' Talks* speaker series *Portraiture at the Intersection of Art and History*, held at the NMAAHC on March 16, 2023. The program was produced by the Office of Public Programs and supported by a generous endowment from Dr. Ruth Simmons, NMAAHC Council Member; President Emerita, Brown University; President Emerita, Smith College; and Former President of Prairie View A&M University.

Thank you to the many individuals who have supported the Museum and this exhibition by donating artwork from their personal collections. We especially want to acknowledge Jan Christiaan Braun, who curated the groundbreaking exhibition *Black USA*, in Amsterdam in 1990, for which David Hammons's *African-American Flag* was created.

We were heartened that the families of the late George Floyd, Rodney King, and Trayvon Martin visited the *Reckoning* exhibition. Their presence in the hallowed pathways of The Rhimes Family Foundation Gallery underscored our charge as a Museum, particularly the necessity for telling and retelling a fuller American history, one that looks back, reflects on the present—our living history—and insists on the importance of reckoning as we endeavor to become a more perfect union.

Michelle D. Commander, Ph.D.
Editor

Published on the occasion of the exhibition
Reckoning: Protest. Defiance. Resilience.,
National Museum of African American History
and Culture, September 2021—April 2025.

First published in the
United States of America in 2024 by
Rizzoli Electa, A Division of
Rizzoli International Publications, Inc.
300 Park Avenue South
New York, NY 10010
www.rizzoliusa.com

in association with

National Museum of African American
History and Culture, Smithsonian Institution,
Washington, DC

FOR RIZZOLI ELECTA
Publisher: Charles Miers
Associate Publisher: Margaret Chace
Editor: Isabel Venero
Production Manager: Alyn Evans
Designer: Elizabeth Karp-Evans (Pacific)

FOR NATIONAL MUSEUM OF AFRICAN
AMERICAN HISTORY AND CULTURE
Andrew W. Mellon Director: Kevin Young
Deputy Director: Michelle D. Commander
Publications Manager: Douglas Remley
Curators: Tuliza Fleming and Aaron Bryant

2024 2025 2026 2027 / 10 9 8 7 6 5 4 3 2 1
ISBN: 978-08478-3669-7
Library of Congress Control Number:
2024932250

Printed in China

Visit us online:
Facebook.com/RizzoliNewYork
X (formerly Twitter) @Rizzoli_Books
Instagram.com/RizzoliBooks
Pinterest.com/RizzoliBooks
Youtube.com/user/RizzoliNY

Front cover:
Bisa Butler, *I Go To Prepare A Place
For You* (detail), 2021

Back cover:
David Hammons, *African-American Flag*, 1990